NATURE PHOTOGRAPHY

NATURE PHOTOGRAPHY

*Insider Secrets from the World's Top
Digital Photography Professionals*

CHRIS WESTON

AMSTERDAM • BOSTON • HEIDELBERG • LONDON
NEW YORK • OXFORD • PARIS • SAN DIEGO
SAN FRANCISCO • SINGAPORE • SYDNEY • TOKYO

Focal Press is an imprint of Elsevier

Acquisitions Editor: Cara Anderson

Associate Editor: Valerie Geary

Publishing Services Manager: George Morrison

Project Manager: Mónica González de Mendoza

Marketing Manager: Christine Degon Veroulis

Cover and Interior Design: Joanne Blank

Cover image: © Chris Weston

Vector art: iStockphoto

Focal Press is an imprint of Elsevier

30 Corporate Drive, Suite 400, Burlington, MA 01803, USA

Linacre House, Jordan Hill, Oxford OX2 8DP, UK

Library of Congress Cataloging-in-Publication Data

Weston, Christopher (Christopher Mark)

 Nature photography : insider secrets from the world's top digital photography professionals / Chris Weston.

 p. cm.

 Includes index.

 ISBN 978-0-240-81016-4 (pbk. : alk. paper) 1. Nature photography. 2. Photography--Digital techniques. I. Title.

 TR721.W47 2008

 778.9'3—dc22

 2008014678

British Library Cataloguing-in-Publication Data

A catalogue record for this book is available from the British Library.

ISBN: 978-0-240-81016-4

For information on all Focal Press publications, visit our website at www.books.elsevier.com

08 09 10 11 12 10 09 08 07 06 05 04 03 02 01

Printed in China

CONTENTS

THE PROFESSIONALS ix

HABIT ONE PLAN FOR THE PERFECT PICTURE 3

Research and Planning 5

Know Your Subject 10

Visualization and the Art of Seeing 16

Pack for the Picture You Want 21

HABIT TWO KNOW YOUR CAMERA 29

Camera Controls and What They Do 31

Image File Type 34

White Balance 38

ISO (Amplification) 39

Exposure Mode 46

Using the Histogram and Highlights Information Screens 50

Focus Mode 54

Using the Menu System 56

Advanced Menu Options and Custom Settings 66

Using Modern Lenses 66

Camera Handling 71

HABIT THREE SEE WHAT YOUR CAMERA SEES 83

Light: Photographers' Paint 85

Contrast: When the World Turns Gray 91

Through the Lens: A Camera's Eye View 94

HABIT FOUR TAKE CONTROL OF YOUR CAMERA 105

Managing Light 107

Painting with Light 110

Understanding Exposure 118

Exposure and Contrast 129

Expose for the Highlights, Process for the Shadows:
 The Digital Exposure Mantra 137

When to Use Specific Metering Modes 140

When to Use Which Exposure Mode 145

ISO Relationship to Exposure 145

Applying White Balance for Artistic Effect 151

Choosing the Right Lens for the Occasion 161

Using Auto-Focus Effectively 162

HABIT FIVE LEARN THE RULES (AND WHEN NOT TO APPLY THEM) 175

Learning the Art of Omission 176

Designing a Photographic Image 189

The Psychology of Design and Its Role in Composition 190

Creating a Sense of Depth 201

Six Rules of Nature Photography … and When to Break Them 203

HABIT SIX CAPTURE THE MOMENT (PUTTING EVERYTHING INTO PRACTICE) 213

What Makes a Compelling Image? 214

Two Questions to Ask Before Pressing the Shutter 214

Defining your Subject 216

The Making of 15 Best-Selling Images 220

HABIT SEVEN PRACTICE (MAKES PERFECT) 251

Armchair Exercises to Keep You Photographically Fit 252

Ten Photo Workouts to Get You Shooting Like a Pro 254

Six Photo Projects to Inspire You 258

Planning Your Own Assignments 262

INDEX 265

The following professional wildlife, landscape, and nature photographers contributed to the content of this book, directly or indirectly, sharing their ideas, techniques, and experience, and the secrets of their trade.

Heather Angel
Freelance nature photographer
England

www.heatherangel.co.uk

For more than a quarter of a century, Heather has been at the forefront of wildlife photography in Britain and her work has been recognized with many awards both in the UK and overseas, including an honorary doctorate from Bath University, a special professorship from Nottingham University, and a top award from the U.S. BioCommunications Association. Heather was president of the Royal Photographic Society from 1984 to 1986. She communicates her enthusiasm for photographing the natural world via her prodigious writing, workshops and lectures. Her exhibition, Natural Visions, toured the UK from 2000 to 2004, and also appeared in Kuala Lumpur, Cairo, and Beijing.

Niall Benvie
Freelance nature and conservation photographer
Scotland

www.imagesfromtheedge.com

Niall Benvie has published three books and over 220 articles; he is one of the UK's most prolific writers on nature photography. The scope of his writing extends into issues of land management and the polarization of nature and culture as well as travelogues, book reviews and commentaries on subjects as diverse as species re-establishment programs and ecotourism. He does not follow the international honey-pot trail, instead preferring to seek out stories in relatively underworked, although biologically rich, areas.

Steve Bloom
Freelance wildlife photographic artist
England

www.stevebloom.com

Steve Bloom is a photographic artist who specializes in evocative images of the natural world. Born in South Africa,

he first used the camera to document life there during the 1970s. He moved to England in 1977, where he worked in the graphic arts industry for many years. In the early 1990s during a visit to South Africa, his interest in wildlife photography emerged, and within a short time he had swapped his established career for the precarious life of a wildlife photographer. He has won awards for his work and his pictures are seen around the world in calendars, posters, advertising, editorial features and a multitude of other products.

Jim Brandenburg
Freelance nature photographer
United States

www.jimbrandenburg.com

Minnesota-based Jim Brandenburg has worked as a photographer with *National Geographic* magazine for over 25 years, resulting in 19 magazine stories, several television features, and over 19 books. His photographs have won a multitude of prestigious national and international awards, and he was twice named "Magazine Photographer of the Year" by the National Press Photographer's Association. He has also been the recipient of the World Achievement Award from the United Nations Environmental Programme in Stockholm, Sweden.

Pete Cairns
Freelance nature and conservation photographer
Scotland

www.northshots.com

Peter Cairns is a freelance nature photographer with a deep fascination for humanity's relationship with the natural world. In addition to documenting Europe's high-profile wildlife species, his work focuses on a diverse range of issues such as wildlife management, ecological restoration, ecotourism and evolving land-use regimes.

Joe Cornish
Freelance landscape photographer
England

www.joecornish.com

Joe has made major contributions to many National Trust publications, especially *Coast* and *Countryside*, published in 1996. His first book was *First Light: A Landscape Photographer's Art* (2002), now in its fifth printing. More recently, he wrote and photographed *Scotland's Coast: A Photographer's Journey*, and shot the pictures for Urbino (a hill town in central Italy), a rare departure into architectural photography. He writes regularly for *Outdoor Photography* and *Amateur Photographer* magazines, and his work has been featured in *Outdoor Photographer* magazine.

In January 2006, *Amateur Photographer* honored him with their annual Power of Photography award. Joe has given lectures on landscape photography throughout the UK and as far afield as New Zealand, and he is an experienced workshop leader. Photographic companies who work with Joe include Lee Filters, Fujifilm UK, Gitzo, and Lowepro.

Steve Gosling

Freelance nature photographer

England

www.stevegoslingphotography.co.uk

Steve specializes in producing creative and contemporary images of the natural world — landscapes, flowers and plants, and trees and foliage. His photographs have been published internationally as posters and in books, magazines, newspapers, calendars and greetings cards. Prints of his work have been exhibited in venues throughout the UK and have also appeared on sets for both theatre and film productions. His work has won awards in national and international competitions, including the Royal Horticultural Society's Annual Photographic Competition in both 2002 and 2003. More recently he achieved success in the 2006 Black & White Photographer of the Year competition.

Paul Harcourt Davies

Freelance macro, nature and travel photographer

Italy

www.hiddenworlds.co.uk

Paul has built up an international reputation for his work through his photographs and his books on orchids, Mediterranean wild flowers, travel and photography. He is a regular contributor to magazines such as *Outdoor Photography* and *Freelance Photography*, and has led numerous photographic tours.

Nick Meers

Freelance location, architectural and panoramic photographer

England

www.nickmeers.com

Nick's work has appeared in many books, calendars, annual reports, book jackets, record covers, greeting cards, postcards and magazines. He has shot over 30 travel books worldwide, three of them in the panoramic format, and written many articles for photographic magazines. His work has been exhibited many times at The Association of Photographers Gallery in London and in several National Trust exhibitions. It has also been purchased for the Citibank Art Collection in London and by private collectors all over the world.

Michael "Nick" Nichols

National Geographic **staff photographer**

United States

www.michaelnicknichols.com

Michael "Nick" Nichols is an award-winning photographer whose work has taken him to the most remote corners of the world. He became a staff photographer for the National Geographic Society in 1996. Dubbed "The Indiana Jones of Photography" in a profile by *Paris Match*, Nichols has been featured in *Rolling Stone*, *Life*, *American Photographer*, *JPG* and many other magazines. He has been awarded first prize four times for nature and environment stories in the World Press Photo competition. His other numerous awards come from Wildlife Photographer of the Year and Pictures of the Year International. In 1982, the Overseas Press Club of America granted him a prize for reporting "above and beyond the call of duty," an honor usually reserved for combat photographers.

Freeman Patterson

Freelance nature photographer and writer

Canada

www.freemanpatterson.com

Although Freeman does much of his photographic work at home, he travels widely to photograph and to teach. Since 1973, he has frequently presented half-day and all-day seminars to large groups (50 to 4,000 persons) in the visual arts, music, education and ecology across Canada and the United States and in other countries. Since 1977, he has written and illustrated several photographic books. In 1996 he completed a CD-ROM entitled *Creating Pictures: A Visual Design Workshop*, and a major retrospective book of text and photographs, entitled *ShadowLight: A Photographer's Life* for Harper Collins of Canada, which was followed in 1998 by *Odysseys: Meditations and Thoughts for a Life's Journey*, and in 2003 by *The Garden*. Freeman has written for various magazines and CBC radio, and been featured on CBC television's *Man Alive*, *Sunday Arts and Entertainment*, and *Adrienne Clarkson Presents*.

Joel Sartore

National Geographic **staff photographer**

United States

www.joelsartore.com

Joel Sartore brings a sense of humor and a Midwestern work ethic to all of his *National Geographic* Magazine assignments. Over 20 years of experience (more than 15 with the National Geographic Society) have allowed him to cover everything from the remote Amazon rain forest to beer-drinking, mountain-racing firefighters in the United Kingdom. Besides the work he has done for *National Geographic*, Joel has completed assignments for *Time*, *Life*, *Newsweek*, *Sports Illustrated*, as well

as numerous book projects. Joel has been the subject of several national broadcasts including *National Geographic's Explorer*, the *NBC Nightly News*, NPR's *Weekend Edition*, and CBS's *Sunday Morning*, as well as an hour-long PBS documentary.

David Tarn
Freelance landscape photographer
England

www.davidtarn.com

Says David, "I would like to claim to have studied fine art and photography under some of the masters, and in a sense this would be true, only none of them was ever aware of me as a student. I learned the craft of photography from books and magazines but most of all in the field, in the real world by trial and error – and more error than I care to recall. I feel that when my photographs work best they have simply achieved the amateur ideal of bringing home part of the experience of being there."

Jeff Vanuga
Freelance nature photographer
United States

www.jeffvanugaphotography.com

Jeff has been photographing nature for over 20 years and his work has been published worldwide in magazines and major advertising campaigns. His credits include National Geographic

Traveler, Outside, BBC Wildlife, National Wildlife Audubon and the Sierra Club. He has won first place in the prestigious BBC Wildlife Photographer of the Year competition and leads photographic tours around the world.

Stuart Westmorland
Freelance nature and underwater photographer
United States

www.stuartwestmorland.com

Stuart Westmorland is recognized as one of the leading nature, lifestyle, marine and general stock photographers in the United States. His images appear in a variety of books, magazines, posters, calendars, brochures and institutional and aquarium displays. He has led photo and natural history trips for two decades, and conducted many photography seminars at yearly film festivals, camera clubs and nature groups. His images are sold through the largest stock photo agencies in the world including *www.gettyimages.com*.

Chris Weston
Freelance wildlife and conservation photographer
England

www.chrisweston.uk.com

Chris has been involved in professional wildlife photography since 1998. He is represented by Getty Images and his work

appears regularly in the national and international press and has been used worldwide in advertising campaigns. In 2003, he became one of only two photographers worldwide to gain affiliate membership of Canopy, a U.S.-based NGO working in the field of conservation and environmental issues. He has written over 20 books on photography and wildlife, including a collaborative project with Art Wolfe. He is an experienced photographic workshop and safari leader via his company Chris Weston (Photography Workshops).

Art Wolfe

Freelance nature photographer

United States

www.artwolfe.com

Art Wolfe's photographs are recognized throughout the world for their mastery of color, composition, and perspective. His vision and passionate wildlife advocacy affirm his dedication to his work. Wolfe's photographic mission is multifaceted. By employing artistic and journalistic styles, he documents his subjects and educates the viewer. His unique approach to nature photography is based on his training in the arts and his love of the environment.

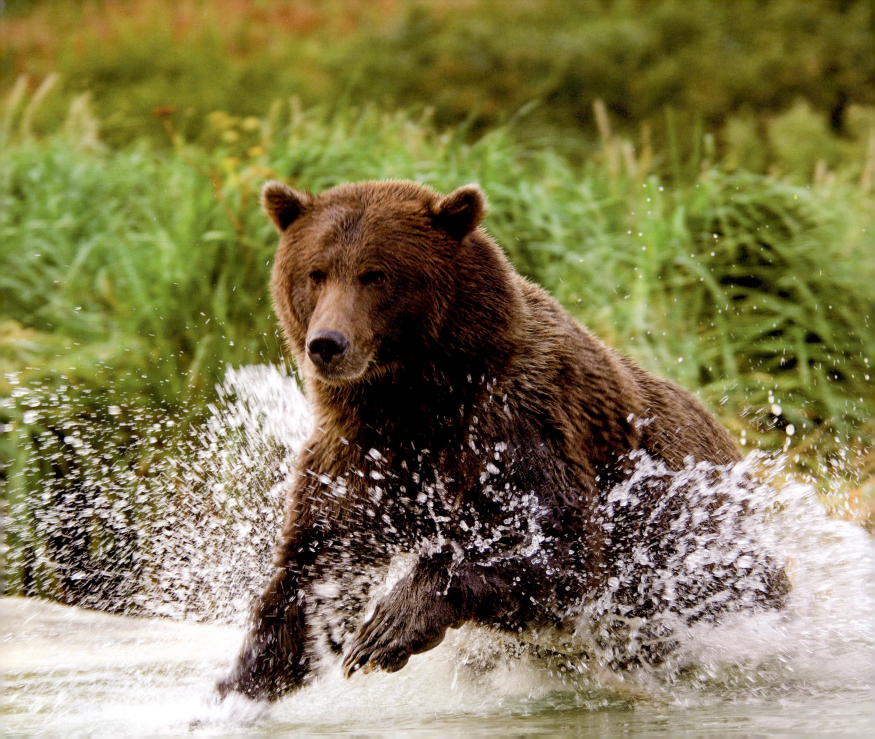

PLAN FOR THE PERFECT PICTURE

You may be amazed at exactly how much work goes into capturing the perfect image, such as the one on this page. This image of zebras took over three years to photograph, from the point of conceiving the idea for the image to actually recording it. Three years of traveling to Africa passed before the combination of perfect lighting and subject came together. The ingredients for this image, which is one of my most successful in terms of art print sales, is an in-depth knowledge of the subject, visualization of the final composition, research and planning into where to go and when, and choosing the right equipment for the job. It won't surprise you to know that these four factors are common to most of the shots in this book, and many of the shots captured by professional photographers around the world, day in day out, irrespective of the subject. So, to sum up, the first habit of highly successful nature photographers is: *Plan for the perfect picture.*

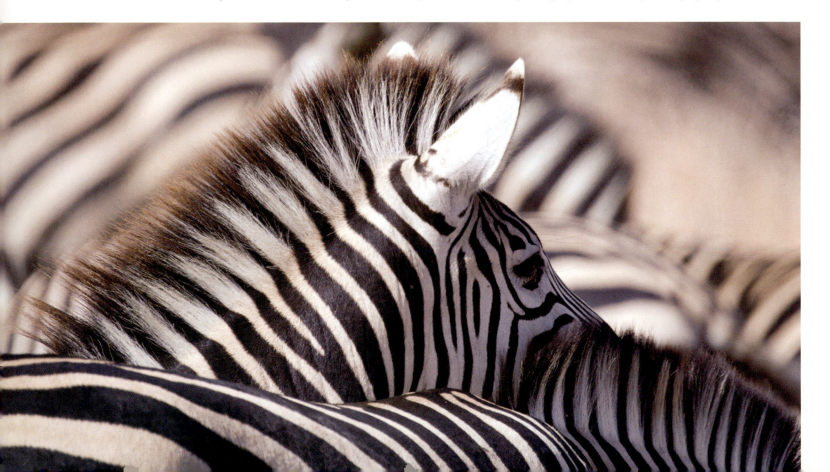

RESEARCH AND PLANNING

There is often an assumption that photography is simply a matter of showing up. Indeed, there is a well-worn cliché that states, "The secret to photography is f/8 and be there." Unfortunately, what the author of these words failed to mention was, exactly where is "there"? Planning and research play a hugely influential role in the success of any professional photographic assignment, whether it is commercial, advertising, social, or, my field and the principal subject of this book, wildlife and nature photography. For example, how would I know when to travel to photograph puffins on the English coast or coastal bears in Alaska if I didn't first do my research? And how great a fool would I feel if I headed for the Farne Islands or Skomer Island in February, when all the puffins had migrated north, or to Katmai National Park in March, before the bears congregate for the summer salmon run?

To put the importance of planning and research into perspective, *National Geographic* staff photographer Michael

PHOTO © CHRIS WESTON

Despite its simplicity, this image was three years in the making, from conceiving the idea to being in a position where the two key requirements—right light, right subject—came together to make it possible. The wait was worth it: It is one of my best-selling art prints.

"Nick" Nichols explains how he plans the successful execution of an assignment:

A *Geographic* assignment is going to take a year of my life any way you slice it, because that's what it takes to get it.

The editor and the director of photography and my editor tell me what to do, but the reality is simple. There's only one person that goes out the door, and the story has to be made from what I took pictures of. I'm on my own out there. One of the things I think people misunderstand is that there's nobody that gives you a list or anything, there's not a whole lot of research that anybody else does.

When I've gotten the assignment, I do as much research as humanly possible about the subject. My rule of thumb is I usually spend as much time in the field as I do preparing. So, two months in the field means two months preparing. Even if 90 percent of that research is useless, it's important. When I'm doing research, ideas about pictures come to my head. That doesn't mean I'm going to go out and set up pictures, but it gives me a lot of ideas so I can hit the ground running. And as long as I let serendipity through, I'll still get pictures

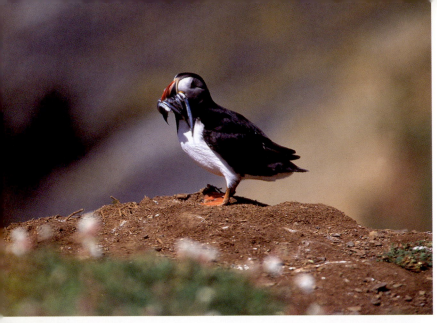

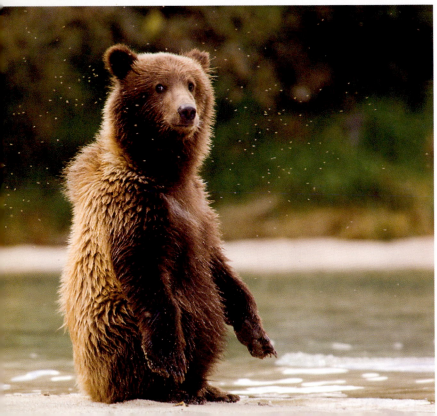

that just happen. But by going to all the places that I've lined up, all the little pieces should start to give us a whole and tell us something about Indonesia or tigers or whatever the particular subject is.

Learning languages is good, though I have to say it's overrated because I don't speak languages. I wish that I had learned them as a child, so if you're really young and you're reading this, definitely study languages. If I had learned all the languages of places I've worked at, you know, I'd just be a linguist. The language you do want to learn, though, is how to be polite in that culture. If you can say hello to people, good afternoon, thank you, they'll know, okay, he's made some effort. And you've got to learn what not to do, all those things you can do wrong. You don't want to make a cultural faux pas.

Research and planning begin in the office, poring over maps, scouring reference books, talking over the phone or via e-mail with local experts and interrogating the Internet,

Planning when and where to photograph specific species will prevent wasted time and money, and ensure that you are in the right place at the right time to capture your shots.

which, has become the lifeblood of my research to the extent that I can't remember what I did before it existed.

The Internet is my usual starting point. I begin with a generic search on the subject or subjects I'm researching and then narrow the search using key words. The problem with the Internet is the amount of information posted, as much of it is outdated or simply inaccurate. For example, if you run a key word search on, say, "gorillas," results will total about 20 million pages. A simple review of a tiny fraction of initial results reveals little new information, but hidden within the mountains of electronic paper are one or two knowledge gems that enable me to move forward on my planning.

Often this information is in the form of names and contacts, which I follow up via e-mail or, preferably, by telephone. Once I have the bases for a trip—locations, timing, ground support—I do further research on the specifics of the assignment, such as local conditions, logistics and terrain, which include all the obstacles I'm likely to encounter and have to overcome to be successful.

PHOTO © PETER WATMOUGH

Research and planning begin at home, referencing maps and books as well as talking to colleagues on the phone.

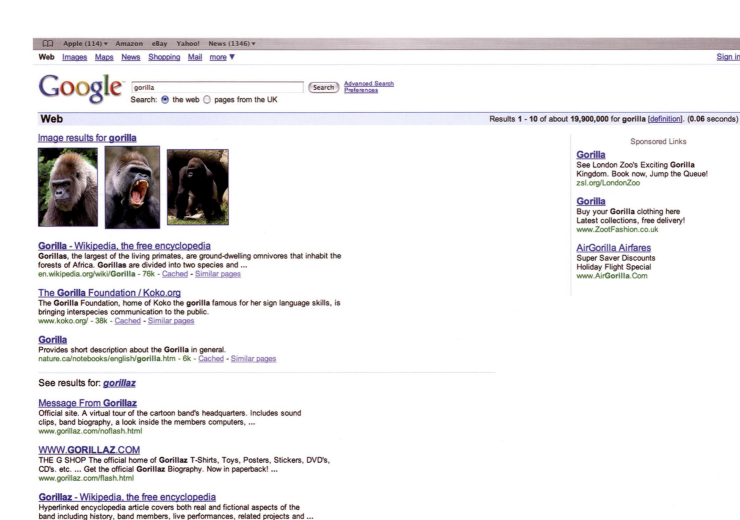

The Internet is my first port of call when researching a project or assignment. It is an essential tool, but must be used wisely to obtain useful and reliable information.

Networking with peers and others in associated professions also helps. For example, a few years ago, while photographing brown bears, I spent some time working with a biologist in Alaska. We became good friends and that friendship has enabled me to work with other biologists in other specialty fields and geographic locations, without whom my assignments would have been far more difficult to complete. In many ways the process is identical to that of any business venture—it's not what you know, it's who you know.

Great nature images rarely happen by chance. It's not a question of aimlessly wandering the globe hoping to bump into a compelling scene. Trusting to luck will only end in

PHOTO © CHRIS WESTON

My good friend and colleague, Chris Morgan, a bear specialist, escorts photographers in Katmai National Park, Alaska. Working with experts such as Chris has enabled me to capture better images more efficiently.

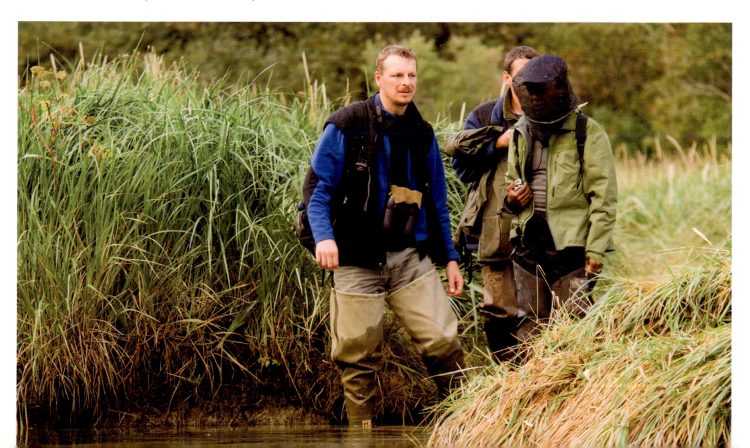

disappointment (and commercially, in no future work). Nor is the belief that the grass is greener elsewhere the secret to success. Just because Africa is abundant in exotic species and habitats doesn't mean that you'll capture the image of a lifetime simply by hopping on a flight and tromping through the bush. So, lesson number one is: Get into the habit of researching your photographic trips, however short or local, and you will find that you achieve better images, more often and, importantly, more consistently.

Get into the Habit: Research

Another *National Geographic* staff photographer, Joel Sartore, explains how he researches an assignment: "I get lots of help from scientists and experts who know the subject I'm working with, people who live in the areas I'll be working in, and people who have worked with a subject or area previously. A lot of time is spent locating books or magazine articles, hunting down phone numbers and doing the several dozen other tasks that go along with putting story research together. The way I research is to read up on a topic, find out who I need to talk with to learn more, and then make phone calls. Talking to those in the know is one of the best ways to prepare."

KNOW YOUR SUBJECT

Ninety percent of my job is biology, and 10 percent is photography. But what exactly does that statement mean? Let me give you an example: When photographing wildlife action, if I were to wait and react to events, by the time my brain had initiated a "press shutter now" command and my finger had actioned it, and the shutter in the camera had actually fired, whatever it was I had been photographing would have long since happened and passed. This is because human reactions are, in reality, incredibly slow.

The solution is to predict the shot and to have the camera framed and ready for the image that's about to happen, rather than reacting to events. It's much like clay pigeon shooting: The weapon is aimed not at the clay but ahead of it, so it's the clay that hits the shot and not the other way around. When photographing wildlife, then, I am anticipating what is about to happen and composing my image based on predicted scenarios. It's only possible to achieve this if you know enough about your subject—in particular, behavior and body language—that you are able to second-guess it. And that knowledge comes from a rudimentary understanding of biology.

As an example, let me refer back to my bear biologist friend. The first time we worked together was many years ago

during my first experience photographing brown bears. We were standing in the middle of Brooks River in Katmai National Park, surrounded by bears. Chris, the biologist, was carefully watching the signals the bears were giving via their body language. Then he whispered to me, "That bear at 2 o' clock will leap for a salmon in three seconds." I looked at him with raised eyebrow and skepticism. He returned my look with a knowing smile. Lo and behold, right on cue, the bear leaped, water splashed and a salmon became lunch. I missed that shot but I never doubted him again.

PHOTO © CHRIS WESTON

My early skepticism about the ability to tell the future by reading body language was quickly dispelled. I now use this technique to capture all my fast-action shots of wildlife.

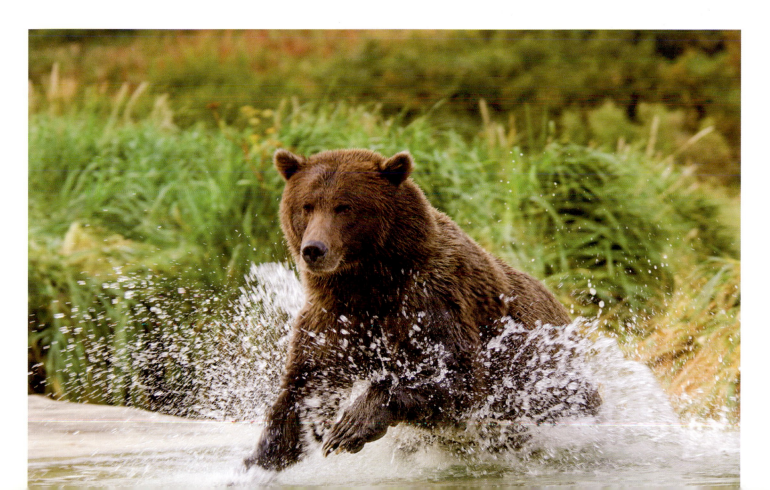

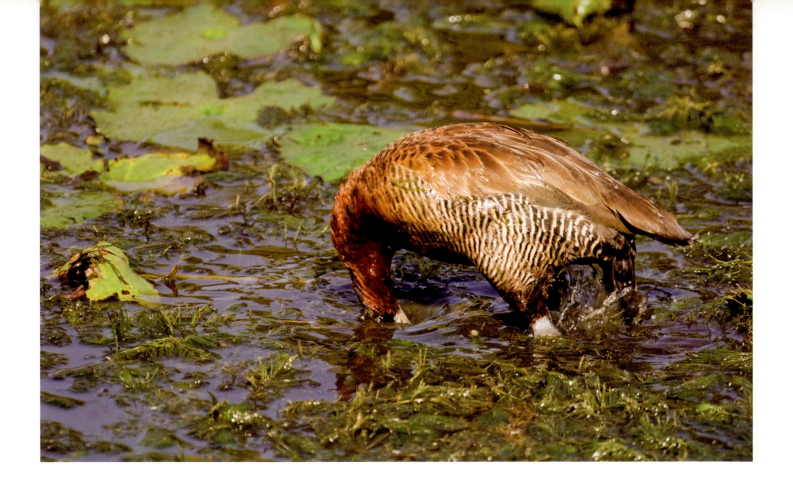

Since then, although I rely heavily on the information provided by biologists and researchers, I pay close attention to animal behavior. I do a lot of reading in the office of works such as *The Secret Language and Remarkable Behaviour of Animals* by Janice Benyus, and *Safari Companion* by Richard D. Estes. More importantly, I spend time in the field watching wildlife to learn habits and traits that reveal important clues about how animals behave. For instance, I was photographing in Kruger National Park when I noticed a particular species of duck that, when feeding, would bob under the water. I fired a few practice shots but in all of them, my reactions were never quick enough to capture an image with a duck's head breaking the water. The head was always submerged.

PHOTO © CHRIS WESTON

Early attempts to photograph whistling ducks as they broke through the surface water failed, as time and again my reactions were too slow (p. 12). After spending a few minutes watching the birds for clues, I noticed their habit of wiggling their bums before diving. Armed with this new knowledge, future attempts were more successful (above).

So, I put down the camera and watched. After a couple of minutes I noticed that, just prior to diving, the birds would wiggle their feathery bums. This was the clue I needed. I picked up the camera and composed the image. Then I waited, watching for the signal. At the moment my chosen subject wiggled its bum, I pressed the shutter. This time the image was in the bag.

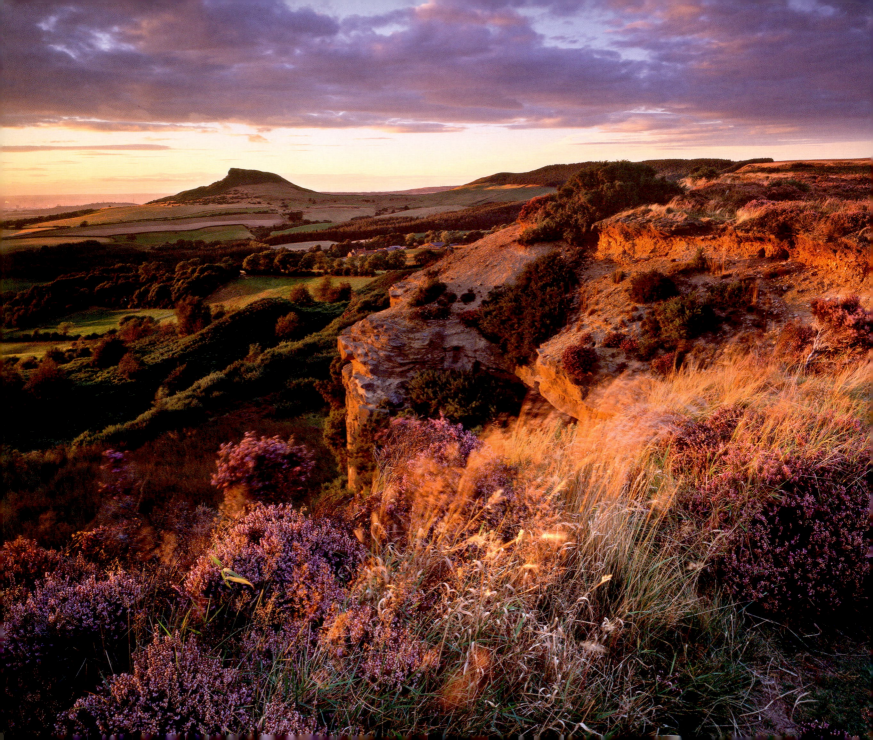

The same rules apply to landscape photography. Another friend, one of Britain's most celebrated and talented landscape photographers, Joe Cornish, has in his office a map of his local area, marked with suggested shooting angles, ideal months and notes on weather (for lighting), all indicating the best times and conditions for photographing a particular scene. So, when he's sitting in his office and looks out to find the ideal conditions, he just grabs his bag and heads off, knowing his intended destination with precision. There's no messing about, no time wasted um-ing and ah-ing about where to go. There is a reason that Joe captures the images he does and this is one of them.

Award-winning macro-photographer, Paul Harcourt Davies, explains how he manages to capture spectacular images of insects: "The problem most people have with photographing subjects such as dragonflies is they do it at the wrong time of day. Most insects become active as the sun warms the air and, although they're easy to find at this time, they never stay still long enough to photograph them. Instead, I venture out early in the morning to known hot spots and photograph them when they're lethargic from the cool morning temperatures. It's not rocket science, just science ... basic biology."

Knowing the best times to locate sleepy insects helps Paul Harcourt Davies capture stunning macro images of the natural world.

In the course of research for this book, I have spoken to many photographers from all genres of photography—sport, press, music, food, social and so on—and without exception, they all say the same thing: Without an in-depth knowledge of their subject, they'd never capture the images they do. Great images don't happen by chance, but rather by

Rosebury Topping is a natural landmark close to Joe's home in Yorkshire. His knowledge of the area is such that at any given time and in any weather, he knows the ideal location from which to photograph it. Joe's knowledge of Rosebury Topping is second to none ... and so are his photographs of it.

judgment, that is, the photographer's ability to read the scene and anticipate the shot. Lesson number two: Know your subject like you know yourself.

VISUALIZATION AND THE ART OF SEEING

"Visualization" is a word that was used frequently by the grandmaster of outdoor photography, Ansel Adams. Adams defined visualization as "referring to the entire emotional-mental process of creating a photograph" and as "a conscious process of projecting the final photographic image in the mind before taking the first steps in actually photographing the subject."

For me, visualization starts before leaving home. Although it would be unfair to suggest that I, or indeed any professional photographer, knows *every* image I am going to record before I record it, frequently I have a clear idea in my head of certain images and compositions I intend to capture. The image of the brown bear (p. 247) is a perfect example. This image was photographed on my third visit to Katmai National Park (although my first visit to the Katmai Peninsula). Before I left home, I pictured this scene almost exactly as you see it on the page. This was the shot I went all the way to Alaska to get.

Now, while it may have been *possible* to photograph the same shot without having visualized it, the fact that I knew what I

was looking for when I arrived on location made it more certain that I'd find it. In other words, visualizing the idea of a photograph increases the likelihood of finding the right subject and conditions in which to photograph it, which, in turn, increases the success rate of your photographic journeys and adventures. As Michael Nichols said previously, "When I'm doing research, ideas about pictures come to my head. That doesn't mean I'm going to go out and set up pictures, but it gives me a lot of ideas so I can hit the ground running."

Tip

Google Earth is an excellent point of reference for determining how a scene looks in real life and can be used in conjunction with a map to help plan a photo excursion.

A question that I am frequently asked by keen outdoor photographers is, "How do you see the images you photograph?" Obviously some subjects are fairly straightforward, but many compositions are relatively subtle. Like Michael Nichols, often I am photographing images to tell a story about a broader picture than the subject itself, such as a report on an

PHOTO © GOOGLE

Modern technology has made researching assignments so much easier. For example, Google Earth has become a great resource for planning trips and assignments, such as a recent visit I made to Mount Rainier in Washington State in the USA.

aspect of conservation (e.g., habitat loss, poaching or global warming). When this is the case, often I am looking for specific scenes that visually reveal the verbal message.

At other times I look beyond the literal subject. For example, the image of wildebeest reproduced on page 20 was photographed during the seasonal migration of wildebeest, zebra and gazelle in the Serengeti, Tanzania. Now, wildebeest are far from the most photogenic of subjects: They're rather ugly and, apart from eating grass, they do very little. So, after a day of nondescript photography I asked myself the question, "What am I actually photographing here?" The answer I came up with was "migration" and I conceptualized what migration means—movement: Migration is the movement of animals (or people) from point A to point B. Thus, movement became the subject of my images and I used my camera to record a sense of motion, rather than straight, simple (and often uninspiring) portraits of wildebeest.

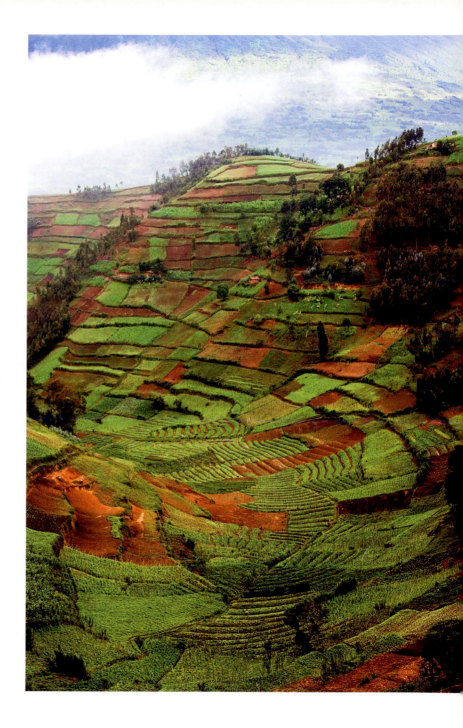

Sometimes my images reflect life and circumstance, and are used in an editorial context, such as the scene revealing the nature of farming in Rwanda, close to gorillas' natural habitat (right). At other times they are more artistic in design, capturing conceptual ideas of nature and the world around us, as the image of movement shows (see image on page 20).

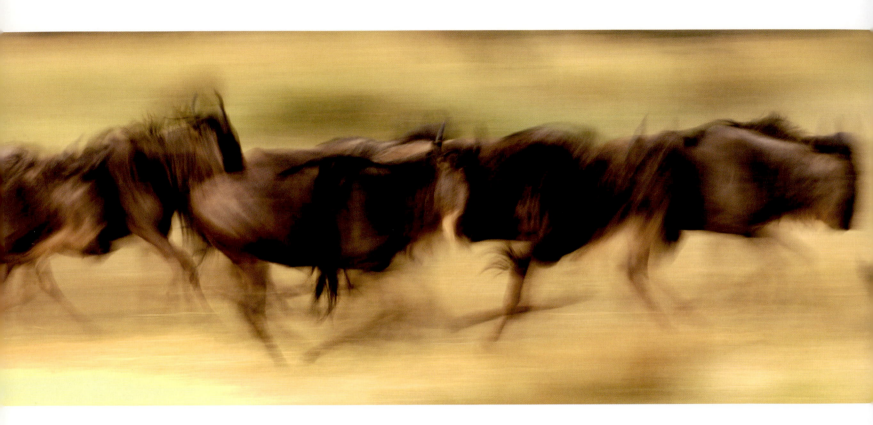

This method of defining the subject, which is covered in more detail later in the book (see Habit 5), is critical to successful photography. To illustrate this point, imagine I asked you to write a short story or to present an illustrated talk. Your first question, quite legitimately, would be, "About what?" You need to know exactly the nature of the subject before you begin, and that applies equally to photography as it does to writing, public speaking or any other form of communication.

The ability to see in photographic terms is limited only by your imagination. Some suggest that it can't be taught, that it's a natural gift that a person possesses or not. I beg to differ. I didn't have a natural ability to see images; I learned the ability from others, in the same way I learned from teachers about math and science. It can be taught and its fundamentals are found in design, a subject that I cover in depth in Habit 5. Lesson 3: Think before you shoot. Imagine the final image in your head before you frame the image and, when it comes to defining the subject of the photograph, use your imagination to think outside the box.

PACK FOR THE PICTURE YOU WANT

Two of the biggest conundrums facing photographers working in the outdoors are what equipment to carry and how to carry it. When it comes to overseas travel, particularly when traveling via or through certain countries, the situation becomes even more problematic.

The easy answer is to carry everything you own because you are almost guaranteed that whatever you leave behind is the piece of kit you'll want most desperately on location. However, lugging great packs of gear around, particularly on extended trips, may not be feasible.

A better answer is found within the topics already covered. If you have researched your trip and visualized the type of images you want to photograph, not only are you likely to improve your chances of getting the desired shots, you will be able to make a more informed decision about the equipment you will need to capture them.

For example, immediately after completing this book I am heading to India and Vietnam to work on a new project. The project is well defined and I have a clear goal as to the images I want to shoot. All of the images involve working in close proximity to the wildlife I'll be photographing and so, when it comes to choosing lenses for the trip, I know that I can leave behind my long telephotos (heavy, cumbersome, difficult to transport and eye-catching to thieves) and pack only the wide-angle and standard lenses and a short—medium telephoto zoom, all of which fit nicely into my carry-on luggage.

Working this way I can limit the amount of gear I need to transport overseas, which, since 9/11 and similar events in London and elsewhere, has become one of the most stressful parts of my job. It also means I have less to carry with me into the field.

Get into the Habit: Photographic Equipment and Airports

Over the years, I have devised many methods of getting my gear from point A to point B, safely and securely. As time has gone by, most of the major airport authorities and airlines have done their best to foil my latest fiendish plan, up to the point that now there are few ways to beat the system.

Given the distinct possibility that anything valuable going into the cargo area won't make it to the intended destination, I rarely, if ever, carry equipment in checked luggage. On a short assignment, my typical method of carrying gear at the time of this writing is to pack as much equipment into a regulation-size photo pack as I can get away with. Packed intelligently, these packs can carry an awful lot of gear. Any other equipment I secrete into the pockets of a large press-style photo vest, which I wear under my jacket. I appreciate that I look a bit idiotic, but I prefer this to having my valuable equipment pilfered.

On longer assignments, where I have to carry much more equipment, I have the bulk of the equipment shipped to my destination by one of the major international courier companies. This way I can track it throughout its journey and the equipment is insured (few insurance companies will insure valuable items between the point of airport check-in and baggage collection). When using this method of transporting gear, I always carry with me a minimum amount of gear

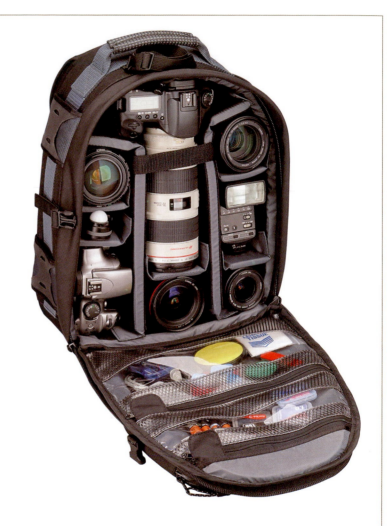

PHOTO © INTRO2020

For short trips abroad, I carry all of my essential gear onto the plane in a regulation-size photo pack, such as this model made by Tamrac.

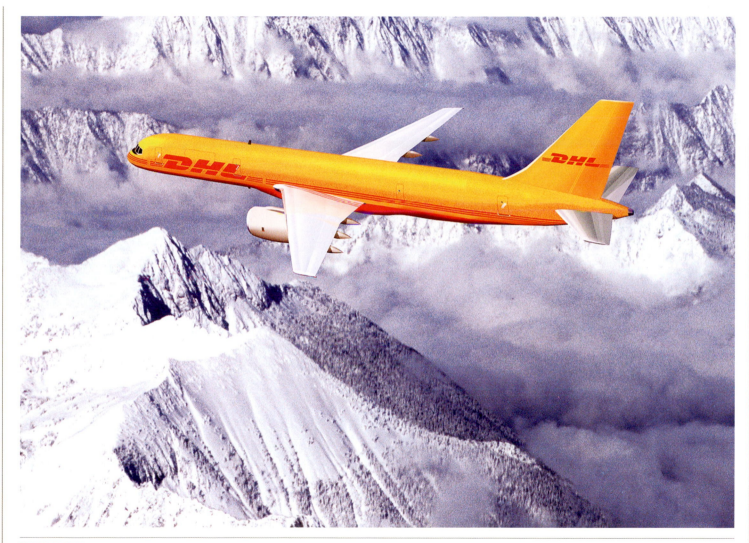

PHOTO © DHL

For long overseas assignments, I often have the bulk of my gear shipped out by air courier. I then collect the containers at my final destination.

to enable me to get some work done in the event my other equipment arrives in Kazakhstan rather than Kenya. This gear includes the following:

- Digital camera body
- 24- to 70-mm AF zoom
- 70- to 200-mm AF zoom
- 200- to 400-mm AF zoom
- 1.4 × teleconverter

- Flash unit and cables/bracket
- Spare batteries and charger
- Memory cards
- Portable HDD
- Camera/lens-cleaning accessories
- Cable release

No doubt I'll need to change my packing method again, but at the moment it seems to work okay.

A Tale of Two Cultures

Given the overly officious attitudes encountered at many airports, the following true story may amuse you.

I was traveling out of a small, provincial airport in Africa, heading for Johannesburg. To set the scene, the terminal building was little more than a tin shack and the arrivals/departure information board was a conference room flip chart.

In front of me in the security line was a lady carrying several rolls of exposed film. The film was in a clear plastic bag and each film cartridge was outside its container. When the attendant, dressed in an old, ill-fitting uniform (no socks), called her forward she asked politely if he would make a hand search of her film, explaining that the x-rays might damage it.

The attendant looked a little perplexed, as if not understanding her request, so she explained again. This time a wide, genial grin crossed the man's face and he pointed to a sign on the wall that read, "All baggage must pass through the x-ray machine."

"Yes, I know that," said the lady "but, as I explained, the x-ray might damage my film."

"I am sorry," replied the attendant, still smiling, "but all baggage mus' pass through the x-ray masheen."

The lady tried again but received the same smiling response, "All baggage mus' pass through the x-ray masheen."

A local tour guide overheard the conversation and tried to help out. He spent five minutes explaining to the attentive, still smiling attendant the reason that the lady didn't want to pass her film through the x-ray machine.

Finally a look of understanding spread across the attendant's face. "Ah!" he said, "I understand. But ... it is o-kay. Because ... the x-ray masheen, it is no' working!"

With that the bag of film passed through the x-ray machine and everyone was smiling.

When choosing a photo bag, your options are seemingly increasing all the time, as new and innovative designs reach the marketplace. However, the two most important criteria are its size (is it large enough to carry all the gear you'll need and, if you plan to travel much, small enough to be accepted as carry-on luggage?) and comfort (how does it feel when fully loaded?). My advice is to head down to your local camera store and experiment with a few different bags.

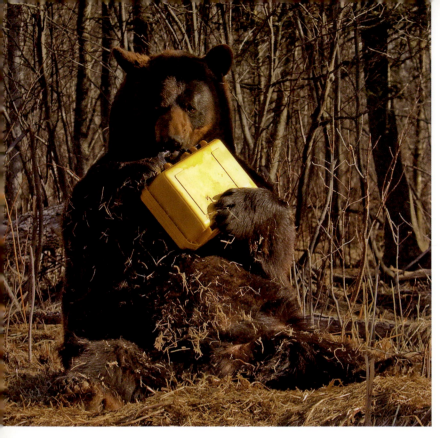

Purpose-designed hard cases, such as those manufactured by Storm, are designed to protect your gear from the hazards of overzealous baggage handlers.

If you intend to ever put camera equipment into an aircraft cargo hold, then I would suggest strongly that you use a purpose-designed hard case, such as those available from Peli and Storm. These cases will withstand the attention of even the most energetic of airport baggage handlers and are almost indestructible. I say "almost" because I have done some lengthy testing of Storm's cases, and have seen them survive the close attention of, among other creatures, a black bear. However, a case finally met its match in the shape of a full-grown adult male elephant. That said, the elephant, which I should point out, was in musth, took 15 minutes to crush the case. This was enough to convince me of its ability to protect my gear in all but the most extreme of circumstances.

When packing a bag for carrying in the field, make sure that weight is evenly distributed; this will make it more comfortable to carry, particularly on longer trips. Also, keep the bag well-organized, with essential gear easily accessible.

When taking camera bags through airports, if you intend to put a case in the cargo hold, try and disguise it by placing it inside a less obvious bag, such as an old army or military duffel bag. Padlocks will prevent minor pilfering but, when traveling via any U.S. airport, use the specially designed padlocks (Travel Sentry or Safe Skies Locks) to which U.S. Customs and Security have a master key (in the United States the authorities have the legal right to break any lock in order to search a bag).

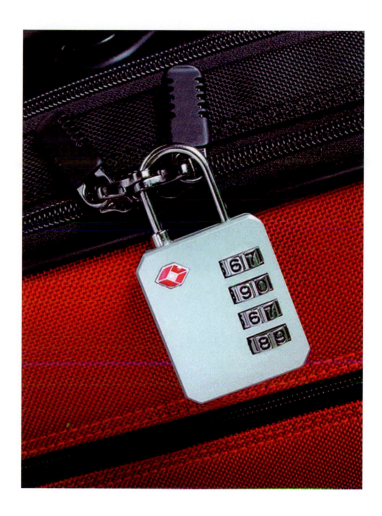

Specially designed padlocks can be used to help keep valuable equipment secure when traveling through countries such as the United States. U.S. security operators have a master key to these locks, which prevents their having to break them open.

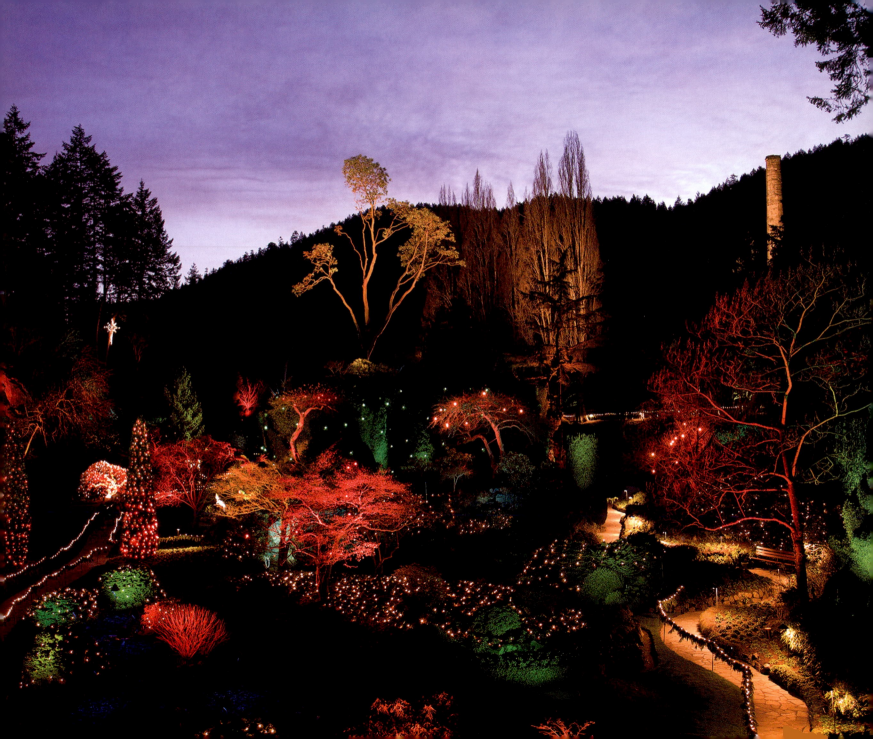

KNOW YOUR CAMERA

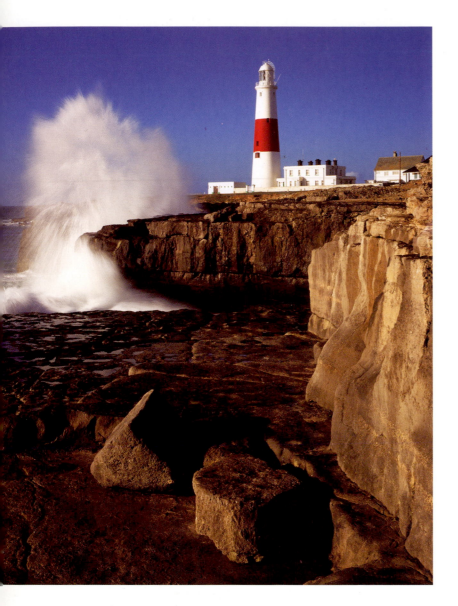

One of the most critical skills to learn in nature photography is the ability to handle the camera without thinking about it. The more time one spends wondering which control dial to adjust and in which direction, the greater the likelihood that your intended image has long since disappeared from the scene. This can be as true of an apparently static subject, such as a landscape, as it is of fast moving subjects like wildlife, particularly when you take into account how quickly light can change.

A useful analogy is driving. Those of us who have been driving for any period of time no longer think about the actual act of driving, we just get in our cars and drive. It's second nature. A competent nature photographer is able to use the camera in the same way. Of course, getting to this point takes practice. Remember when you couldn't drive at all? At that point, we are in a state referred to as unconscious incompetence—we don't know what it is we don't know. So, we decide to get some instruction. The driving instructor places us in the car and explains all the controls and how they work, and we move into a state described as conscious incompetence—we now know what it is we don't know.

PHOTO © CHRIS WESTON

The better you know your camera and its controls, the more quickly you can respond to and capture dramatic events.

After a few lessons and a bit of practice we begin to get the hang of driving and our confidence increases, although we still have to think about what it is we're doing. This is the state of conscious competence—we know what we're doing but have to think about it. Then after many weeks, months and years of practice, we are able to drive without thinking about the mechanics of driving—a state known as unconscious competence.

For many nonprofessional photographers, who do not get a chance to use their cameras day in day out, camera skills often sit in the second or third of these four categories. In order to master professional-level nature photography, however, developing the habit of using the camera instinctively is critical. Habit 2: Know your camera!

CAMERA CONTROLS AND WHAT THEY DO

In a cupboard at home I have an old Nikon F3 film camera. For many years the F3 was Nikon's flagship camera, a top-of-the-line, fully specified professional camera used by practically all professional photographers in the fields of press and outdoor photography. I also have the manual for the F3, which runs to a "massive" 47 pages. I also have the instruction manual for Nikon's current top-of-the-line digital camera, the D3, which runs to a total of 444 pages. What this

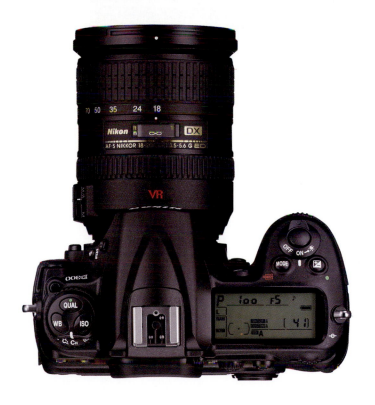

Today's digital cameras have a plethora of control buttons, switches, dials and menu options that can, at first glance, appear daunting and confusing.

point illustrates is that cameras are becoming increasingly sophisticated and complex.

The average digital camera today literally has many tens of buttons, switches, dials and menu options. The question, then, is which of all these options do you really need to know and understand?

To answer this question, let me relate a story from my childhood. When I was a young boy, my father was a pilot in the British Royal Air Force, flying high-level reconnaissance and bomber planes. Every year the RAF base at which we were stationed would hold an open day and, as the son of a pilot, I received special privileges, one of which was the opportunity to sit in my father's flight seat. So, at the age of five, I found myself perched in the cockpit of a Canberra aircraft, surrounded by hundreds of switches, dials and buttons.

Intrigued, I asked him, "Dad, how do you know what all these switches, buttons and dials mean?"

"Well," he replied, "it's really quite simple. In an airplane there are six instruments that are essential and they are the ones sitting directly in front of you on the flying panel— altimeter, air speed, vertical speed, artificial horizon, turn-and-slip indicator, and the compass. Of the others you only really need to refer to them when they begin flashing. When they flash, there's a manual in the back of the cockpit, so you look it up and follow any instructions the manual gives you."

I relate this story from my childhood because it sums up perfectly the controls on a modern digital camera. Of the many buttons, switches and dials, there are a few that are essential to capturing an image—metering and exposure modes,

Working your way around the controls of a modern camera can be likened to learning the controls in an aircraft.

focus, file type, white balance and ISO. The rest are nice to have and, if shooting in JPEG mode, can be utilized in place of postcapture processing. However, for the most part, and particularly when shooting in RAW mode, most can be ignored except in extraordinary circumstances. So, to begin this section of the book, I'm going to provide an outline of the essential camera controls—what they do and why you need to master them.

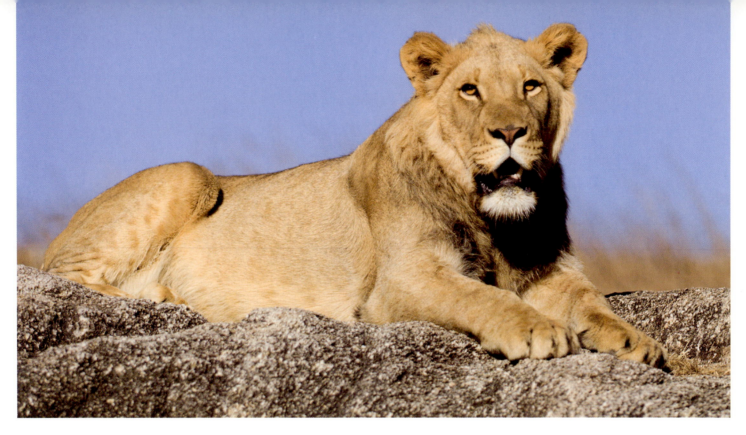

Printed to no more than A4 size, visually there is little obvious difference in quality between a high-resolution JPEG image (this page) and a high-resolution TIFF created from a RAW file (next page).

IMAGE FILE TYPE

With few exceptions, digital images may be stored as JPEG or RAW files. The option you choose will depend largely on what you plan to do with the images once you get them home. The general rule is that if you prefer to do little or no postcapture processing, have no intention of ever selling your images, and have no plans to print them much larger in size than A4 (approximately 10 × 8 inches), then shoot in JPEG mode. If, however, you enjoy the postcapture processing side of photography, want to sell your work, and/or print them beyond A4 size, then select RAW mode. Here are the reasons I make this assertion.

JPEGs: The Good, the Bad, and the Ugly

When a digital image is saved as a JPEG file, four things happen:

1. The camera processes the RAW data, based on the image optimization settings, using built-in image processing software.

2. Color information is compressed from the original 12- or 14-bit (tens or hundreds of billions of shades) range captured by the camera into an 8-bit (approximately 16.7 million shades) range.

3. The processed image data is compressed to reduce the file size, using a technique known as "lossy" compression.

4. The processed, compressed file is saved to the memory device.

There are two main advantages to these actions. First, because the file is processed in-camera, the image can be

printed with very little or no additional external computer (e.g. Photoshop) processing. In other words, JPEGs are the digital equivalent of Polaroid instant film. Second, because the image data is compressed so that file sizes are reduced, a memory device is able to hold a greater number of images, compared to larger RAW (or TIFF) files.

However, there are disadvantages to these actions as well. Most importantly, the processing software in digital cameras is relatively basic and lacks the processing finesse of much more sophisticated software solutions such as Photoshop. Simply, you will get far better image quality if you process the image file using better software than the camera provides.

Second, if you make an error when setting any of the image optimization settings (or when setting white balance), it is a complicated and sometimes impossible task to fix the error. At the very least, it means having to spend a lot of time in front of a computer trying to unscramble the proverbial scrambled egg, which somewhat defeats the objective.

Third, the means by which JPEG files are compressed results in actual data being discarded permanently. As a result, image quality will be degraded to some extent, even if it isn't immediately obvious or even apparent in a small-size print.

Furthermore, every time a JPEG image file is processed and re-saved in the JPEG format, the same lossy JPEG algorithms are applied, compounding the issue.

Finally, an 8-bit file contains only 256 levels (tones), compared to the 4,096 or 65,536 in a 12-bit or 16-bit file, respectively. This may result in artifacts and banding appearing in JPEG images that are heavily processed.

RAW Files

All of the disadvantages discussed previously are overcome when images are recorded in RAW mode. In RAW mode, the image data is saved unprocessed, that is, in its original form. While this means that the data must be computer-processed, the advantage is that software with greater functionality, such as Photoshop, can be used to do it, optimizing image quality.

Further, because the data is recorded in the RAW state, image optimization settings applied in-camera can be discarded and reapplied during computer processing, making it possible to correct some user errors without degrading image quality. Further still, a RAW file is like having an endless supply of exposed but unprocessed film, which can be processed any number of times and in any manner of different ways without losing the ability to return to the original and

start over. Not only does this enable processing of images in different ways for different effects, it also means that when new software technology becomes available, older images can be reprocessed with the latest technology.

Finally, because RAW image data is stored in an uncompressed state, no data is discarded. (Some cameras provide a RAW compression option, which roughly halves file size.

Close up, the effects of high levels of compression of JPEG images begin to tell.

However, RAW compression uses reversible (or loss-less) algorithms, meaning that no data is discarded.)

RAW + JPEG Mode

Many current DSLR (digital single-lens reflex) cameras enable image files to be saved in both RAW and JPEG format simultaneously. This is primarily a commercial tool, allowing photographers in the field to transmit images wirelessly to a remote site for instant upload to the Web via the Internet (the small-size JPEG), while maintaining a high-quality RAW file for other uses, such as submission to a photo library.

This option can be applied, however, in noncommercial ways. For example, when starting out in digital photography and before the user has the requisite knowledge of image processing software, by selecting RAW + JPEG, an immediately usable file (JPEG) can be created while the RAW file is stored until such time that the user feels comfortable with computer processing techniques using Photoshop (or any similar package).

A less commercial use of this function is as a back-up. If the RAW or JPEG file becomes corrupted, the other may still be useable. Of course, if it's the RAW file that is corrupted, you won't be able to create a RAW copy from the JPEG file. However, something is better than nothing.

WHITE BALANCE

Although we can't see it, light at different times of the day (e.g., sunrise and noon), under different weather conditions (e.g., cloudy vs. sunny), and from different sources (e.g., natural daylight and continuous-source studio lighting) varies in color. The technical term for the color of light is *color temperature*, and it is measured in degrees Kelvin.

Humans perceive all light to be neutral white, irrespective of its source, time of day or conditions. This is because we have a built-in white balance (WB) control in our brain. In technical terms, the purpose of the WB control in your camera is to operate in the same way as the WB control in your head, that is, to record all light as neutral white light.

However, there are numerous occasions when light benefits from a color cast. For example, humans respond positively to warm colors and to warm light, such as the light prevalent at sunrise and sunset. Imagine a sunset without the beautiful red glow—it's just not the same. Yet this is exactly what the camera is trying to achieve when WB is set to auto.

White balance can be used then to creatively enhance or introduce color casts, in much the same way that optical filters (e.g., 81-series "warm" filters) are used for the same purpose. Applying WB creatively is discussed in detail in Habit 4.

Meanwhile, consider that setting the camera to auto WB mode may not achieve aesthetically pleasing results.

Also consider that WB settings can be easily changed after the fact when using RAW capture. If using JPEG, the camera's setting at the time of capture is used to generate the file and cannot be altered easily afterward.

ISO (AMPLIFICATION)

In digital photography, ISO relates to the extent to which the light signal received by the sensor is amplified to make it stronger. The higher the ISO rating, the greater the level of amplification applied and the less signal (light) is needed to create a workable exposure. For example, in very

The golden colors of early morning light are diminished when the camera is set to auto WB (page 39). Using the WB control in the same way as one might use optical filters, in this case adding the equivalent of a warming filter by setting WB to the pre-set shade setting, will result in more aesthetically pleasing results (above).

bright conditions where light is plentiful, ISO may be set to a low value (e.g., 100). However, in dim lighting a faster ISO might be needed in order to achieve an adequate exposure value.

In effect, this makes digital ISO much the same as film ISO. However, the fact that digital cameras use amplification makes the process of digital ISO very different from that of film (which uses an increase in the physical size of the

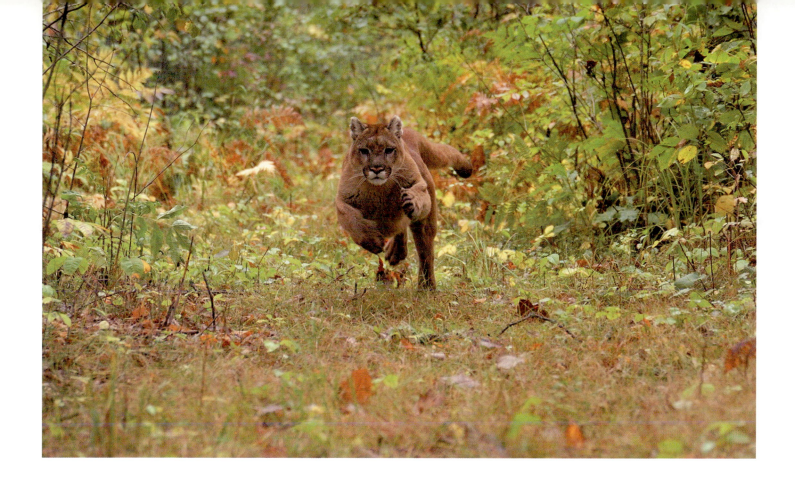

silver halide crystals to affect sensitivity). The role of ISO and the effects of increases in ISO rating are covered in detail in Habit 4. At this stage, it is simply important to understand two main facets of this camera control:

1. The higher the ISO rating, the less signal (light) is needed to create an exposure.

2. The higher the ISO rating, the greater the possibility of noise adversely affecting image quality.

Metering Mode

The tool used to measure the intensity of light, in order that photographers can set an appropriate exposure, is the light meter. In DSLR cameras this meter usually takes the form of

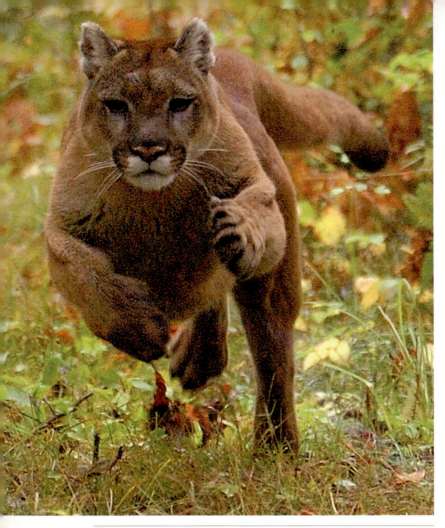

The disadvantage of high ISO ratings can be seen in this image of a puma. Note the high level of noise that can be seen, particularly in the shadow areas of the chest and belly.

a TTL (through the lens) reflected light meter that is incorporated in the camera and measures light passing through the lens.

Most cameras today have three main metering modes, each of which calculates exposure in a slightly different way.

Multisegment Metering

The most commonly used metering mode is multisegment metering. Canon refers to this mode as evaluative metering; other manufacturers, including Nikon, call it matrix metering; Sony/Minolta uses the term honeycomb metering; and still others refer to the simple term "multisegment" only.

It is a highly accurate form of metering when the subject brightness range (i.e., the difference between the darkest and brightest areas, also referred to as the scene's dynamic range) falls within the dynamic range limits the sensor is capable of capturing, and when an exposure is required that faithfully reproduces the scene as we experience it. The system works by taking several separate meter readings from various areas of the frame and then assessing them collaboratively in order to

Multisegment metering mode is ideal for general shooting conditions, when scene dynamic range doesn't exceed camera dynamic range.

produce an exposure value (EV) that will create an image with a full tonal range (or as close to it as the sensor is capable of).

Some systems go further. For example, some Nikon cameras have a database of historic images stored in the camera's computer together with a light pattern and the actual exposure used to record the image. When the light meter is activated, the camera reads the light levels in the scene to produce a current-scene light pattern, which it then matches against the image database. Once a match is found, it makes a note of the exposure used for the historic image and applies the same exposure value for the current image. Pretty clever stuff, when you think about it.

Despite its accuracy, this system has some limitations. First, when scene dynamic range exceeds the camera's ability to record detail in highlights and shadows simultaneously, clipping of pixels (i.e., pixels having no measurable digital value) may result. Additionally, the system is the least suitable for capturing images with a degree of creativity, such as photographing silhouettes or rim lighting. (For details of when to use multisegment metering mode, see Habit 4.)

Center-Weighted Metering

When center-weighted metering mode is selected, the camera measures the light for the full picture frame, but weights the exposure value to the level of light present in the center of the viewfinder.

The size of the center area to which the weighting is applied can be adjusted in some cameras, ranging from a circle with a diameter between 6 and 12 mm. Although a slightly older form of metering, it is accurate when matched with the right subject, typically portraiture (of people or animals). (For details of when to use center-weighted metering mode, see Habit 4.)

Spot Metering

When metering mode is set to spot, light from a tiny portion of the frame (around 3%) only is assessed. This makes it possible to assess the brightness of an area of the scene in isolation from surrounding areas. For example, when photographing for a silhouette, a spot meter reading can be taken for the bright tones, without shadow areas influencing the resulting EV.

PHOTO © CHRIS WESTON
Center-weighted metering is ideal for portraits of animals. (left)

PHOTO © CHRIS WESTON
Creative exposures are easier to manage when metering mode is set to spot metering. (right)

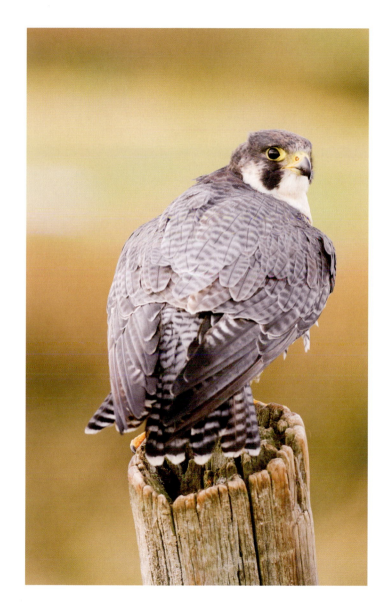

Spot metering is also the most accurate mode to use when manually assessing scene dynamic range, which is often done in landscape photography, (for example, when calculating the strength of a graduated neutral-density filter required to balance highlight and shadow tones in a high-contrast scene). (For details of when to use spot metering mode, see Habit 4.)

EXPOSURE MODE

Exposure mode determines how much control the photographer has over the two main tools of exposure—lens aperture and shutter speed. Most current DSLR cameras have four main exposure modes: program, aperture priority, shutter priority, and manual. All modes work slightly differently, but they all achieve the same end, which is to control exposure.

(Manufacturers refer to these modes in different ways. Typically, they will be labeled P for program mode, A or Av for aperture-priority mode, S or Tv for shutter-priority mode, and M for manual mode.)

Program Mode

In program mode, the camera determines both lens aperture and shutter speed, based on the meter reading. While this has advantages for basic point-and-shoot photography, it is of no use for anyone serious about mastering the skills of

photography. Another disadvantage of program mode is that in this setting many existing cameras also set ISO and white balance automatically, leaving no control to the photographer over four of the five most important camera controls.

PHOTO © NIKON UK

Some DSLR cameras provide a range of variable program modes suitable for photographing different types of subject. Even so, they should be used with caution, if at all.

Most entry-level and mid-range DSLR cameras have a program mode subsetting, often referred to as variable program mode. Icons on the exposure mode dial identify these variable programs, the icons representing subject types (e.g., sport, landscape, portrait).

When a variable program mode is set, the camera weights the exposure setting toward either lens aperture or shutter speed (and sometimes ISO), depending on the nature of the subject. For example, when the sport setting is selected, the camera will set a fast shutter speed at the expense of lens aperture in order to freeze the moving subject. Conversely, in the landscape setting, the camera will select a narrow (small) aperture to maximize depth of field.

While the program mode option makes the camera exposure-settings decision more informed, in all cases the camera is effectively making some very basic assumptions. For example, it is assuming that you want your moving subject to appear sharp, as if frozen in time, and that in all your landscape images you want maximum depth of field. Of course, this isn't always the case and relying on the camera to make these decisions for you may often end in disappointment.

Ultimately these decisions are yours to make. You are the photographer, and therefore you must take responsibility for the exposure. In order to do that, I urge you to forget program mode and concentrate on the other three options.

Aperture Priority

When aperture-priority auto mode is selected, the user sets the lens aperture and the camera sets an appropriate shutter speed, based on the meter reading. ISO and white balance are also set manually. By controlling lens aperture, the user determines the extent of depth of field, that is, the area of the scene in front of and behind the point of focus that appears sharp (also known as the zone of acceptable sharpness).

More significantly, by managing depth of field what you are really doing is controlling emphasis and deciding which pictorial elements within the scene remain visible to the viewer of the image, and which are hidden or blurred. Taking things a step further, it's also possible to dictate the order in which objects are viewed. In a nutshell, lens aperture plays an important and influential role in composition, which is why it's so important that aperture decisions are not left to the camera! I'll cover this in depth later in the book (see Habit 5).

Shutter Priority

In shutter-priority auto mode, the user selects the shutter speed and the camera sets an appropriate lens aperture

PHOTO © CHRIS WESTON

Lens aperture controls depth of field, that is, how much of the scene in front of and behind the point of focus appears sharp.

PHOTO © CHRIS WESTON

Shutter speed controls how time and motion are depicted. A fast shutter speed will freeze the appearance of motion (left), while a slow shutter speed will blur movement, in this case creating an ethereal effect on the water (right).

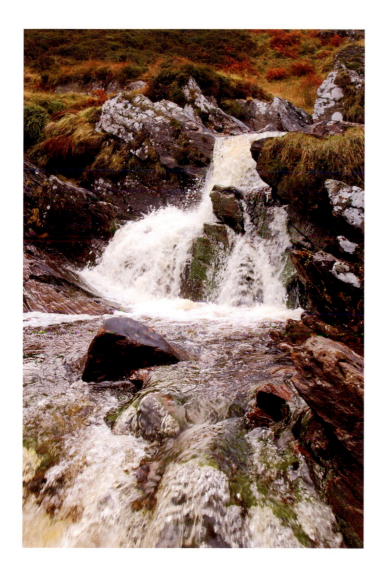

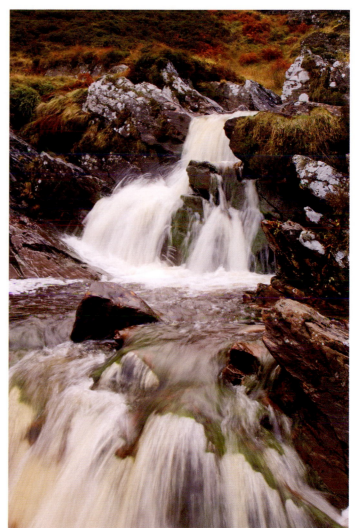

(again based on the meter reading). As with aperture-priority mode, ISO and white balance are set manually. Shutter speed determines how motion appears in a scene. A fast shutter speed (relative to the subject) will freeze the appearance of motion, revealing subject detail. At (relatively) slow shutter speeds, the appearance of motion is blurred, creating a sense of motion.

The obvious example is a waterfall. When a fast shutter speed is set, the motion of the water is frozen and detail is clearly visible. Conversely, setting a slow shutter speed will blur the movement of the falling water, creating a more ethereal, shroud-like appearance. The effects of shutter speed are covered in detail in Habit 5.

Manual Exposure Mode

When the camera is set to manual exposure mode, the user controls both lens aperture and shutter speed, with no input from the camera other than to provide a meter reading (which the photographer might not rely on). Typically, manual exposure mode is used in conjunction with spot metering mode (see Habit 4), although this isn't a requirement. There are some conditions under which selecting manual exposure mode is almost imperative, such as when using graduated (split) neutral-density filters.

Tip

Some of the more recent DSLR cameras have additional exposure modes to select from. For example, the Pentax K10D has a Sensitivity-priority Auto mode. In most cases these options are simply variations on a theme and I'm doubtful of any advantage they provide above and beyond using one of the existing options.

USING THE HISTOGRAM AND HIGHLIGHTS INFORMATION SCREENS

One of the great advantages of digital photography is the level of information provided by the camera in the field. On the face of it, this makes assessing exposure a relatively simple task: Simply take the image, check the histogram and, if all's well, move on to the next shot. Unfortunately, it's not as simple as that. (In photography nothing is, ever!)

Reading the Histogram

The digital histogram is, for all intents and purposes, a bar chart. The horizontal axis represents levels or tones of gray, from black (left) to white (right). The vertical axis represents

This histogram shows an even spread of tones across the tonal range and is indicative of a technically well-exposed image.

the quantity of pixels of any given tonal value. This is shown in the next illustration, where the sample histogram shows an image containing a full tonal range (pixels across the gray-scale from black to white) with a predominance of light and mid-tones.

Here the two histograms show a preponderance of light tones (top) and dark tones (bottom), indicating over- and under-exposure, respectively.

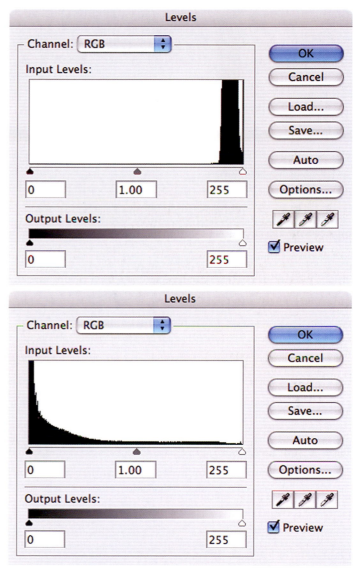

The histogram, therefore, can be used to determine whether an image is accurately exposed. For example, the previous illustration indicates a (technically) well-exposed image. Conversely, the following figure shows the histogram skewed heavily to the right, an indication of clipped pixels and over-exposure (top), as well as the opposite, a histogram skewed heavily to the left, indicating preponderance of dark tones and underexposure (bottom).

In addition to the luminance histogram described here, some higher-end DSLR cameras provide an individual histogram for each color channel (red, green, and blue (RGB). These color channel histograms enable the user to see whether any of the RGB light waves has been over- or under-exposed, providing a more accurate assessment of an individual exposure.

However, the data provided by the histogram must be read with caution for two main reasons. First, if you are photographing a high-key image, a low-key image, or a silhouette, then it is entirely reasonable for the histogram to show a skew toward one end of the tonal range or another. The next illustration shows a histogram, for example, that is representative of a high-key image.

Histograms can be misleading. For example, the previous histogram appears to show a majority of pixels at the two

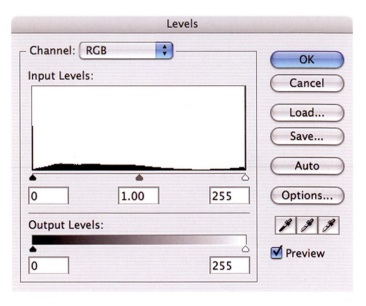

This histogram illustrates the distribution of tones for a high key image.

extremes (blacks and whites) with very little detail in the quarter, mid, and three-quarter tones. However, the histogram is taken from a high-key image and is exactly what would be expected.

More importantly, the histogram on the camera represents processed image data, that is, data reflective of a low-resolution JPEG image. If you are shooting in low-resolution JPEG mode, this is fine. However, if you are shooting in

RAW mode (in particular) or high-resolution JPEG mode, then the data provided by the histogram (and this also applies to the preview image displayed by the LCD screen) will be inaccurate and unreliable.

On a recent visit to the UK, professional nature photographer Art Wolfe explained to me why he rarely, if ever, uses the in-camera histogram: "First of all I don't have time to interpret the information it's giving me in the field. Besides, as I always shoot in RAW mode, for commercial reasons, the data is unreliable. I prefer to use my experience and instinct and, when necessary, take a quick peek at the highlights screen to ensure I'm not blowing out large blocks of highlights."

The Highlights Information Screen

The highlights indicator, which is the information screen I have my camera set to, reveals recorded pixels that have no digital value, otherwise known as clipped pixels. A quick review of this information screen will identify areas of the image containing blown highlights, enabling the user to assess whether exposure needs adjusting or whether clipping is present only in areas of the image space that are unimportant, in which case the exposure can remain unadjusted.

PHOTO © NIKON UK

Most DSLR cameras provide three types of focusing: manual, single AF and continuous AF.

FOCUS MODE

Focus mode determines how the camera focuses, initially between automatic (AF) and manual (MF) operation, and then, in AF mode, between focus-and-lock, where focus is locked after it is attained, and focus-and-track, in which setting the camera continues to adjust focus in order to maintain an accurate focus distance when the subject is moving.

The selected setting will depend on the subject of the photograph. For example, if the subject is static (e.g., a landscape scene), then focus-and-lock is an appropriate setting. However, if your subject is moving, such as a running animal, then the focus-and-track mode is often a better tool for the job.

Focusing is one of the hardest skills to learn, particularly when photographing moving subjects in wildlife or macro photography, and is discussed in depth in Habit 4.

PHOTO © CHRIS WESTON

Continuous (or AI-servo) AF is ideal for photographing moving subjects

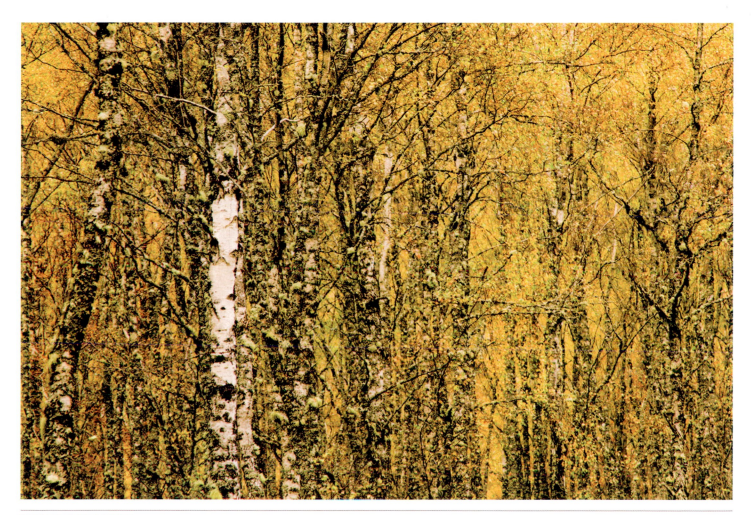

Single (or one-shot) AF is ideal for photographing static subjects, such as landscapes.

AF Mode Terminology

AF mode names vary by manufacturer. Nikon and most other manufacturers use the term "single AF" or "single-servo AF" for focus-and-lock mode, and "continuous AF" or "continuous-servo AF" for focus-and-track mode. Canon uses the terms "one-shot focus" (focus-and-lock) and "AI servo" (focus-and-track). Nikon and Canon also have a dual-role AF mode, referred to as "AF-A" (Nikon) and "AI-focus" (Canon), where the camera automatically switches between the two types of system, depending on what the subject is doing.

Get into the Habit: Know Your Equipment

Whenever I acquire a new camera, the first thing I do is memorize the position and method of adjustment of any new controls. I then practice using any that have changed from my previous camera in order to familiarize myself with them. In this way I can ensure that I am not left guessing when the time comes to use them in action.

I approach new lenses in the same way, making sure that I'm aware of the purpose, position, and adjustment of any new switch. I also download a depth-of-field chart for any new focal length that my existing lenses don't cover.

USING THE MENU SYSTEM

The controls described above are those I consider to be essential to capturing images. In addition, there are menu options that may speed up certain aspects of the process or that, on acquisition of the camera, need to be set in order to get the camera performing the way you want.

Press the menu button (or whatever the manufacturer of your camera has deemed to call it) on the back of the camera, and presto—an array of options appear. Some of them are right there in front of you, while others are hidden in submenus and sub-submenus.

I find that the best way to get to grips with menus is to think of them in terms of an office filing system. In brief, think of the main menu groupings as drawers in a filing cabinet. Then, the menu options are the folders stored in the drawers, and the submenu options are files kept in the folders. To access any particular menu action or function, you simply have to look in the right drawer for the folder that contains the desired file.

I have to be very honest and say that I rarely delve into the catacombs of menus available on my own camera. In fact, of the camera's multiple menu options, my custom menu includes just eight options, which says a lot about how often

SHOOTING MENU

Optimize image	⊘ N
Image quality	RAW+F
Image size	⊑
White balance	A
ISO sensitivity	100
Long exp. NR	OFF
High ISO NR	OFF

PHOTO © NIKON UK

The menu options in modern DLSR cameras are many and varied.

many of the menu options are likely to be used. However, I've made that decision based on trial and error and experience, so it's probably best if you do the same—that way, you can't blame me if later you miss something that you come to discover is important to your photography. So, here's a guide to digital camera menus.

Note: Menu options and headings vary by camera make and model. I have used terminology that is as generic as possible, but some terms may differ from those found in your particular camera.

Set-up Menu

The top drawer in the camera menu filing cabinet is labeled the set-up menu, which contains functions used to control the basic parameters by which the camera operates, such as how the camera manages the storage of images on the memory device, file numbering and the protocols by which images are downloaded from the camera. Most of these settings can be set once, when you first get the camera, and then left alone.

Perhaps the most important setting relates to file numbering (i.e., the reference or file number the camera gives to an individual image). Typically, the camera provides two options:

1. Reset numbering to 0001 whenever a new memory device is installed or the existing memory device is formatted.

2. Continue the numbering sequence from the last recorded reference number whenever a new memory device is installed or the existing memory device is formatted.

I find the latter more useful, because I change memory cards constantly and there's the possibility, however remote, of overwriting an image when downloading images to my main hard drive and two files have the same reference number.

I prefer to name and rename folders when I download them to the hard drive.

Setting the date and time are important to me, as they provide a useful reference when key-wording images. I also add an image comment, which typically takes the form of a copyright notice, but which I have also used to record information about species and locations.

One important option in this menu is the mirror lock-up function (sometimes referred to as the sensor clean option). The purpose of this function is to raise the mirror and open the shutter curtain without activating the sensor in order to manually clean the sensor.

Finally, when downloading images from the camera directly, it's important to set the USB menu option to the correct setting (typically mass storage for both Windows and Mac OS-X).

Playback Menu

The playback menu contains options that affect the data you see when reviewing an image. The only parameters I select in this menu pertain to the shooting information provided when I review an image. For example, my Nikon provides options that cover most of the shooting data, illumination and color channel histograms, and highlights indicator. Of

these, the only data that I generally refer to when in the field is the highlights indicator and sometimes, although rarely, focus point and shutter speed.

Typically, because of the inaccuracies of the LCD monitor, I rarely use it to assess exposure or focus, preferring instead to rely on my experience and intuition. However, the review image is useful for gauging the effectiveness of my composition.

Shooting Menu

Many of the functions in the shooting menu, such as white balance, ISO, and file mode (and image size), can be adjusted using external dials on the camera, where it's far quicker and easier to operate them. How and when to use these settings is covered in the next subsection.

In the shooting menu you will also find functions to deal with excessive noise. It is worth learning how these work in relation to high ISO settings and long-time exposures so that you can apply them when appropriate to minimize the negative effects of noise on image quality.

Elsewhere in the shooting menu there are several menu options that fall under the category of image optimization tools. If you shoot exclusively in RAW mode, then how these

options are set is largely irrelevant, as they more than likely will be overwritten during in-computer RAW conversion.

However, when shooting in JPEG (or TIFF) mode in-camera, it is important to set the image optimization values according to conditions and how you want the image to appear in print, as these are the values used by the camera for image processing. Once they are applied, it takes a considerable amount of time and effort in front of a computer to undo or change the effects of these settings, with the added disadvantage that reprocessing JPEG or TIFF files is a more destructive form of processing than that applied during RAW conversion.

Image Optimization Settings

Although the extent of available image optimization settings varies between the make and model of camera, the main options arc common across all DSLR cameras. These are:

1. Color space

2. Color mode

3. Tone

4. Saturation

5. Hue

6. Sharpening

Color Space

The color space option selects between Adobe RGB and sRGB and informs the camera's processor of the range in which the color values recorded from the scene should be placed. Of the two, the sRGB color space has the narrower range of colors. It is considered the ideal standard when uploading image files to the Internet for Web viewing, as it approximates the range of colors that can be displayed by the most common computer monitors and is, therefore, likely to reproduce colors more accurately across the thousands of different monitors on which your photographic images are likely to be viewed via the Internet.

Tip

When shooting in RAW mode, color space can be altered during the RAW conversion process without affecting the quality of the data recorded.

However, for reprographic print requirements (i.e., professional photography), the Adobe RGB color space is the better option. Adobe RGB, designed by Adobe Systems (makers

The Adobe RGB color space (Left) gamut exceeds that of the sRGB color space (Right). However, the sRGB color space is well matched for most computer monitors and, subsequently, for images intended for Web use.

of Photoshop), has a color range (gamut) much wider than that of the sRGB space, and encompasses most of the colors achievable on a CMYK printer.

Color Mode

The color mode option is as close as you'll get with a digital camera to switching between film stock. When buying film for a film camera, it's possible to choose from myriad film "flavors." For example, FujiFilm makes highly saturated films, such as Velvia, designed for use in outdoor photography, as well as Fujicolor Pro 160S, which is designed to reproduce skin tones smoothly and accurately, for optimal portrait and social photography.

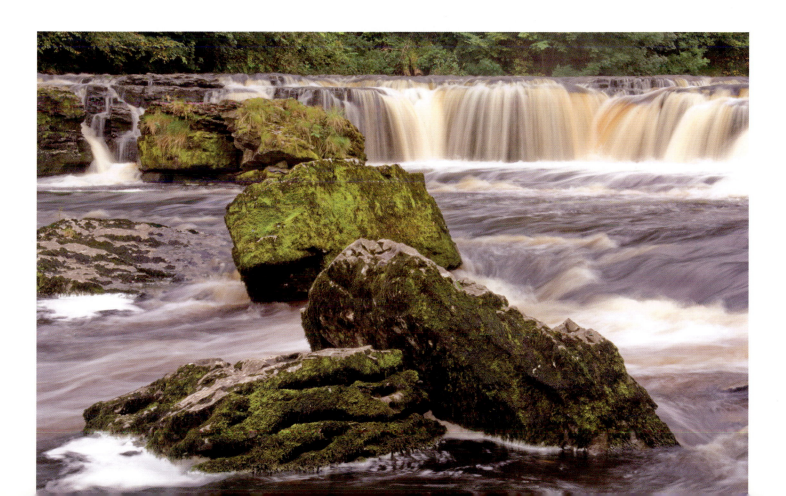

Color mode is similar to choosing between film types. In these examples, the image on page 61 was photographed at the nature setting, while the image above, which has an increased magenta cast, was photographed at the portrait setting.

To give you a practical working example, before I switched to using a digital camera, when I was using film cameras for both my landscape and wildlife photography, I alternated between Velvia film (for landscapes) and Provia (for wildlife).

Velvia gives heavily saturated colors that make images jump from the page, but I felt that it was too overpowering for wildlife subjects, which required the more natural and subtler treatment of Provia film.

DSLR cameras do not have the diversity of options available to film photographers, and color space settings typically are limited to only three choices for two main subject types:

Digital effect	Subject
Saturated colors	Landscape and outdoor subjects
Optimized skin tones	Portraiture
Auto	General shooting

Tone

Tone refers to contrast and can be set to increase or reduce the distribution of tones (processed using a tone curve similar to that found in Photoshop). When shooting in JPEG mode on a bright sunny day, tone can be set to medium-low or low to reduce image contrast. On an overcast day, tone can be set to medium-high or high to increase contrast levels. Care should be taken, however, not to set the tone option too high, as this may result in clipped pixels.

For this reason, again when shooting in JPEG mode, the histogram (see page 50) can be used to judge how much tone compensation to apply. For example, when the histogram shows a narrow distribution of tones, then tone can be increased. Conversely, when the histogram shows clipping of pixels at either end, then tone can be set to a reduced level in an attempt to restore lost detail.

Saturation

The saturation adjustment is used to increase or reduce color vividness. When set to a high (or enhanced) value, the camera will process colors to make them deeper and punchier (e.g., mimicking the effects of the contrast-rich Fuji Velvia and Kodak Ektachrome VS films). When a subtler, more subdued look is required, reducing saturation will tone down colors.

Hue

Digital cameras create color by adding two or more of the RGB (red, green, blue) colors together. For example, mixing equal parts of red and blue results in magenta. The same combination of blue and green produces cyan, while equal parts of green and red creates yellow. An equal mix of all three RGB colors produces pure white. In photography, then, by adding various combinations of red, green, and blue light, all the colors of the visible spectrum can be created.

The hue control function in the shooting menu enables the user to introduce a color cast. Red is the base color (0°) and raising the hue level above 0° will add a yellow cast making

PHOTO © CHRIS WESTON

The tone adjustment increases or decreases contrast. In the two example images shown here, the first was photographed with tone set to normal, and the second with the tone level increased to high.

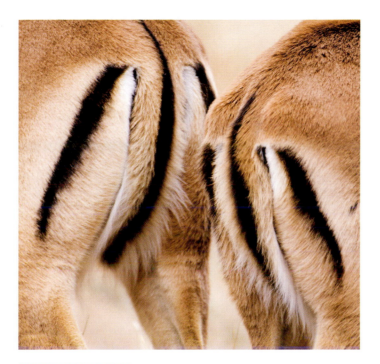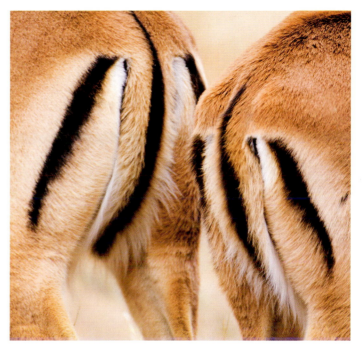

PHOTO © CHRIS WESTON

The saturation adjustment increases or decreases color vividness. In the two example images shown here, the first (left) was photographed with saturation set to normal, the second (right) with the level of saturation increased to high.

colors that start off as red appear increasingly more orange, (i.e., mixing red and yellow creates orange). Reducing the hue level will add a blue cast resulting in reds becoming increasingly purple. A typical adjustment range varies between −9° to +9° in increments of 3°. The greater the degree of change, the stronger the effect.

Sharpening

Because of the design of digital image sensors, practically all digitally captured photographs need to be sharpened. This sharpening can be applied in-camera (when shooting in JPEG mode) or later in-computer via image processing software such as Photoshop.

The settings in the camera allow for more or less sharpening to be applied. Arguably, this is an area of image processing that is done best in-computer, as a far greater degree of user control is available.

However, for direct-print images using the camera's sharpening function will suffice. From experience, particularly when photographing wildlife subjects, I have found that a medium-high sharpening value gives the best results. For scenes that include people (e.g., travel photography), a reduced level of sharpening is often preferable.

Always avoid oversharpening, as increasing sharpening after the event is always possible, while reducing levels of sharpening is not.

ADVANCED MENU OPTIONS AND CUSTOM SETTINGS

All of the camera settings and menu options discussed thus far relate to controls that you will need to use on a regular and frequent basis (some when shooting in RAW mode and most when shooting in JPEG mode). In addition, there are several more menu options that you may find useful at times, however infrequently. Furthermore, most DSLR cameras enable you via the menu to customize how the camera performs to make it more intuitive to a particular style of photography. Within the context of this book (i.e., my intent is not to reproduce a camera manual), it would be impossible to list all the possible combinations of settings and custom options. What I do recommend, however, is that you read carefully the manual to familiarize yourself with the available options and decide which you feel may be of use in your photography.

USING MODERN LENSES

Lens technology has become increasingly sophisticated with the introduction of functions such as image stabilization, fast and silent AF motors, and optics designed specifically for use with digital cameras. And, just as getting to know your camera is critical to certain aspects of photography, so too is knowing how to get the most out of your lens—quickly and efficiently.

A (Quick) Buyer's Guide

Since the descriptions that go with lenses have become increasingly wordy and less meaningful, a quick translation of current lens terminology is provided here. For example, a glance down a listing of Canon lenses reveals an EF 70–200 mm f/2.8 L IS USM lens. A similar perusal of Sigma's website draws the viewer's attention to an APO 50–150 mm f/2.8 EX DC HSM lens and, just to show my objectivity, the Nikon lens brochure announces an AF-S 18–200 mm

f/3.5–5.6 G VR DX IF-ED lens. First prize, however, must go to Tamron and its AF 28–300 mm f/3.5–6.3 XR DI VC LD Aspherical (IF) Macro lens.

Now, while the millimeter bit and the f/stop numbers probably make some sense, the rest of the acronyms are likely to be more confusing. So here is my "Dummies Guide" to (increasingly ridiculous) lens terminology:

The **focal length** of a lens is expressed in millimeters and relates to the distance between the focal point and the optical center of the lens. Combined with the format of the image sensor (e.g., full-frame, Nikon DX, etc.), focal length will determine angle of view, that is, how much of the scene the lens sees, which, in turn, describes the type of lens, as shown in the following table.

Angle of View	Lens Type
<10-degrees	Long telephoto
10–39-degrees	Short to medium telephoto
40–60-degrees	Standard
61–74-degrees	Wide angle
>74-degrees	Extreme wide angle

The **maximum aperture range** (f/xx–xx) relates simply to the maximum lens aperture of the lens. On zoom lenses, where the values are given as a range (e.g., f/3.5–5.6), this indicates

PHOTO © NIKON UK

A long focal-length lens.

PHOTO © NIKON UK

A wide-angle to short telephoto-zoom lens (24–70 mm).

that the maximum aperture changes depending on what focal length is set. Where a zoom lens has just one maximum aperture value, this indicates that the maximum aperture is fixed across all possible focal lengths of that lens.

An extreme wide-angle zoom, ranging from 14 to 24mm.

A short to long-medium telephoto lens (70 to 300mm)

Maximum lens aperture is cited because it identifies the light gathering ability of the lens. The wider the maximum aperture (i.e., the smaller the f/number), the more light the lens is able to gather and, therefore, the darker the conditions in which it can be used effectively. For example, a lens with a maximum aperture of f/2.8 can gather two stops (four times) more light than a lens with a maximum aperture of f/5.6, making it more versatile in low light conditions.

This is the main reason that professional photographers are willing to pay significantly more money (e.g., £2,800 for a 300-mm f/2.8 lens compared to £800 for the one-stop slower 300-mm f/4) for a lens with a wide maximum aperture.

Many lenses now have some form of **optical stabilization** function, which aids the hand holding of a camera by compensating for camera shake, thereby reducing the quality-degrading effects of image blur. First used in the military, it is a highly effective technology that uses a system of motors to compensate for vibrations (or movement) in the light signal transmitted via the lens. The technology has various names according to manufacturer, as shown in the following table.

Manufacturer	Name
Canon	Image stabilization (IS)
Nikon	Vibration reduction (VR)
Sigma	Optical stabilization (OS)
Tamron	Vibration compensation (VC)

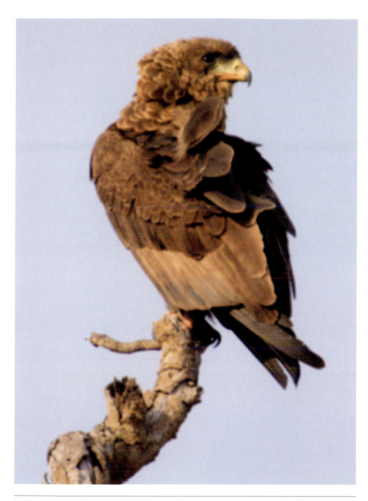

PHOTO © CHRIS WESTON

The effects of optical lens stabilization can be seen clearly in these two images. The first was shot without the aid of optical stabilization and appears blurred due to camera shake. The second image was shot with optical stabilization switched on, resulting in a sharper image.

In the following table, I've tried to cover all of the one-, two and three-letter acronyms, but may have missed a few of the more obscure ones.

Acronym	Manufacturer	Meaning
ED	Nikon	Extra-low dispersion glass minimizes chromatic aberrations (a type of color and image dispersion that reduces image quality). Improves sharpness and color correction.
G	Nikon	A lens having no aperture ring (aperture being set instead via the command dial on the camera body).
IF	Nikon	Internal focusing (the physical size of the lens remains unchanged).
D	Nikon	Refers to a lens that provides focus distance information to the camera. Improves the accuracy of the TTL light meter and flash metering.
SWM	Nikon	Stands for silent wave motor, enabling fast and quiet AF operation.
VR	Nikon	Vibration reduction (see above).
DX	Nikon	Refers to Nikon's range of lenses that are designed specifically for use with D1- and D2-series digital cameras, as well as the latest D300 (i.e., models with small-frame sensors). Can be used on the D3 in DX-mode.
ASP	Nikon	Aspherical lens elements, effective at eliminating the problem of coma and aberrations.
EF	Canon	Lenses compatible with Canon's modern EF mount, used on the EOS line of cameras (distinct from older FD mount).
L	Canon	Canon's designation for premium performance lenses, often using special glass, as in Nikon's ED or other APO lenses.
IS	Canon	Image stabilization (see above).
USM	Canon	Ultrasonic motor (similar to SWM above).
APO	Sigma	Designate apochromatic lenses, designed to focus all colors in the same plane, thus reducing chromatic aberration and improving optical performance, especially on long lenses.
EX	Sigma	Sigma's designation for premium-performance lenses.
DC	Sigma	Lenses designed to cover cropped sensors (similar to Nikon's DX). Can be used on the Nikon D3 in DX-mode.
HSM	Sigma	Hypersonic motor (similar to USM and SWM above).
OS	Sigma	Optical stabilization (see above).
XR	Tamron	Refers to lenses having a compact (small) design.
DI	Tamron	Digitally integrated (designed to work with both digital and film cameras).
VC	Tamron	Vibration compensation (see above).
LD	Tamron	Low dispersion glass minimizes chromatic aberrations.
IF	Tamron	Internal focusing (the physical size of the lens remains unchanged).
SP	Tamron	Stands for super performance, identifying a lens with a higher specification (and higher cost) than noneSP lenses.

Lens Controls

In addition to the above, there are two main lens controls that I always prefer to have access to, although not all lenses provide them. Some telephoto lenses have a limiter switch, which increases the closest focusing distance, thereby limiting the distance range the lens travels during auto-focus operation. This control option speeds AF performance and is particularly useful when photographing fast and erratically moving wildlife. The other control I find particularly useful is a manual override option, which enables focus to be set manually even when AF mode is selected.

For more detail on why these two functions are useful in nature photography and how I employ them in the field, refer to Habit 5.

CAMERA HANDLING

The most important aspects of camera handling are keeping the camera steady and in the right position to capture the image. While this might sound obvious, the techniques are easier to describe than to achieve.

Hand-Holding a Camera

Many people prefer to hand-hold a camera, finding tripods cumbersome, monopods restrictive, and beanbags often impractical. I won't condone laziness as an excuse for not bothering with a tripod, but for those occasions when

PHOTO © CANON UK

The AF limiter switch on a Canon telephoto lens.

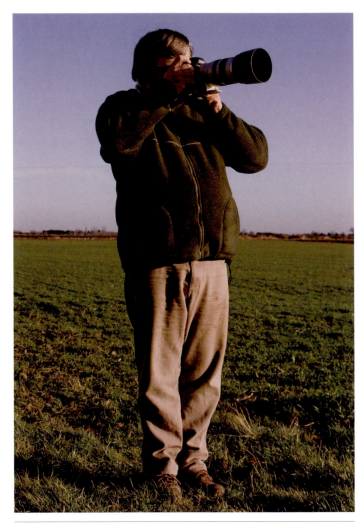

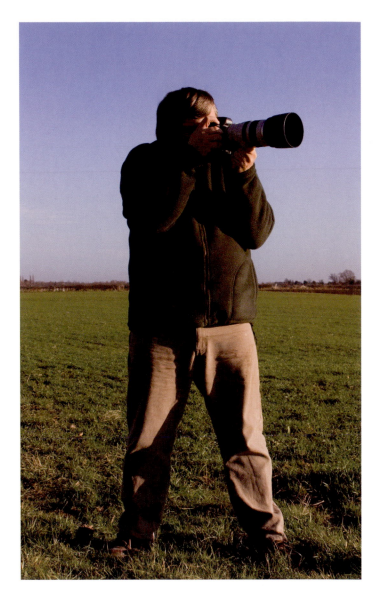

The image, left, shows how not to hand hold a camera. The right hand image illustrates a much more stable stance.

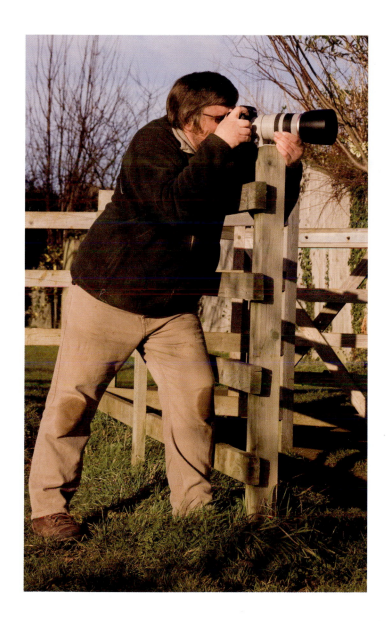

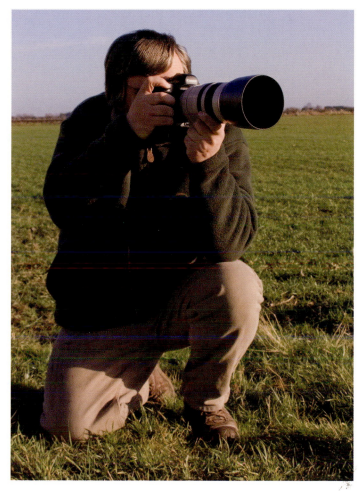

Ideally, find a natural support, such as a solid fence or wall, against which you can steady yourself and the camera.

Keep your center of gravity low by kneeling or lying down when taking the picture.

hand-holding is the only practical option there are some useful habits to develop to help ensure that you get the best results.

As I find myself often in a position when hand-holding the camera is necessary, I once sought an expert in the field for advice—not a fellow photographer but a retired Special Forces sniper. He explained to me the mechanics of the body and how a sniper will train to hold a rifle perfectly steady prior to discharge.

Our bodies are constantly in motion, although we don't often realize it. Our lungs are inflating and deflating with every breath, blood is rushing through our veins, and our hearts are perpetually beating. All these factors combine to make the human body a very unstable support.

The first phase in rectifying this situation is to bring the center of gravity to its lowest possible point, by lying down or kneeling rather than standing. Next is to create a tripod from your body parts, for example, using the arms and legs to form a pyramid structure to serve as the principal support. Once the body is at its most stable, controlled breathing will minimize camera movement, the key being to fire the shutter at the bottom of the breathing cycle—breath in, breath all the way out, and, before taking another breath, fire.

If you want to get really serious about it, military snipers are trained to count their heartbeats and will fire the rifle between beats!

Using Optical Stabilization Technology

The optical stabilization (OS) systems built into modern lenses were developed for the military for use in telescopic sights for sniper rifles. There is an art to using them, the first being not to believe all the lens manufacturers' marketing spin. OS works, to a degree, but excessive camera shake still results in blurred images. It's important, therefore, to continue to stabilize the body as best as you can, given the circumstances in which you're working.

If your lens has more than one OS setting, then ensure that you apply the correct one. The standard setting (sometimes referred to as mode 1) is for general use, while the active setting (mode 2) tends to be geared toward photography from a moving vehicle or when panning the camera.

Also, when using an optically stabilized lens with the camera attached to a tripod with a locked head, many OS systems won't work effectively and must be switched off. This doesn't apply to some later Canon and Nikon lenses that are designed to work with or without a tripod. To be certain, you must check the manual for your lens.

Get into the Habit: Exploiting Stabilization Technology

Washington State-based Stuart Westmorland has developed an excellent technique for photographing without the aid of a tripod in low light, using image stabilization technology. Stuart explains:

With a digital camera and image-stabilized lens combination, I have found that you can really push the limits of hand-held shooting way beyond what I ever thought possible. Using the rapid-fire mode on my camera, I brace the camera against a nearby object, elbows into the body, and shoot a burst of multiple frames. Even at shutter speeds as slow as 1/2 second there will almost always be one tack-sharp image in the sequence. I've even used this technique with shutter speeds as slow as several seconds. When I'm shooting on a tight deadline or covering a large area in a short space of time, this technique has allowed me to do so much more, as well as enabling me to scamper up hills unburdened of my tripod.

When using a tripod, the camera should be well balanced. If using long lenses, this may mean attaching the lens to the tripod, via a tripod collar, rather than attaching the camera.

Stuart Westmorland photographed this low-light scene with the camera hand-held, using image stabilization. The shutter speed was 6 seconds.

Using Camera Supports

On solid ground, tripods are the optimum form of camera support. However, it's important to use the right tripod for the job at hand. All tripods are designed to carry up to a specific load weight, beyond which they become unstable. Thus,

when choosing a tripod, it's important first to ascertain the weight of your heaviest camera/lens combination to select a particular model that is strong enough for the job.

Equally important is the focal length of the lens used, or more precisely the lens angle of view. For example, a 200-mm lens has an angle of view of 12 degrees, while a 400-mm lens has an angle of view of 6 degrees—a deviation of 6 degrees, which, when projected over a distance of 300 m, is equal to 31.5 m. To combat this and to maximize rigidity, a tripod should have a torsion angle that is inferior to the lens angle of view.

When using the tripod, the laws of physics apply and its center of gravity should be kept to the lowest point practical for the circumstances of the shoot. In fact, tripods have two centers of gravity, the second being between the top of the tripod legs and the head. Again this should be kept to a minimum, which means effectively avoiding using any attached center column unless absolutely necessary. To add to my tripod's rigidity, I also use a low-profile head to further reduce the center of gravity.

When attaching the camera to the tripod, it should be balanced correctly. When using long focal length lenses, particularly those with a wide maximum aperture, this may result in the lens being attached to the tripod (via a tripod collar) rather than the camera body. And in some situations, it's not unheard of for a photographer to use two tripods, one for the camera and one for the lens, a technique employed by Art Wolfe, when conditions permit.

Art explains:

> When using extreme long focal-length lenses, anything between 600 and 2400 millimeters, even the slightest breeze or vibration can create enough movement to soften significantly the resulting image. And, the problem is even greater with the latest crop of very high mega-pixel DSLR cameras. Using two tripods is essential to get around the problem.

When tripods are impractical, such as when shooting from a vehicle, then my preferred option is to use a beanbag. The advantages of a beanbag are the ability to use them in confined spaces, coupled with the fact that the "beans" will absorb a lot of the vibration from the vehicle.

PHOTO © PETER WATMOUGH

When using extreme long focal-length lenses, using two tripods—one for the camera and one for the lens—gives maximum stability. This is a technique practiced by Art Wolfe.

Based on my experience, the best type of beanbag to use is an H-shaped design, where the middle of the H fits over the window ledge, balancing and stabilizing the bag. A leather or rubber patch on the underside of the H will also stop the bag from slipping.

For fillers, I typically prefer to use a natural substance, such as maize or rice. These have the advantage over polystyrene of not flattening after continued use. However, they do have the disadvantage of being attractive to elephants, as I have discovered on at least two occasions in the past.

Get into the Habit: Tripod Legs
Although Joe Cornish is better known for his large-format photography, he does on occasion use a digital camera. For added stability in either camera format, Joe uses a tripod that has spikes attached to the base of the legs, which enables him to bed the tripod firmly in soft ground, such as soft undergrowth or sand.

PHOTO © PETER WATMOUGH

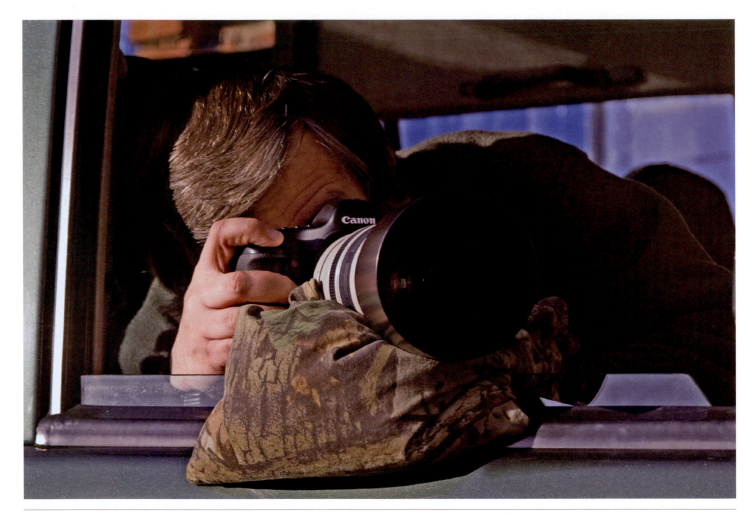

When tripods are impractical, a beanbag is an excellent alternative.

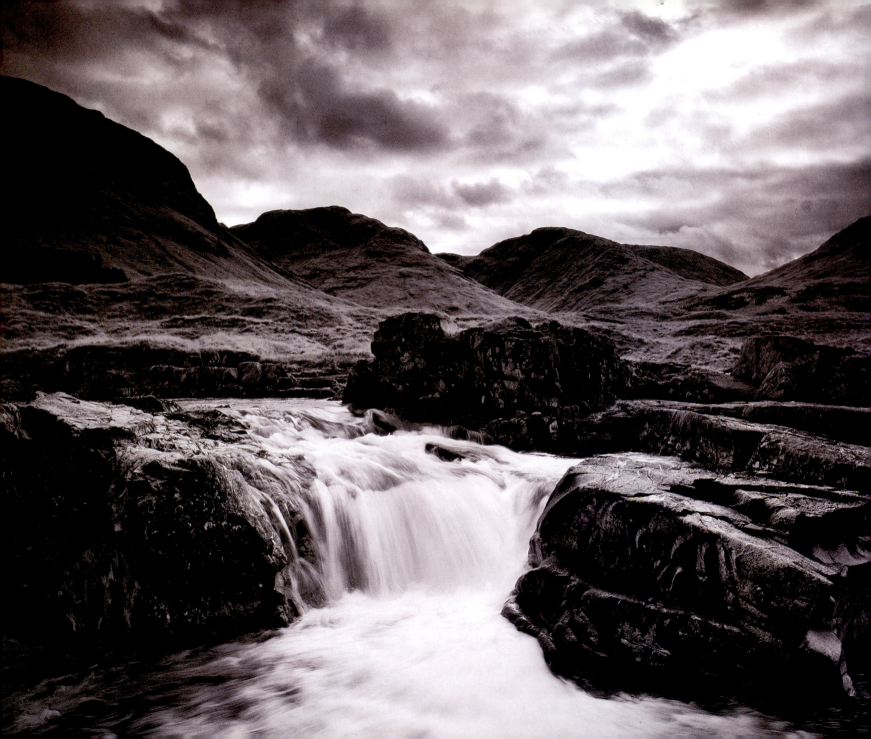

SEE WHAT YOUR CAMERA SEES

Have you ever returned from a photography session only to find that the image you made looks nothing in print like it appeared to you at the time? This is the type of conundrum I hear talked about often during the workshops I run and in e-mail questions I receive via my website. It is the perennial photographic problem and one that continues even after the technical aspects of photography have been mastered. That's the bad news. The good news is that there is a simple solution.

The camera sees the world very differently from the way in which we see it. For example, we see in color, while cameras see in black and white and shades of gray. So what? Well, imagine a red pepper and a green pepper. Photograph them next to one another in color and it's easy to tell them apart. Photograph them in black and white, however, and it is impossible to tell the difference—they are the same gray tone.

Another difference is that we have two eyes, while the camera has only one. Having two eyes enables us to calculate the distance between objects, an ability lost when you close one eye. If you want to try this out, the next time you're sitting in the passenger seat of a vehicle—and I emphasize the words *passenger* seat—close one eye and try to determine the distance to the car in front of you. Note how the sense of depth created by two eyes is no longer apparent and that the scene in front of you now appears to be two dimensional, or flat.

Something else is lost when we make a photograph. When you're outside taking pictures, all of your senses are working, taking in information and making you feel and respond in a certain, usually positive, way. Not only do you see the scene before you, you hear the wind in the trees, smell the sweet aromas of nature, feel the texture of the land and the breeze on your skin, and taste the air. But when you press the shutter, the camera only records what it sees and four out of the five senses that influence how you respond emotionally to the subject are lost.

When you think about it, it's little wonder that a two-dimensional, single-sense photograph might struggle to live up to the actual experience we had at the time of its taking. The real skill in photography that sets apart the great images from the snapshots is the ability to replace this missing/lost information using purely visual tools, to give the viewer a sense of what you felt by recording the image in such a way that it stimulates the imagination and stirs emotions.

It is a skill that can be learned and the starting point is to get into the habit of seeing what your camera sees.

PHOTO © CHRIS WESTON

Compelling photographic images should reveal a sense of what the photographer was feeling.

LIGHT: PHOTOGRAPHERS' PAINT

Let me be blunt about this: Without light there is no photography, just as without paint there is no painting. Light is the photographer's paint, and how it is applied to the canvas, (i.e., the digital sensor), will determine its visual attributes. By manipulating light it is possible to reveal and hide objects, tones can be made lighter or darker, colors altered, changed and replaced. Shadows can be softened, hardened and made to disappear; highlights lost and gained; dimensions molded or flattened at will; objects positioned to order. Put simply, forget about the technological wizardry that is the modern-day camera and think about light because, without it, frankly the camera is about as useful as a saw without wood or, indeed, a canvas without paint.

Light Intensity

The intensity of light affects exposures in that the greater the intensity the shorter the duration of exposure (shutter speed) or the less quantity of light (lens aperture) is needed, giving the user greater flexibility in exposure settings. For example, bright conditions will enable faster shutter speeds and smaller apertures, which may be required for freezing the appearance of motion or increasing depth of field, respectively.

Of course, the opposite can be true. If a slow shutter speed is needed to blur motion or a narrow depth of field is desired to hide background detail, then lower intensity light is advantageous.

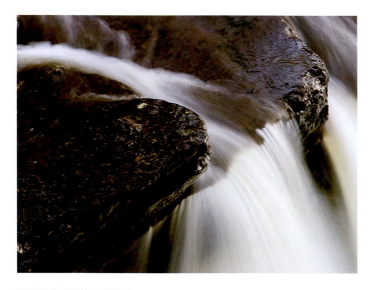

PHOTO © CHRIS WESTON

Light intensity will determine the shutter speeds and apertures available to you. High intensity increases flexibility in exposure settings, but low intensity light is useful when slow shutter speeds are necessary, such as when creating images of water with an ethereal quality.

In outdoor photography, intensity is determined primarily by the time of day and the weather. Light becomes more intense as its angle to the Earth increases. And, on sunny days light is more intense than on overcast days when clouds absorb and scatter light. The other factor influencing intensity is the light-to-subject distance. But when referring to sunlight, light-to-subject distance is, for all intents and purposes, fixed; this distance measure applies only to lighting from an artificial source.

Quality of Light

Light can be hard or soft, referred to as its quality. Hard light is directional and emanates from a small (point) source, creating distinctive shadows with well-defined edges. To visualize the effects of hard lighting, imagine shining a high-power torchlight at an object and the shadows that would appear on the object's unlit side.

Soft lighting is the opposite. Soft light emanates from a large diffused source or is reflected from multiple sources, and is omnidirectional, scattering over a wide area. As a result, shadows are less intense as they are partially lit by this scattered light, and shadow edges are less easily defined.

The quality of light determines levels of contrast, which is important to photography because cameras have a limited ability to record contrast. In addition, compositionally shadows enable photographers to create a sense of depth, form

The direction from which the light falls on a subject will define how detail and texture are revealed.

and dimension, helping to make the two-dimensional print appear three-dimensional in form.

Outdoors the quality of light is determined primarily by the weather. On a sunny day the sun acts as a small, point source, much like a spotlight. When the sky is overcast, however, clouds scatter the light in many directions throwing illumination over a much wider area. Therefore, the shadows and contrast that create a sense of depth are more apparent on sunny days than cloudy days, when a scene is more likely to appear flat.

Direction of Light

The direction from which light falls on an object will define various aspects of its appearance. For example, front lighting will reveal detail but not texture, while side lighting will emphasis texture and form by creating shadows. Backlighting is the primary tool for creating silhouettes and the golden halo effect of rim lighting.

The reality of outdoor nature photography, under natural light conditions, is that the direction of light at any given time cannot be changed and, if the subject of the photograph

is immoveable, such as a mountain or an obstinate animal, then you either have to work with what you've got or come back at a better time.

For photographers then, an important habit to learn in relation to the direction of light is to know how to determine the best time of day to photograph any given subject, as highly successful travel and landscape specialist, Nick Meers, explains:

I use maps, together with a Sunrise/Sunset compass, to plan my shoots and visualize my compositions. When traveling I always make a note of places that are worth going back to in better conditions, or when I have more time. When I get back to the studio I mark the location on the appropriate Ordnance Survey map—I have the entire set—and read the contours and try to image how the scene will look under different lighting conditions. I use the compass to assess the direction of light at sunrise and sunset to help me determine the best time to return to take the image.

PHOTO © CHRIS WESTON

The direction from which light falls on a subject will greatly affect how that subject appears in the final image. Here the lighting creates a stark silhouette of the chapel and monolith. (left)

PHOTO © PETER WATMOUGH

Using maps to visualize how a scene will look is a technique used by Nick Meers, which saves him time in the field, enabling him to be more productive photographically.

Color Temperature of Light

Think about what happens to a piece of metal when it's heated in a furnace. As well as getting hotter it changes color. First it goes red, then orange, yellow, and finally, at its hottest point, a blue/white color. Exactly the same thing happens to the color of light as the sun rises throughout the day.

At sunrise the color temperature of light is low resulting in its reddish appearance. In the early morning, the color changes to orange and then at mid-morning to yellow, and finally, around an hour before and leading up to noon, white. In the afternoon, the changes are reversed in the same way that the changes in color of metal are reversed as it cools from its hottest point.

It is the color temperature of light that makes sunrise and sunset, early morning, and late afternoon the ideal times for nature photography, times of the day we refer to in photographic circles as the "golden hours," as the warmth of the color of light around these hours shines through.

PHOTO © CHRIS WESTON

The color temperature of light changes as the sun rises and falls throughout the day.

CONTRAST: WHEN THE WORLD TURNS GRAY

If you look at a plain blue sky your brain says, "That's a plain blue sky." Point your camera at the same sky, however, and the camera sees nothing but monotone gray. Add some clouds and your brain will inform you that you are seeing a cloudy blue sky. Once again, however, all your camera will see is gray tone. A pattern is emerging here: All that a camera ever sees is tones of gray or, in other words, contrast.

Contrast is important in several areas of photography. For example, camera auto-focus systems use contrast in order to attain focus; contrast affects light meter readings and exposure. In terms of composition and visual information, contrast creates a sense of depth, adding a third dimension to an otherwise two-dimensional print or screen image.

Control: The Advantage of Seeing in Black and White

Because the camera sees in black and white, it is important for photographers to view the world around them similarly. For example, when I look at a landscape, I don't look at the colors in isolation, instead I look at tones, categorizing them into imaginary boxes labeled white tones, light gray tones, medium tones, dark gray tones and black tones.

By going through this process I am able to visualize how the scene will appear in two-dimensional form, as opposed to how I perceive it in three-dimensional reality. I am able to judge whether the shadows in the scene will create sufficient depth, which objects will appear flat and which three-dimensional, and whether objects will integrate within the frame or become isolated.

Going a step further, I am able to determine where and whether detail appears and which objects I am able to include or exclude from the image space. For example, when attempting to photograph a silhouette (effectively, removing subject detail such as pattern and texture), by reading scene contrast I can quickly assess whether the available light is conducive to my composition or whether I must wait for more appropriate lighting.

The bottom line is that if you learn to read and assess the world in terms of tone as your camera does, then you will be far better placed to control the camera in order to record the scene as you want it.

Dynamic Range

Varying intensities in light within a scene creates contrast. The depth of contrast (i.e., the difference between the darkest area of the scene and the lightest) is referred to as scene dynamic range (and can be measured using the same stop-unit system used for exposure; see Habit 4).

The sensor in a DSLR camera also has a dynamic range, relating to its ability to record detail in areas of shadow and highlight simultaneously. In a similar way, human vision has a dynamic range relating to our ability to see detail in black-and-white objects at the same time.

On a bright day a typical scene dynamic range is around 9-stops. As the dynamic range of human vision is nearer to 14-stops, this presents no problem, as we are able to see detail in black objects and white objects within the scene, simultaneously. For example, imagine being at a wedding: You would be able to see the texture of the groom's black suit and the intricate detail in the pattern of the bride's white dress.

However, this is not the case with cameras. The current crop of DSLR cameras has a dynamic range varying, on the whole, between 5- and 7-stops, depending on the camera model. In practically all cases in the above example, camera dynamic range is less than scene dynamic range.

What this means is that where humans can see detail in shadow and highlight areas simultaneously, the camera

By visualizing this scene in gray tones, I was able to assess that the shadow area in the lower portion of the frame would appear to be featureless black, because it was outside the camera's dynamic range. Armed with this knowledge, I could apply the necessary graduated (split) ND filter to balance the light and dark tones to a level within the camera's dynamic range.

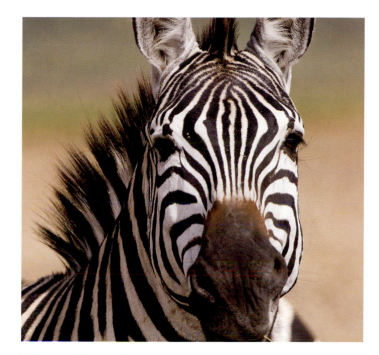

Compared to human eyesight, the dynamic range of current DSLR cameras is limited, which makes photographing scenes or subjects with high contrast, such as this black-and-white striped zebra, challenging in bright light.

cannot. In the wedding example, a picture of the bride and groom together would result in detail being lost completely in either the black suit or the white dress, depending on how exposure was set.

It is therefore important for photographers to understand that when recording contrast (dynamic range), cameras have

limitations and are sometimes unable to record the detail that humans can see. In high-contrast conditions, it is necessary to measure scene dynamic range and compare it to camera dynamic range in order to understand how a scene will be reproduced photographically—a technique described in detail in Habit 4.

THROUGH THE LENS: A CAMERA'S EYE VIEW

As well as learning how to read the effects of light and contrast in relation to how both of these factors will influence composition, it is also necessary to understand how lenses change and alter the world as we it.

Again this is an area where humans and cameras differ. I have already described the effects of single optic (camera) vision compared to the dual optics that humans are fortunate to possess. However, there are further differences, most notably that the human eye has a fixed, prime focal length lens, whereas we are able to attach to a camera lenses of varying and moveable focal length, with the consequence that magnification, angle of view and perspective can be altered compared to what we would normally see.

Focal Length, Magnification, and Angle of View

The focal length of a lens is a precise value calculated as the distance between the sensor plane and the optical center of the lens (when the lens is focused at infinity). For this reason, focal length remains constant irrespective of the physical size of the sensor.

Additionally, all lenses have an angle of view, which is related to both focal length and the physical dimensions of the sensor. Consequently, while focal length remains constant, angle of view may change depending on whether your camera has a full-frame (36×24 mm) sensor or a smaller sensor, such as Nikon's DX sensor chip, which measures 24×16 mm, or the Olympus E-system cameras that are based on the FourThirds standard (i.e., half the size of full-frame sensor).

This distinction is important because magnification is affected by focal length, but is unaffected by angle of view. For example, if an object photographed with a 100-mm lens is reproduced on a full-frame (36×24 mm) sensor at 20 mm in height, it will still be 20 mm in height on a small-frame (e.g., Nikon DX) sensor or even a large-frame (e.g., Hasselblad 48×36 mm) sensor.

What will change is the amount of space visible around the object, to the left, right, above, and below. This is affected by the angle of view, which increases with large-format sensors and reduces with small-format sensors, when compared to a full-frame 36×24-mm sensor.

To some extent this will alter your choice of lens. For example, what would be considered a wide-angle lens on a full-frame digital camera, such as the Canon EOS 1Ds Mark III or the Nikon D3, has the characteristics of a standard lens when attached to a small-format digital camera, such as the Nikon D300 or Canon 40D. Conversely, a medium telephoto lens (e.g., 200 mm) acts akin to a long telephoto lens under the same circumstances.

Angle-of-View Characteristics

Use the following table to ascertain the angle-of-view characteristics of various focal-length lenses used with sensor formats of different sizes.

	Full-Frame Digital Format (36 × 24 mm)	Medium-Format Digital (48 × 36 mm)	Nikon DX Format (24 × 16 mm)	Canon Small Format (22.2 × 14.8 mm)	Four-thirds Format (18 × 13.5 mm)
Effective magnification factor	1 ×	0.6 ×	1.5 ×	1.6 ×	2 ×
Focal length (mm)	20	12	30	32	40
	24	14.4	36	38.4	48
	28	16.8	42	44.8	56
	35	21	52.5	56	70
	50	30	75	80	100
	70	42	105	112	140
	80	48	120	128	160
	105	63	157.5	168	210
	135	81	202.5	216	270
	180	108	270	288	360
	200	120	300	320	400
	210	126	315	336	420
	300	180	450	480	600
	400	240	600	640	800
	500	300	750	800	1000
	600	360	900	960	1200
	800	480	1200	1280	1600

How to use this table: A lens used on a digital camera with a full-frame sensor shares the same angle-of-view characteristics as it would when used on a 35-mm film camera. However, when the same lens is used on a camera with a smaller or larger sensor format, its angle-of-view characteristics change. For example, a 28-mm, wide-angle lens will give an angle of view equivalent to a 42-mm standard lens when used on a Nikon camera with a DX-type sensor (highlighted in red).

Angle of view doesn't affect magnification. In these two images (pp. 96, 97), the bird is exactly the same physical size, although it appears closer in the second image (right) because the angle of view is narrower, caused by the small-size sensor.

Perspective

Lenses also change our perspective on the world. Because human eyes unaided have a fixed focal length (roughly 42 mm), we see life with a fixed perspective. When we look through a camera with, for example, a wide-angle lens attached, that perspective is altered.

Two things happen to perspective when we change focal length. First, the amount of the scene we can see from a fixed position increases (shorter focal lengths) or decreases (longer focal lengths).

Increasing focal length alters how much of the scene is visible in the image space, as shown in this sequence of images shot with a 28-mm, 50-mm, 100-mm, and 200-mm lens.

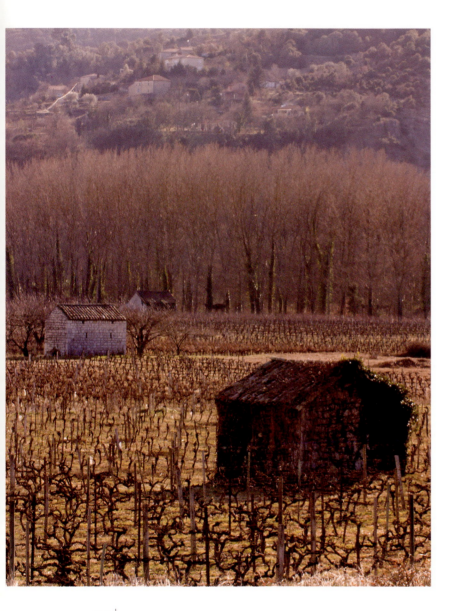

Second, the spatial relationship (the apparent distance between objects on different planes) between disparate objects alters. As focal length decreases (toward wide angle), spatial relationships increase, giving an increased sense of space between objects that results in the visual effect of stretching distance. The opposite happens when focal length is increased, with the amount of space between objects seemingly squashed so that they appear closer together.

Increasing and decreasing spatial relationships, therefore, affect the sense of depth and this must be considered when choosing a lens to work with, which is discussed in more detail in Habit 4.

PHOTO © CHRIS WESTON

Compare these two images and notice how the buildings in the first image (left) appear farther apart than they do in the second image (p. 101). This relationship between objects is referred to as spatial.

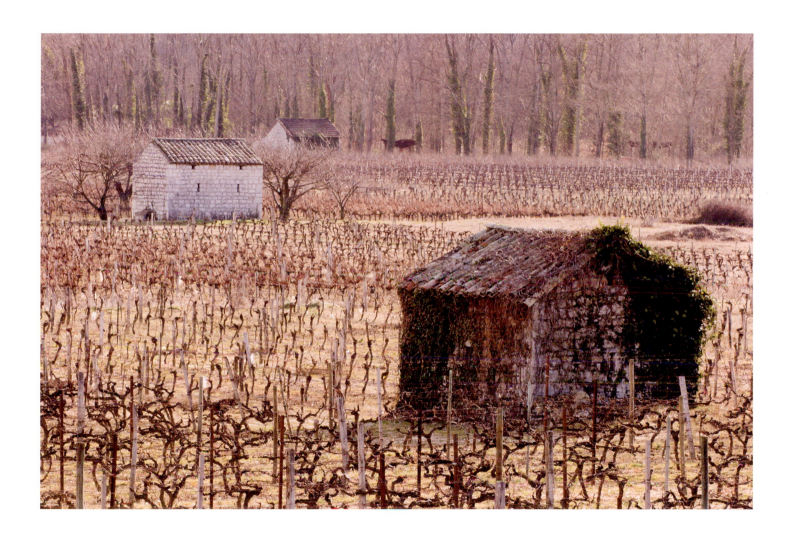

Get into the Habit: See What Your Camera Sees

Landscape photographer, Joe Cornish, is considered a master of composition. Before he attaches his camera to a tripod, Joe first positions the tripod and rests his chin on the tripod head. This gives him a general view of how the scene will appear through the view-finder. From this position Joe determines the most effective position (location, height, and angle), and only when he is comfortable with his assessment will he finally attach the camera. He explains, "Using this technique, I find it easier to determine the final composition as I can see the whole scene and decide what elements I want to include or exclude more easily. It also prevents having to keep readjusting the camera, which saves time and effort."

PHOTO © PETER WATMOUGH

This image shows a technique for visualizing the scene prior to setting the camera used by landscape photographer Joe Cornish.

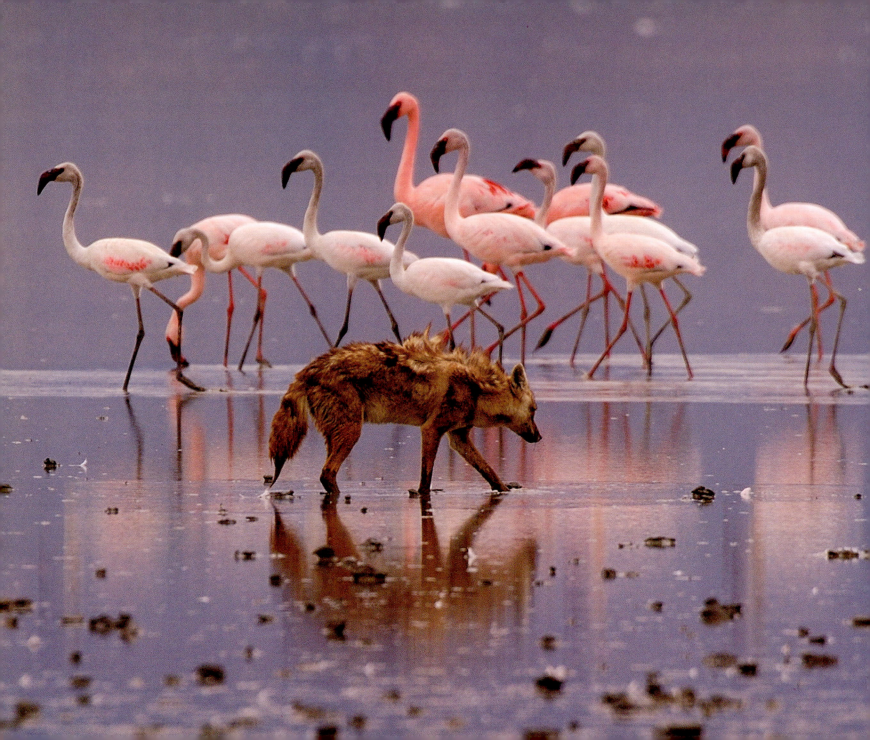

Take Control of Your Camera

One of the problems with modern cameras is that they do too much. Everything is automated and there are programs to cover most photographic possibilities. Let me give you an example. I could take any entry-level or mid-range DSLR down to one of my local landscape hot spots, set exposure mode to the program (landscape) setting, switch on auto-focus, and press the shutter. Given a pretty view, I'm likely to get a reasonable image.

But here's the thing. Who took this picture: me or the camera? And who wants reasonable images, anyway? Aren't we aiming for masterpieces? In this example, even had I composed the image well, by allowing the camera to make all the decisions about what shutter speed to use, which lens aperture to set, where to focus and other settings that affect how a photograph is recorded, I ceded control to the camera of all the creative tools at my disposal: The camera became the photographer and I, merely its assistant. That's fine, if you want to be a photographer's assistant. If, however, you want to be a photographer, and a good one at that, then you have no choice but to learn how to control the camera and get

PHOTO © CHRIS WESTON

What matters in photography is not how much your camera cost, but how skillfully it is used to create, in print, the image perceived in the imagination and the mind.

it to record an image the way *you* perceive it, not how *it* is programmed.

Now, I know that as photographers, we get hung up about our camera gear. Trust me, I'm as guilty of this as anyone. But let's put things into perspective. A camera is just a tool, nothing more and nothing less. It is no different than a saw to a carpenter, a spanner to a mechanic, or a spade to a gardener. What really matters is not how good or expensive the tool is, but how skillful the user is at applying it to the job in hand.

As I pointed out in Habit 2, there are certain camera controls and functions that are essential to creative photography. There I described what they were and here I am going to explain how to use them effectively, so that the images you create are yours and not the camera's. So, this section is all about helping you get into the habit of taking control of your camera.

MANAGING LIGHT

The fundamental role of a camera body is to provide a mechanism for holding a light-sensitive device (or material) and to control the amount of light passed through the lens for a specified period of time. That's it. Everything else is just an add-on. (The lens is responsible for focus.) So, when taking control of the camera the most important step is learning how to quantify light and the relationships between light and the shutter and lens aperture.

In photography, light is measured using a unit-based system, each unit being referred to as an exposure value (EV) (sometimes referred to as a stop). Adding stops of light will increase the amount of light received by the sensor, and subtracting stops will reduce it. The two mechanisms for adding and subtracting stops of light are the shutter and the lens aperture.

The Shutter

The shutter controls the duration of the exposure, that is, the length of time the sensor is exposed to light. Timing is measured in seconds and fractions of seconds, denoted by shutter speed values, which, in a typical camera, range from between 30 seconds to 1/4,000 second (additional settings, such as bulb and up to 1/8,000 second may be possible). Each doubling or halving of shutter speed equates to a 1-stop change in exposure. For example, by reducing shutter speed from 1/250- to 1/125-second, exposure duration is doubled. Conversely, increasing shutter speed from 1/250 to 1/500 second reduces exposure duration by half.

Most cameras these days enable shutter speed to be changed in increments of 1/3- or 1/2-stop. Where this is the case,

then the effect on exposure duration is not a doubling or halving but relative to the incremental change. For example, reducing shutter speed from 1/60- to 1/45-second increases exposure duration by a factor of 1.5 times.

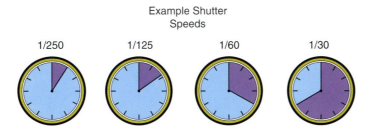

Example Shutter Speeds

1/250 1/125 1/60 1/30

ILLUSTRATION © CHRIS WESTON

Each full 1-stop change in shutter speed equals a doubling or halving of the duration of exposure.

Lens Aperture

Lens aperture controls the quantity of light passing through to the sensor by increasing or decreasing the size of the hole created by the diaphragm in the lens. Like shutter speed, a doubling or halving of the area of the hole equates to a 1-stop change in exposure. And again, like shutter speed, modern cameras and lenses enable aperture adjustments to be made in 1/3- or 1/2-stop increments.

The numbers used to denote aperture size appear at first glance to be meaningless and confusing. They aren't. The

numbering system, referred to as f/numbers or f/stops (f stands for focal), is a ratio relating the focal length of the lens to the diameter of the diaphragm opening. For example, the f-number 2 (f/2) equates to a ratio of 2:1, that is, the focal length of the lens is double the diameter of the diaphragm aperture (or, in other words, the diaphragm aperture is half the focal length of the lens).

Reading f/numbers as fractions, which they are, also makes sense of the small number–big hole conundrum. Many photographers who are learning have asked me why a large aperture has a small number (e.g., f/2), while a small aperture has a large number (e.g., f/22). The answer is that f/2 actually means 1/2 and f/22 means 1/22nd. One-half (1/2) is bigger than 1/22nd as the aperture at f/2 is bigger than the aperture at f/22.

The f/number scale relates to the area of the aperture. For example, a 50-mm lens set at f/2.8 has an area of $250\,mm^2$, while at f/4 the area is $123\,mm^2$, essentially half the area. At f/2 the area is $491\,mm^2$, or in other words, double that of f/2.8. In these terms, the f/number system becomes more apparent: a 1-stop change in f/number equates to a doubling or halving of the area of the aperture and, by association, the quantity of light reaching the sensor.

Lens aperture is adjustable, ranging from around f/2 to f/32. The larger the aperture, the greater the amount of light passes through the lens.

Where Do the f/Numbers Come From?

The area of a circle is calculated using the formula πr^2. Doubling or halving the area requires multiplication or division by the square root of 2, which is approximately 1.4. For example, $2 \times 1.4 = 2.8$ (f/2.8), $2.8 \times 1.4 = 4$ (f/4), $4 \times 1.4 = 5.6$ (f/5.6), and so on.

Lens Aperture and Image Quality

Lens performance is diminished when very small or large apertures are set. So, for example, while it may seem an ideal solution to set an aperture of, say, f/22 or f/32 to increase depth of field, a better solution for increased depth of field would be to use a larger aperture (e.g., f/11) along with the hyperfocal distance–focusing technique described in the "Maximizing Depth of Field" box. Lens performance is at its maximum when mid-range apertures, such as f/8 through f/16, are used.

Reciprocity Law

Knowing that a 1-stop change in either shutter speed or lens aperture equates to a doubling or halving of the exposure value, makes understanding the reciprocity law a matter of common sense. Simply, reciprocity means that if you double the quantity of light reaching the sensor (by increasing lens aperture) then you must halve the duration of the exposure (increase shutter speed) to maintain the same exposure value, and vice versa.

The same rule applies when making fractional increments. For example, if you make the lens aperture smaller by a 1/2-stop (reducing the quantity of light), then you must make shutter speed longer by the same 1/2-stop value (increasing duration) in order to preserve the exposure value.

Exposure Value for ISO 100

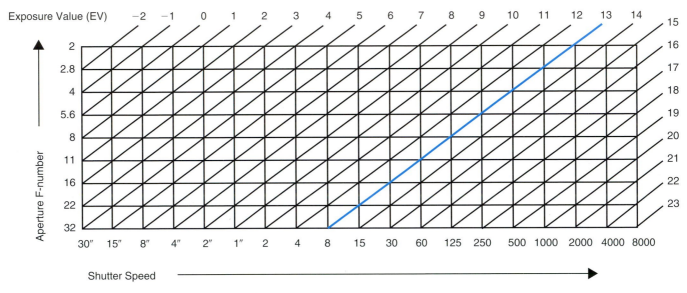

An exposure value (EV) chart reveals how reciprocity works in photography.

Reciprocity Law Failure

Photographers familiar with film may have heard or read about failure in the reciprocity law. This is unique to film and doesn't apply to digital capture.

PAINTING WITH LIGHT

Now that the technical jargon is out of the way, what does it all mean in a practical sense? Photography is an art (except in certain very specific applications, such as the military, science, and law enforcement), and as an artist your role is to

paint a picture. And, as I alluded to earlier (Habit 3), a photographer's paint is light. Lens aperture and shutter speed, then, are your brushes. And just as in painting where you can use different sizes of brushes and apply more or less paint in order to create aesthetically pleasing visual effects, so you can change the appearance of light to the same end in photography using lens aperture and shutter speed.

The Appearance of Time and Motion

When you select a particular shutter speed, what you are doing essentially is defining the visual appearance of time and motion. Few things in nature are perfectly static. In landscape photography, cloud formations move and light changes, and leaves rustle and blow in the wind. In wildlife photography, animals move, sometimes fast and sometimes slow; their motion, however, is constant. Even buildings sway, their movement imperceptible to us but apparent to a camera over a long period of time. I remember one particular night after photographing a lighthouse near my home, I noticed from the image how much the top of the building had swayed.

Setting a shutter speed relative to motion and time will either freeze the subject, enabling detail to stand out, or blur the subject, creating a sense of speed and movement. For example, compare the next two images. In the first, a fast shutter speed of 1/4,000 second has frozen the motion of the animal, and it is possible to discern every aspect of its movement, from body shape to the direction of focus of its eyes.

In the second image, however, detail is lost. Here the motion of the body has blurred into a whir of moving legs, individual animals begin to merge into one, and what is left is a powerful and compelling sense of speed.

Creating Emphasis and Order

Lens aperture controls depth of field and in so doing defines emphasis and order. Human beings are visual creatures; our primary sense is vision. When we see an object that appears to be sharp and in focus, we take notice of it. When an object is blurred or obscured, we lose interest in it to the extent that when it is completely obscure we tend not to see it at all.

Translating this observation into photographic terminology, objects that appear sharp are emphasized and draw our attention. Objects that are blurred lose emphasis and we tend to treat them as secondary. Therefore, by selective use of focus and depth of field, it is possible to dictate what objects the viewer of an image sees and in what order. It is also possible to hide objects completely.

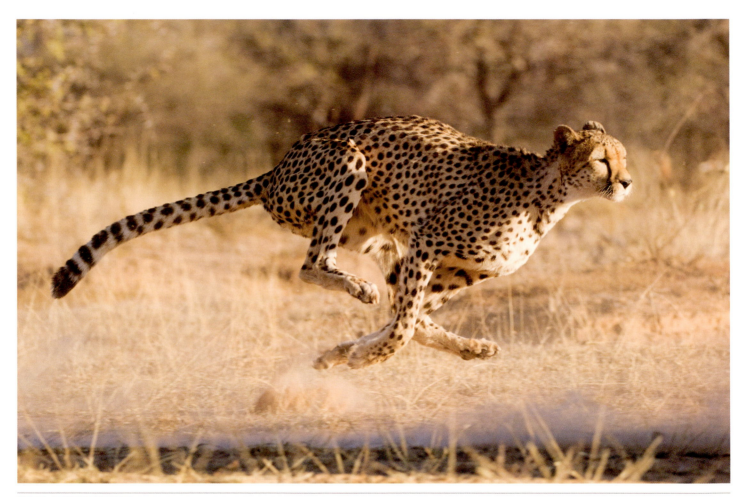

PHOTO © CHRIS WESTON

A fast shutter speed has captured in detail the action of a cheetah mid-sprint.

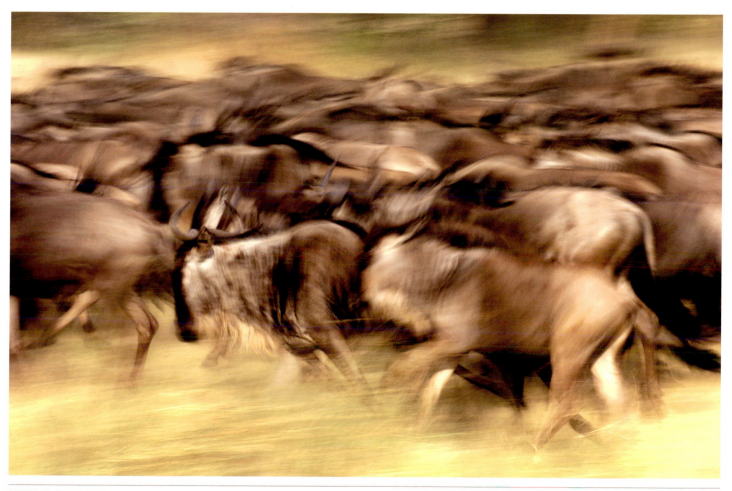

A slow shutter speed has blurred the appearance of motion, creating a sense of movement and visual energy.

Let's take two examples. The image on the right has extensive depth of field from foreground to background. Because this is a landscape image, and I want you to follow the imaginary path I have created all the way through the picture space, it's important that all visual elements are sharp. The image on the next page illustrates the opposite. Here I want your attention to fixate on the bird. Therefore, to isolate it from the background, which in reality is a clutter of dead leaves and a mishmash of dry branches, I have selected a large aperture to greatly reduce depth of field. The result is a background so far out of focus that you ignore it completely.

The next image (p. 116) is even more interesting in that here I am dictating the order in which you view the subjects. The jackal in the foreground is sharp, and is therefore the first element you see. Then, because the flamingos are discernible, albeit slightly soft, your eyes travel to them next. Again the background is lost, which isolates the animals, emphasizing this predator–prey relationship.

PHOTO © CHRIS WESTON

In landscape photography, it is often essential that all objects in the picture frame, from foreground to background, appear sharp, necessitating maximum depth of field.

In this scene, because I wanted to remove the distraction of the cluttered and messy background, I used a wide aperture to help minimize depth of field.

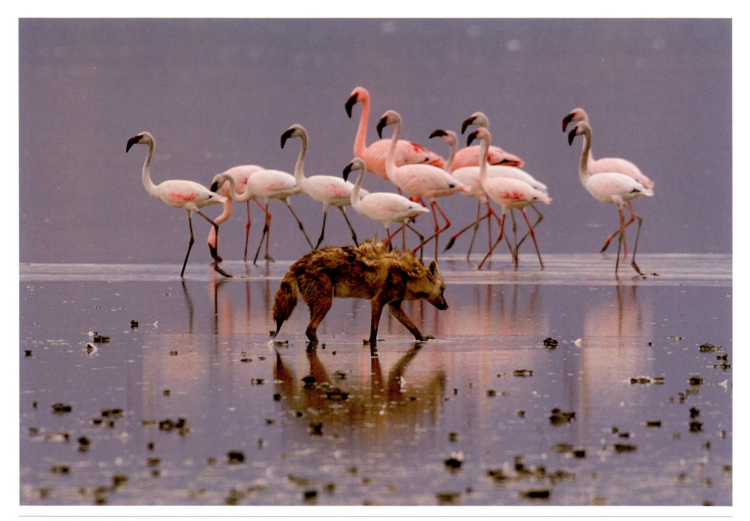

In this more complex scene, depth of field has been calculated to create a degree of order, emphasizing first the jackal, and then the flamingos.

Depth of Field Explained

Increasing or decreasing lens aperture causes less or more, respectively, of the scene in front of or behind the point of focus to appear sharp. This fact of optical law is known as depth of field. (Depth of field is also affected by other factors, such as focal length, camera-to-subject distance, print size, viewing distance and even the quality of an individual's eyesight. Because of the subjectivity of some of these influencers, depth of field is an inexact science.)

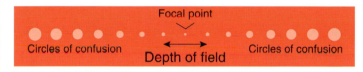

ILLUSTRATION © CHRIS WESTON

Depth of field is possible because of the limitations of human vision. When a circle is less than 0.03 mm in diameter, it appears as a sharp point, that is, in focus.

Depth of field is a phenomenon caused by the limitations of the human eye. When a lens is focused, light is formed into a point. However, light reflecting from other parts of the scene, closer to or farther from the focal plane (i.e., areas that are out of focus), instead forms blurry circles called "circles of confusion." The farther from the focal plane, the larger the circle of confusion.

The resolving power of the average human eye enables us to detect in a print roughly A4 in size, viewed from roughly 10-feet and photographed with practically any current DSLR camera, the presence of circles that are larger than 0.03 mm in diameter. Anything smaller than that will appear as a point rather than a circle, and therefore will appear sharp. Smaller apertures result in smaller circles of confusion; therefore, depth of field increases when small apertures are used.

Maximizing Depth of Field

Depth of field can be maximized by focusing on a point in the scene known as the *hyperfocal distance*. For example, imagine a scene where the closest visible object in the scene is 10 feet from the camera and the farthest object is at an effective distance of infinity. Now, with the camera focused at infinity, say that the depth of field stretches from 20 feet to somewhere beyond infinity. In this example, the closest object, which is 10 feet from the camera, would appear

blurred as it lies beyond the range of depth of field (i.e., 20 feet to beyond infinity).

However, it's possible to bring the close object within range of depth of field using hyperfocal distance focusing, as shown in the bottom illustration.

Referring to the top illustration, note how depth of field extends beyond infinity. The extent of depth of field that lies beyond infinity

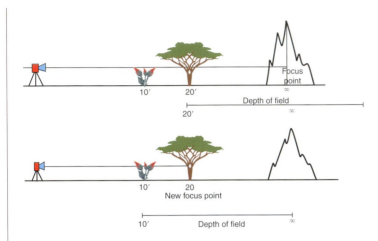

ILLUSTRATION © CHRIS WESTON

Depth of field can be maximized using the hyperfocal distance–focusing technique.

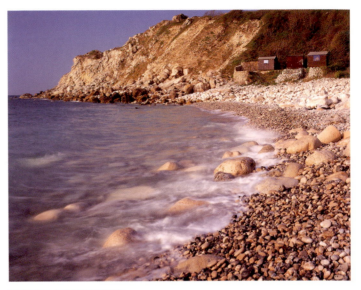

PHOTO © CHRIS WESTON

In order for all the objects in this scene to appear sharp, I used the hyperfocal distance–focusing technique to maximize depth of field.

is in effect wasted (i.e., it will appear sharp anyway—that's the point of infinity). So, what we need to do is position the farthest point of depth of field *at* infinity, thereby bringing the nearest point closer. This can be achieved by adjusting focus from infinity (its current setting) to the distance at which depth of field begins (the hyperfocal distance, which is 20 feet in this example).

The result bringing the depth of field forward to a point halfway between the camera and the hyperfocal distance—in this example, 10 feet, the position of the nearest object.

UNDERSTANDING EXPOSURE

In digital photography, there is a belief among some that it doesn't matter whether an accurate exposure is made in-camera because it can be fixed later in Photoshop, or a similar image processing software package. There is also a large number of followers of the "avoid at all costs clipped highlights" brigade. In this section, I am going to explain the reason that neither of these beliefs holds true.

Exposure is one of those functions of photography that seems to bamboozle everyone. It needn't be. The key to mastering

exposure is an understanding of what a camera's TTL meter is telling you when it gives you an exposure value. Once the concept of metering is fixed firmly in the mind, not only is it possible to ensure accurate exposures every time, it is also possible to "paint" a scene as you perceive it, rather than as it actually is, thereby giving you complete control over the aspects of image-making that are influenced by light.

Metering: A Line in the Sand

In Habit 3, I explained that all that a camera ever sees is shades of gray. The same is true of the camera's light meter. TTL meters see the world and everything in it as 18% middle-tone gray, irrespective of whether it is or not. Swan feathers, snow, heaps of coal—everything according to the light meter is 18% middle-tone gray.

So, the exposure value given by the TTL meter in the camera will record the subject as medium tone. For example, say you are photographing a beautiful snowy landscape. You set your camera to auto-exposure (AE) mode and take the photograph. When you review the image, you find that the snow looks

In scenes where the tones are predominantly light, such as a snow scene, when using automatic metering it's necessary to apply exposure compensation to avoid underexposure.

When photographing dark-toned subjects, such as Highland cattle, it may be necessary to underexpose the camera's recommended exposure in order to faithfully reproduce the tones.

gray rather than the same brilliant white that it is on the ground. Now you know why: The camera thinks it is gray— 18% medium-tone gray, to be precise. The same thing occurs when photographing a dark subject. At the camera's exposure value, a black bear, for example, would look more like a gray bear.

The 18% Value

The value 18% refers to reflectance and relates to how humans perceive medium gray.

Now that you have this line in the sand, calculating exposure becomes far simpler and all you have to ask yourself is, "Is the subject I'm photographing medium-tone, is it lighter than medium tone or is it darker than medium tone?"

If it is medium tone, then the exposure value calculated by the camera will be technically accurate. If, however, it's lighter than or darker than medium, then you will need to compensate for what the camera is doing when it calculates an exposure value that will record the subject as medium-toned.

The following diagram shows scene tonality broken down into five segments from black to white. (This segmentation can be further refined, but I am using five segments to make things simpler at this stage.) The middle segment represents medium-tone gray. To the right of middle is light gray (1-stop brighter than medium tone) leading on to white (2-stops lighter than medium tone). To the left of middle is dark gray (1-stop darker than medium tone) going on to black (2-stops darker than medium tone).

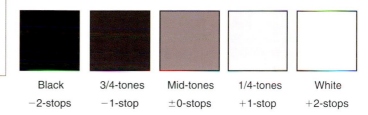

Black	3/4-tones	Mid-tones	1/4-tones	White
−2-stops	−1-stop	±0-stops	+1-stop	+2-stops

ILLUSTRATION © CHRIS WESTON

In simple terms, tonality can be broken down into five segments, referred to as light tones, quarter-tones, mid-tones, three-quarter tones, and dark tones.

By deciding in which of the five boxes the tone of the subject falls, it is easy to see by how much the camera is under- or over-exposing in order to render the subject medium tone. For example, white snow would fall into the box marked white, far right, which is 2-stops brighter than medium tone. To make white appear as a medium tone, the camera will underexpose the scene by two stops. So, in order to compensate for what the camera is doing, you need to apply an equal

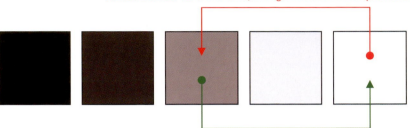

To return an EV for a mid-tone, the light meter under-exposes white by 2-stops.

By applying +2-stops exposure compensation, white is recorded in its true tone.

PHOTO © CHRIS WESTON

Snow is a light tone but the camera's meter will record it as a medium tone, essentially by underexposing by 2-stops. In order for snow to appear white, to compensate it is necessary to overexpose what the camera's meter is telling you by 2-stops, effectively applying an opposite action to that taken by the camera.

and opposite amount of exposure compensation, which, in this example, is plus 2-stops (i.e., open up the exposure to enable two stops more light).

If the subject of the photograph is dark gray in tone (an example would be a conifer tree), this would fall into the box second left, marked dark gray (1-stop darker than medium tone). In order to record a dark gray subject as medium tone, the camera will overexpose by 1-stop (to make dark gray lighter). Again, you will need to apply an equal and opposite amount of exposure compensation—in this example, minus 1-stop (i.e., close the exposure to enable one stop less light).

To illustrate how this works, I'm going to walk through a real-life example of calculating an accurate exposure. The subject of this image is a flock of pink and white flamingos wading through water. The difficulty in calculating an exposure for this scene is the presence of no obvious medium tones and the effect of light reflecting off the surface of the water.

To calculate the exposure, I select the spot-metering mode. I then take a meter reading from the breast of the bird at center front, which gives me in this case an exposure value of

Exposure compensation applied = +1.3-stops.

Exposure compensation applied = ±0-stops.

Exposure compensation applied = +1.7-stops.

1/1,000 second at f/8. Because I know from experience that this uncompensated exposure value will render the almost-white feathers medium gray, I apply plus 1.5-stops exposure compensation (near white is 1.5-stops brighter than medium tone). This gives me a revised exposure value of 1/375 second at f/8.

Exposure compensation applied = ±0-stops.

The result is a photograph of the flamingos that records the birds' feathers as the same light tone they appear to be in real life.

Exposure compensation applied = −1.5-stops.

Exposure compensation applied = +1-stop.

PHOTO © CHRIS WESTON

In order to reproduce faithfully the light tone of these flamingos, I applied plus 1.5-stops exposure compensation.

Get into the Habit: Run Your Own Tests

Because of the nature of levels (tones) in digital photography, many in-camera light meters are now calibrated to a different level of reflectance than 18% gray, which complicates the process of calculating exposure based on the theory outlined above. This fact has not gone unnoticed by U.S.-based nature photographer Jeff Vanuga: "When shooting film, I'd normally compensate between plus 1.7- and 2-stops for a white subject, such as snow. With my Canon digital camera, I now find that I compensate as little as +{2/3}-stop for whites."

For this reason, it is worth testing your own camera to reveal how its meter is calibrated. This is a simple enough process involving the following steps:

1. Set your camera to auto-exposure mode and spot-metering mode.

2. Set auto-bracketing to capture a sequence of nine images at {1/2}-stop increments. (Use manual bracketing if your camera doesn't enable this option.)

3. Using an 18% gray card as your subject, expose the bracketed sequence (ideally, shoot in RAW file mode).

4. On a computer, review the images. Whichever is the closest match to the gray card will reveal the degree of compensation that should be applied for an exposure value equivalent to 18% reflectance.

Calculating Exposure Compensation

The easy part is now out of the way. The hard part, and the real skill in mastering exposure, is determining the actual tone of the subject, that is, what is and isn't medium tone.

In nature, many commonly occurring subjects are medium tone. Examples are green grass, mid-day blue summer sky, and poppy red. Some examples of brighter-than medium tone subjects are daffodil yellow, buttercup yellow (plus 1.3-stops brighter than mid-tone), clear blue sky in the early

ILLUSTRATION © CHRIS WESTON

This diagram identifies the required level of exposure compensation for subjects of different tones.

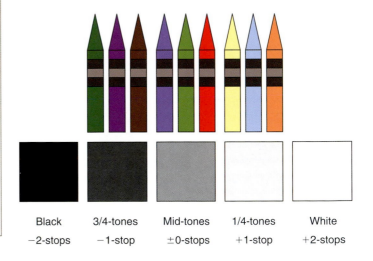

Black	3/4-tones	Mid-tones	1/4-tones	White
−2-stops	−1-stop	±0-stops	+1-stop	+2-stops

morning (plus 1-stop), and the palm of the human hand (plus 1-stop). The extremes are subjects such as snow or a swan's feathers—or anything textured white—all of which are around 2-stops brighter than mid-tone.

Examples of darker-than-medium tone subjects are conifer green, deep purple, and dark gray (all minus 1-stop) and black (minus 2-stops).

The next illustration shows the relative colors and their equivalent exposure compensation values.

Get into the Habit: Assessing Tonality

A useful habit to get into when learning how to assess tonality for calculating exposure compensation is to carry with you a Kodak Gray Card, which can be purchased from most large photographic retailers. In the field, hold up the card and compare its tone to the tone of the subject. With the Gray Card as your reference, it is relatively simple to assess whether the subject is medium tone, or lighter or darker than medium. Once you have assessed the subject's general tone, then you need to decide within which of the five boxes (refer to page 128) it falls. For example, if it's lighter than medium tone but not white, then it must be light gray. Conversely, if it's darker than mid-tone but not black, then it must be dark gray. This is a relatively easy and simplified way of calculating the required value of exposure compensation.

EXPOSURE AND CONTRAST

The approach to exposure, outlined above, is all very well when a single tone predominates. But what happens when a scene contains a wide dynamic range?

The dynamic range of the current crop of DSLR cameras ranges from 5- to 7-stops. This compares to scene dynamic range, which can reach an average of 9- to 11-stops (and a wider range is not impossible, especially at night), and the dynamic range of human vision, which equates to around 14-stops. What this means in photographic terms is that the range of tones in the scene, while easily resolved by the human eye, are often beyond the capability of the camera to record them.

Camera dynamic range often falls short of scene dynamic range, which may result in clipped pixels at one or both extremes of the tonal range.

Measuring Scene Dynamic Range

To measure scene dynamic range, first switch the camera to spot-metering mode. Select an area of the scene that is representative of the brightest tones and record an exposure value. Then move the camera to meter an area of the scene with the darkest tones. Again, note the exposure value. By counting in stops the difference between the two values, you will calculate scene dynamic range.

For example, take the scene depicted in the image on the right. Here the brightest area of the scene can be found in the white clouds. Conversely, the darkest area of the scene is found in the shadows in the dark green trees at right center of the frame. When I exposed for this scene I took a meter reading of the clouds, which gave me an exposure of 1/2,000 second at f/16. In comparison, the meter reading for the shadow areas was 1/15 second at f/16. Counting in stops between the two readings—1/15 to 1/30, 1/60, 1/125, 1/250, 1/500, 1/1,000, and 1/2,000 second—gave me a scene dynamic range of 8-stops, beyond the dynamic range

PHOTO © CHRIS WESTON

In this image, scene dynamic range exceeded the ability of the camera to simultaneously record detail in both highlights (the clouds) and shadows. Exposure for the highlights has left clipped pixels in the shadow areas.

of my camera's sensor (which is 6-stops). Therefore, in order to retain detail in all areas of the scene, it was necessary to reduce scene dynamic range.

Managing High-Contrast Scenes

As scene dynamic range in the previous example is beyond the dynamic range of the camera, if I were to take the photograph without managing the light, then I would have lost detail in either the highlights or shadows or both, depending on how I set the exposure. For example, by exposing for the highlights, the shadow area would have been underexposed. Conversely, had I exposed for the shadows, the highlights would have been overexposed and clipped. Exposing for the middle tones would have resulted in clipping of both highlight and shadow detail.

Where tonal variations follow a linear pattern, such as a bright sky darkening toward a shaded foreground, it is possible to manage the light optically using graduated neutral density (GND) filters. The purpose of a GND filter is to block a portion of light from one part of the scene while allowing all light to pass through the filter from another, thereby reducing scene dynamic range.

Using the example landscape described above, my calculations showed a scene dynamic range of 8-stops, 2-stops

beyond the dynamic range of my camera. Because the brightest area of the scene is in the upper portion of the frame (the clouds), I can position on the front of the lens a 2-stop strength GND filter to cover this section of the frame, which will reduce the shortest exposure from 1/2,000 second at f/16 to 1/500 second at f/16 (shutter speed equals 2-stops slower), which will reduce scene dynamic range from 8-stops to 6-stops (within the camera's range).

In actual fact, I used a 3-stop–strength GND filter and exposed for the shadow area, which lifted the shadows from textured black to dark gray, gaining additional detail as shown in the illustration.

Get into the Habit: Calculating Exposures for GND Filters

Professional nature and landscape photographer, Steve Gosling, frequently encounters high-contrast scenes and uses a hand-held reflected light meter to determine an appropriate exposure that will manage contrast effectively. Steve explains, "Using a Sekonic meter, I first measure the brightness of the mid-tones, noting the exposure value. I then meter an area of sky that I want to render the brightest tone, which is usually a formation of clouds, and calculate the difference in brightness between these two meter readings. If the difference exceeds 2-stops, I will then use a graduated neutral density filter to bring the light tones to within 2-stops of the mid-tones."

Where tonal variations are less uniform and nonlinear, your options for managing the light are reduced, as using a GND filter becomes impractical. Under certain circumstances it may be possible to use a diffuser or a reflector to soften the quality of light or to throw light back into shadow areas, respectively; both of these solutions reduce contrast. However, this solution may also prove to be impractical. Further, it may be possible to remove specular highlights using a polarizing filter, but this won't help where contrast appears in nonspecular form.

If managing contrast to within camera dynamic range is impossible, then the only recourse is to expose the scene to record detail in either the highlights or the shadows. When this is the case, as a rule of thumb, it is better to capture detail in the highlights. The reason for this is psychological. Humans are used to seeing areas of featureless black in real life—we call them shadows. So when we see an area of toneless black in an image we simply think to ourselves, "That's a shadow." However, we rarely, if ever, see large areas of burned-out highlights (unless you look directly at the sun) and so we are sent off-balance when we see them in a photograph because we are unable to recognize them.

PHOTO © CHRIS WESTON

By using a graduated (split) neutral density filter, I have managed to reduce scene dynamic range to a point where detail is visible in both the highlight and shadow areas.

Nature photographer Steve Gosling uses a hand-held meter to assess scene dynamic range.

High-Dynamic-Range Imaging and Photo Merging

High-dynamic-range (HDR) imaging is becoming more popular with digital photography, and is the likely area of future developments in DSLR cameras. Currently, HDR imaging is applied postcapture and is a solution when scene DR exceeds camera DR. However, as the HDR process involves merging multiple images, for the best results it requires a static subject, such as a building interior or a relatively still landscape. It is a less effective solution in wildlife photography.

Photo merging is a similar technique, but it is not true HDR imaging. However, it is a technique practiced by U.S.-based nature photographer, Jeff Vanuga. Jeff explains, "Shooting digitally, I no longer use split (graduated) neutral density filters. Instead, when the level of contrast is too high, I shoot two images: one exposed for the highlights, another for the shadows. I then merge the two files, using the merge tools in Photoshop, to create a single image that takes the detail from the bright tones of the first image and the shadow tones of the second image."

There is a final option, and that is to return when conditions are more conducive to the image you're trying to create. Often this is the best option. Refer to the image of zebras shown in Habit 1, which took three years to capture. It wasn't that I hadn't traveled to Africa for that length of time, simply that it took three years for the necessary components—light and opportunity—to come together. In nature photography, patience is often the key to success.

Bracketing

Bracketing exposures—the technique of exposing two or more identical or near-identical frames at varying exposures—has advantages and disadvantages for the digital photographer. In complex lighting scenarios, where it is difficult to accurately gauge an appropriate exposure value, the use of the bracketing technique will provide variations in exposure, making it more likely that you capture a high-quality image.

For example, compare the following two images reproduced along with representative histograms (for detail on how to read a histogram, see Habit 2). The original image (shot at the camera's suggested exposure value) is reproduced on the left. Note how the histogram is biased to the left of the graph, although with minimal clipping of shadow detail. The second, bracketed image was shot at plus 1-stop, which has resulted in a histogram where the graph is closer to the medium tones and slightly biased to the brighter tones on the right.

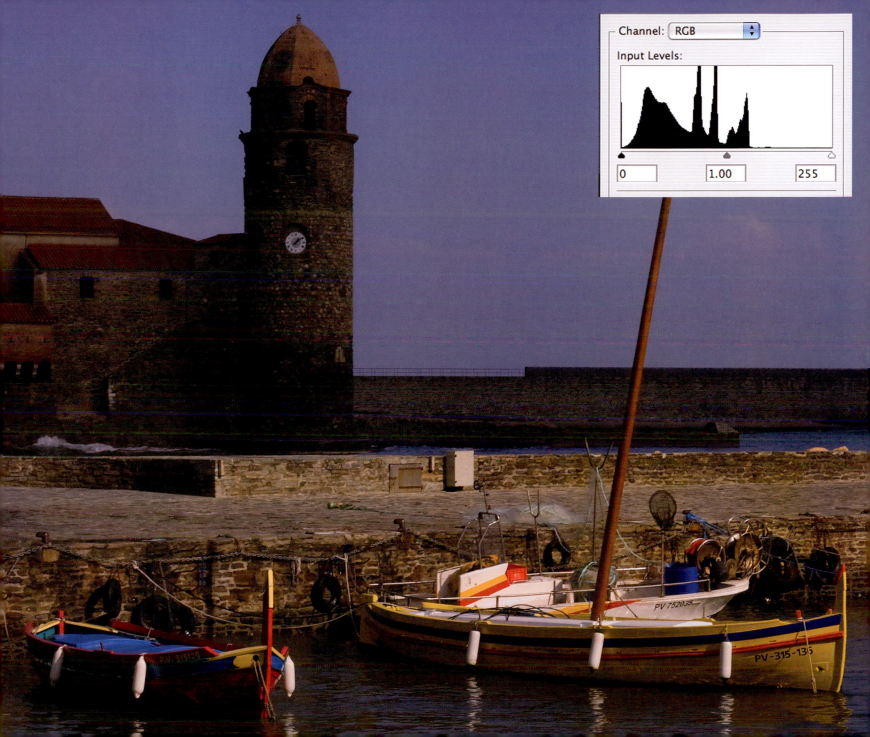

Channel: RGB

Input Levels:

0 1.00 255

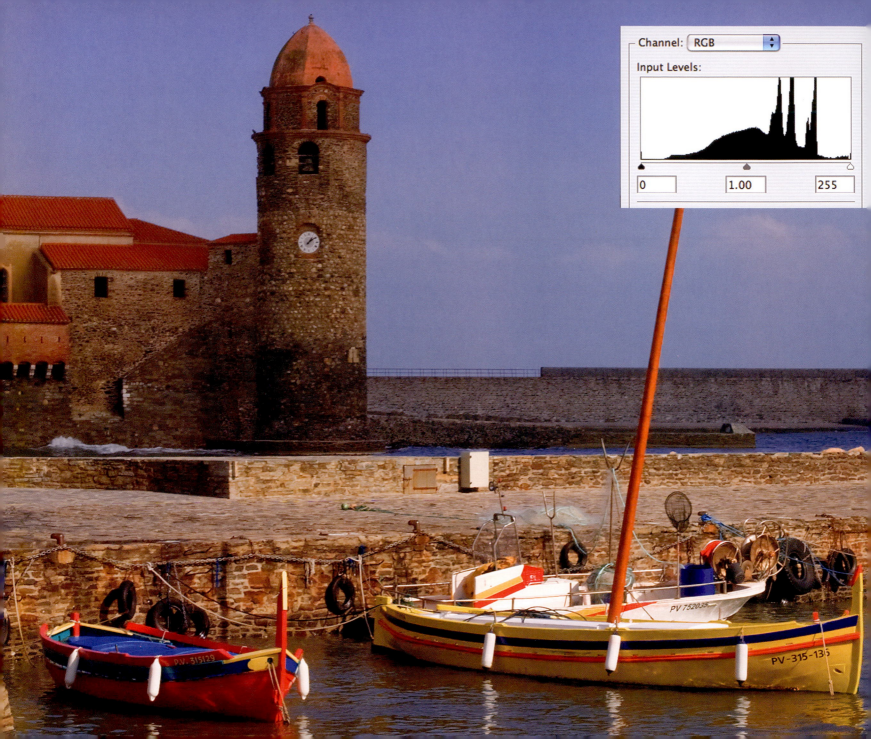

Channel: RGB

Input Levels:

0 1.00 255

Bracketing this scene has paid off, as the second image, exposed at plus 1-stop, is a more faithful reproduction of tones.

Although both exposures are reasonable and workable, the bracketed image will retain higher digital quality through the processing stage because it contains a higher level of data to work with when the effects of linearity are taken into account.

On the downside, taking several images of the same subject will more quickly fill your memory device and involve you in more editing than is necessary. Also, when the subject is moving rapidly, it's likely that changes in composition become apparent. My advice, then, is to bracket when it is essential and not for the sake of it.

EXPOSE FOR THE HIGHLIGHTS, PROCESS FOR THE SHADOWS: THE DIGITAL EXPOSURE MANTRA

Digital photo sensors are far less forgiving of exposure errors than film, which makes ensuring an accurate in-camera exposure essential. I know this is contrary to popular belief, so let me explain the reason.

Imagine six test tubes lined up in a row. These test tubes relate to the average 6-stop dynamic range of a current digital camera, with the test tube at the far right equating to white tones, and then, in turn, light gray, light medium tones, dark medium tones, dark grays, and on the far left, black tones.

Now, when you expose the digital sensor to light, the camera collects all that light in a large bucket. What it then must decide is how to distribute the light from the bucket among the six test tubes. It starts with the white tones (highlights) and fills this test tube to the very top.

Next are the light grays. We know from the diagram on page 121 that light gray is 1-stop darker than white (or, in other words, half as bright). Because digital sensors are linear devices (film is not), the means by which the camera records this 1-stop difference is to fill the test tube relating to light gray tones only half way (half as much light equals half as bright).

This process of halving the quantity of light distributed among the test tubes continues all the way down to the black (shadow) tones, which receives, in this example, 1/32nd the amount of light as the white tones.

When the process is complete, the distribution of light looks like that portrayed in the following illustration.

It's important to understand what this means in terms of the data the camera captures. Most current DSLR cameras are

32 64 128 256 512 1,024 2,048

Diagram illustrating the distribution of tonal levels across a linear device (i.e., a digital sensor).

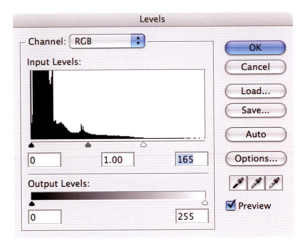

12-bit devices, which means they can capture 4,096 tones (otherwise known as levels). Half of all these tones (2,048) are contained in the test tube at the far right, the white tones. Half of the remaining tones (1,024) are in the light gray test tube, half again (512) in the light medium tones, 256 in the dark medium tones, 128 in the dark grays, and only 64 levels in the black (shadow) tones.

The next question might be, so what? Let's superimpose over the top of the test-tube diagram the digital histogram. And let's use an example where an image is underexposed by 2-stops. The distribution of pixels would look a shown in the next illustration.

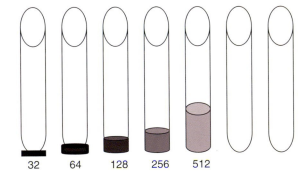

32 64 128 256 512

If a digital image was underexposed by 2-stops the distribution of tones would look like this. Note how the majority of levels (75% of the total) are lost.

To fix this underexposure in-computer, you would open the Levels control in Photoshop and drag the white slider (right side) across to the left, thereby telling the computer to remap the medium-toned pixels to white (next illustration). But now look at what you are actually doing by applying this process of re-mapping tonal values (levels). Levels are important in digital photography because they are the basis for creating what appears to be a continuous tone image, that is, one that mirrors the continuous tone nature of film. Human vision is unable to resolve tonal differences at around about 200 levels or more. At lower levels than these, you begin to see distinct gradation between one tone and another.

By underexposing a digital image you lose the levels contained in the light tones, that is, a large percentage of the light data captured by the camera. In the previous example, all of the data in the first two test tubes, which equate to 75% of the total, are lost and unavailable. By stretching the remaining 25% of the data (the amount actually recorded by the camera) to cover all 4,096 levels, the result is digital banding and increased noise visibility, which is most prevalent in the shadow areas. In effect, the result is significant degradation of image quality. The worst thing you can possibly do when exposing in digital photography is to underexpose.

PHOTO © CHRIS WESTON

This image shows what happens when trying to lighten an underexposed image. Note the high occurrence of noise and the appearance of banding in the shadow areas.

Nor should you overexpose, as significantly clipped pixels (more than $\frac{2}{3}$-stop overexposed) are lost forever. (Some recovery of clipped pixels up to around $\frac{2}{3}$-stop is possible when an image is shot in RAW mode, using modern image processing software.)

The answer to the problems inherent in digital exposure is to expose for the brightest part of the scene where detail is needed and process for the shadows. To more fully explain this statement, let's go back to the earlier example, this time exposing for highlights. When the histogram is superimposed, we see light data contained in the test tubes to the right but lack-

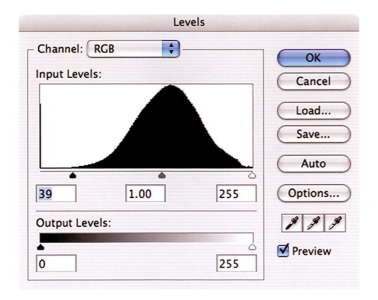

ing in the test tubes to the left. In this instance, the answer would be to open the Levels control in Photoshop and to drag the black slider (at left) across to the right, re-mapping the dark middle tones to black. The difference is that this time we are using 3,904 of the possible 4,096 levels (95% compared to 25%) to complete the task. It doesn't take a rocket scientist to work out that the results are going to be significantly better.

WHEN TO USE SPECIFIC METERING MODES

The necessity to ensure very accurate in-camera exposures in digital photography makes selecting the right metering mode essential. The various metering modes available on current DSLR cameras were described earlier in the book (Habit 2). Here I will explain the appropriate times to choose each mode.

Exposure is not simply a matter of calculating how much light is needed to accurately expose a scene. Most of it is an art of managing light in order to emphasize or de-emphasize objects in a scene. For example, when photographing a silhouette, exposure is used to hide color, pattern and texture—three of the five design elements—leaving only shape to inform and stimulate the viewer. Similarly, overexposure

By exposing for the brightest areas of the scene where detail is necessary, processing of the shadows becomes more detailed and there is no loss in image quality.

is used in high-key imagery to obscure background detail. Selective exposure, such as the two examples stated here, is best achieved when the right metering mode is selected.

While multisegment metering is highly accurate in assessing a general exposure value that will expose the scene evenly across the tonal scale, it is the least useful exposure mode when attempting artistic interpretation of the scene. In the example of the silhouette, for instance, it is very unlikely that, unaided by manual user input, multisegment metering will expose correctly to generate a silhouetted subject, as its purpose is to create a more balanced exposure.

In this instance, spot metering would be the better selection of metering mode, enabling metering of the brightest area of the scene independently of the shadow areas, resulting in an exposure that recorded highlight detail accurately and caused shadow detail to underexpose to featureless black.

The opposite of a silhouette is rim lighting, where the exposure is biased toward the shadow areas causing highlights to overexpose, creating a rim or halo of light around the subject. In this instance, multisegment metering would again

PHOTO © CHRIS WESTON

To capture these giraffes in silhouette during a display of dominance, I switched the camera to spot-metering mode.

Here I used center-weighted metering to create a halo of rim lighting outlining the head of this young hyena.

In landscape photography I almost always use spot metering, which gives me the greatest degree of control over my exposures.

fail the task and spot metering would likely overemphasize the shadows leading to a grossly overexposed background. In this case, center-weighted metering would be the ideal selection. In center-weighted metering mode, the camera weights the exposure to the center of the image frame, where the subject is likely to be, but does not ignore the background completely (as spot metering will). The result is enough bias toward the shadows to create the rim light effect without burning out background detail.

When photographing landscapes, I always use a hand-held spot meter. Hand-held meters are more convenient than in-camera meters when the camera is attached to a tripod.

Simply, I find it is easier to compose the image and set the camera, and then use the hand-held meter to assess scene dynamic range than to complete the composition stage of the process only to remove the camera for metering purposes.

I have two reasons for using a spot meter in landscape photography. The first is to assess scene dynamic range so that I know whether this falls within the dynamic range of the camera or whether I need to manage the light using optical filtering. Second, with a spot meter I can be very selective in which area or areas of the scene I expose for. In turn, this enables me to emphasize or isolate objects in order to achieve the desired composition.

Get into the Habit: Compensating for Light-Absorbing Accessories When Using a Hand-Held Meter

One of the downsides to a hand-held-light meter is that it won't take into account the light-absorbing properties of various lens attachments, such as filters and extension tubes (for close-up and macro photography). Despite this apparent disadvantage, Steve Gosling still relies on his hand-held Sekonic meter in preference to his camera's built-in TTL meter. Here he explains how he still manages to record faithful exposures: "Whenever I use lens attachments, I simply subtract the absorption value of the attachment from the reading the meter provides. Where this is a known value, of course, it's simple.

For example, if I'm using a 2-stop neutral density filter, I simply deduct 2-stops from what the Sekonic tells me. Sometimes, it's less specific. Polarizing filters, for instance, absorb different quantities of light depending on their degree of rotation. When this is the case, I work off values I've calculated manually during absorption tests of the different bits of equipment. These tests are easy to run. Using the camera's spot meter I take a meter reading without the attachment in place and note the exposure value. I then add the attachment and take a new reading. The difference between them is the absorption value of that bit of kit."

WHEN TO USE WHICH EXPOSURE MODE

The types of exposure mode available were described in Habit 2. Of the four main modes, I confess to only ever using two of them, except in very particular circumstances. I shoot most of my wildlife images with the camera set to aperture-priority AE mode, even though I am, more often than not, controlling shutter speed. I use aperture-priority, rather than shutter-priority mode, for a simple reason. My widest-ranging lens has eight aperture settings (f/2.8 to f/32). In contrast, the camera has 19 shutter speed settings. If I set the camera to shutter-priority mode, there are 11 shutter speeds at which there would be no corresponding aperture to generate an appropriate exposure, causing the shutter release to lock. By selecting lens aperture instead, it is highly unlikely, except in extreme lighting conditions (e.g., at night), for there to be no available corresponding shutter-speed.

The only time I deviate from this method of controlling shutter speed using the aperture-priority exposure mode is when I need a very specific shutter speed, which I occasionally do, particularly when using flash lighting.

When photographing the landscape, I almost always select manual exposure mode. This is partly due to the lack of urgency around landscape photography, which differs from much of my wildlife photography, but also due to the fact that I am often using light-managing optical filters and metering with a hand-held device.

Get into the Habit: Manual Exposure Mode

Of all the photographers who have contributed to this book, a majority prefer to set camera exposure using the manual exposure mode. Most cite the fact that they were brought up using fully manual cameras as the reason. Without exception, everyone agreed that continuing to apply exposure manually gave them greater control over the appearance of the final image and that the practice helped to maintain familiarity with the process of exposing an image.

ISO RELATIONSHIP TO EXPOSURE

In digital photography the term "ISO" relates to amplification, the means by which the amount of light is adjusted to record an acceptable image. The advantage of digital ISO over its film counterpart is that its value can be changed for each individual shot, an advantage previously open only to users of single-sheet film (i.e., in large-format photography). This means that if a desired aperture/shutter speed combination isn't achievable at the set ISO value, then amplification (ISO) can be increased or decreased without affecting previous or future exposures.

PHOTO © CHRIS WESTON

When photographing wildlife, I nearly always select aperture-priority AE mode.

For example, say you are photographing a waterfall with the intention of blurring the movement of the water to create an ethereal effect but, with the camera set at ISO 400, the level of illumination is too bright to enable a sufficiently slow shutter speed. By reducing the ISO rating to 100, amplification is reduced by a quarter, requiring that the shutter remain open four times as long, which may be sufficient to achieve the desired effect.

Conversely, imagine trying to photograph a fast-moving subject, such as a bird of prey in flight. Freezing high-speed motion requires shutter speeds in excess of 1/1,000 second, which might require setting the ISO value to a very high rating, such as 800, particularly if light conditions are low.

The ability to make these per-shot changes is the flexibility provided by a digital camera. However, there's no such thing as a free lunch, and this flexibility comes at a cost.

It is important to realize that digital ISO is not the same as for film. With film, the ISO rating relates to sensitivity, which is governed primarily by the size and quantity of silver halide crystals used in its manufacture. In digital photography, ISO

PHOTO © CHRIS WESTON

For landscape photography, where I have more time to consider exposures, I typically set the camera's exposure mode to manual.

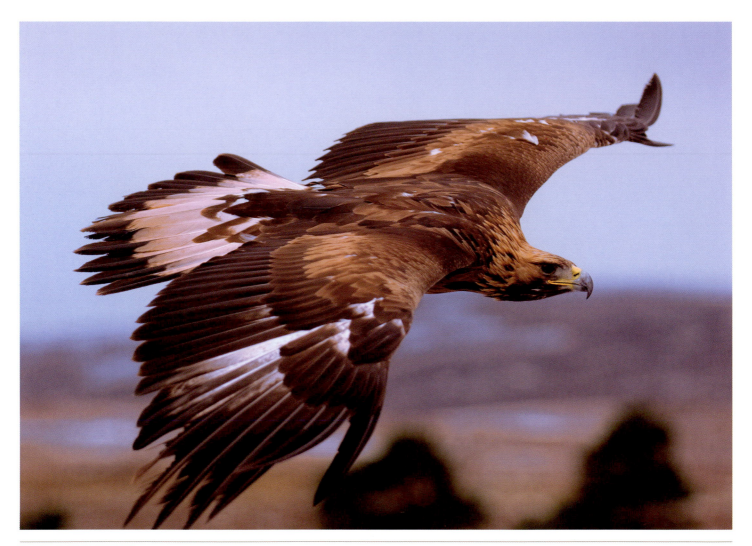

In order to capture this image of a golden eagle in flight in sharp detail, I increased the ISO rating, which enabled me to select a fast shutter speed.

relates to amplification, that is, the extent to which the voltage measurements calculated from a capacitor's (pixel's) charge are multiplied, or "turned up" in much the same way you might turn up the volume on your television or radio set.

The significance of the difference between these two methods of adjusting up or down the extent to which light is recorded comes in the underlying effect on image quality, which, in digital photography, is affected by a phenomenon known as noise—randomly generated erroneous pixels. The higher the set ISO value, the more likely it is that noise will adversely affect image quality. So, while digital cameras do increase flexibility within exposure settings, the true extent of that flexibility is diminished if image quality is to be maintained.

Get into the Habit: ISO Values

Professional nature photographer and digital expert, Niall Benvie, explains how he uses ISO with his digital cameras, "Because I sell my images commercially, image quality has to be flawless. Over the years, working with my current camera system, I never use ISO rated above 200, as beyond this value noise becomes a real issue. Things might change as technology develops, but what I think is important for users to understand is that just because you *can* increase ISO to fix an exposure problem doesn't mean that you *should*."

PHOTO © CHRIS WESTON

Heat generated by the sensor during long-time exposures is a major cause of noise, as can be seen clearly in the shadow areas of this night-time scene.

Noise Pollution

There are four main causes of digital noise. You can do little about two of these causes—inherent noise and sensor-generated noise. Inherent noise refers to the noise that is present in light itself, while sensor-generated noise refers to the type of sensor (charge-coupled device [CCD] or complementary metal oxide semiconductor [CMOS]) used by your camera.

Two user-manageable types of noise are those generated by heat and amplification. Heat-generated noise occurs when long-time shutter speeds are used. The actual time of the shutter speed depends on the camera, but usually exposures that run into several seconds or minutes are likely to result in noticeable noise.

Amplification noise is a result of two things. First, the reduced level of light signal needed to produce the exposure results in a lower signal-to-noise ratio, which increases visible noise. Second, as the signal and noise are amplified simultaneously, the noise that is present becomes even more obvious.

PHOTO © CHRIS WESTON

High ISO ratings (increased amplification) are another cause of noise. This image shot at ISO 800 has a high level of noise in the shaded foreground area and on the models' clothing.

The solution to noise, then, is to always shoot at low-value ISO ratings (e.g., 100 or 200 ISO) and to avoid long-time exposures. Of course, this makes certain photographic applications more suited to film, such as night photography.

As noise is an inexact science, it is advisable to test your camera at different ISO values and long shutter speeds to get a true sense of the camera's limitations in this area.

Tip

JPEG compression may introduce noise-like artifacts and can exacerbate the appearance of noise.

Noise-Reduction Software

It is possible to apply noise-reduction software solutions to overcome or minimize the effects of noise. Some of these solutions are available in-camera via the menu options and are listed either as one option (noise reduction) or sometimes as two separate options (noise reduction—high ISO or noise reduction—time).

When the options are separated out, they work in very different ways. High-ISO noise reduction uses edge softening to hide the noise, with the result that image sharpness is compromised. Long-time–exposure noise reduction, on the other hand, works via the camera generating a "dark image." Effectively, after the initial exposure the camera records a second image of the same exposure duration but with the shutter curtain closed, thereby generating a noise pattern that it matches against the original image, interpolating noise pixels for image pixels. In my experience, it is effective at low noise levels but less so when there is a high presence of noise. It also increases considerably in-camera image processing times and adds to battery drain.

In-computer software solutions are more sophisticated than camera solutions but they share the problem that they all work on an edge-softening basis, so image quality will be compromised when noise reduction is necessary.

APPLYING WHITE BALANCE FOR ARTISTIC EFFECT

In Habit 3, I explained what happens to the color temperature of light as the sun rises throughout the day. The purpose of white balance (WB) is to counter the resulting color casts to record light as we see it, neutral white.

When WB is set to auto, the camera will always attempt to nullify any color casts created by the prevailing lighting

conditions. Often, however, this has a negative effect on the appearance of the image, such as photographing a beautiful golden sunrise only to find that the camera has effectively filtered out the orange/yellow light.

In nature photography, often we want to exploit color casts for artistic effect. In this instance, WB can be considered as a set of digital color filters that can be applied in the same way that you might use an 81-series warming filter or an 80-series blue filter.

WB menu options include several pre-set WB values:

- Sunlight
- Flash
- Cloudy
- Shade
- Fluorescent
- Incandescent (tungsten)

When set to Sunlight (the flash setting is very similar), the effect is an unfiltered image, similar to photographing with daylight-balanced film without filtration. This will res[...] any color cast present—caused by a variation in actual color temperature compared to the color temperature set via the WB control—showing in the final image.

To enhance warm tones, that is, replicating the use of warming filters, the Cloudy or Shade settings can be set. The Cloudy setting is similar to an 81B warming filter, and the Shade setting is closer to the stronger, more pronounced 81C or 81D warming filters.

To enhance cool blue tones, the Fluorescent and Incandescent settings can be applied. In this case, Fluorescent is similar to an 80C or 80D blue filter, while incandescent will mimic an 80A or 80B blue filter.

By thinking of WB in terms of filtering orange or blue light, the WB control can be used to create artistic effects and to enhance the color temperature of light. For example, in landscape photography warm images often stand out because they have a positive psychological effect on us (humans are warm-blooded creatures and we like to feel

PHOTO © CHRIS WESTON

In-camera noise reduction solutions are sometimes effective, but may also degrade image quality, causing a softening of edge detail, as can be seen in this close-up section of a night-time scene.

PHOTO © CHRIS WESTON

This sequence of images shows the effect of altering white balance. Note how the images get noticeably warmer as WB changes from daylight (p. 154), to cloudy (p. 155), and then shade (p. 156).

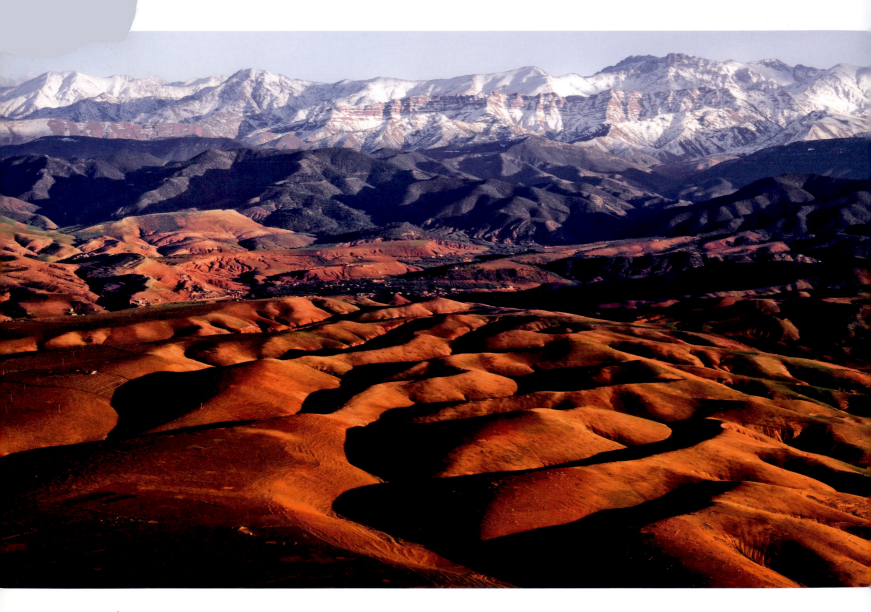

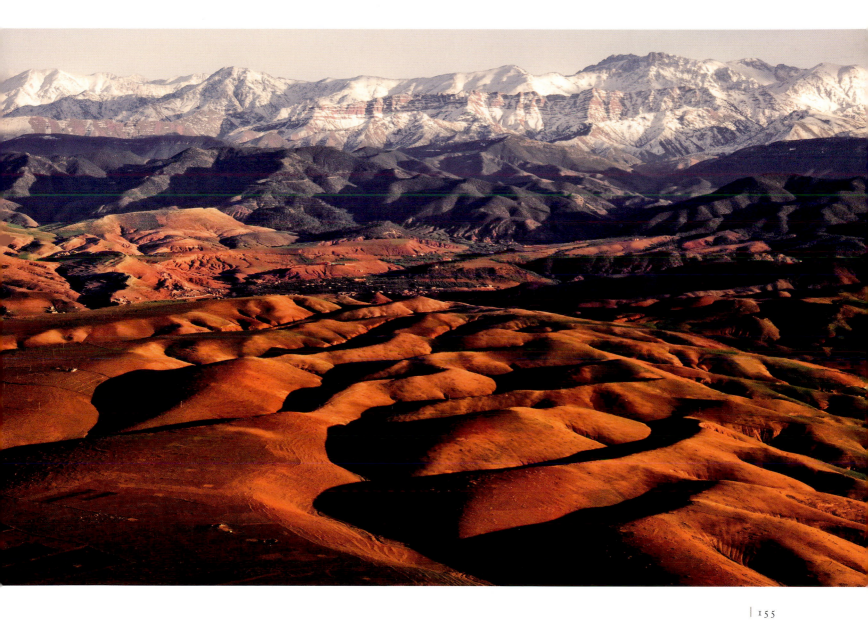

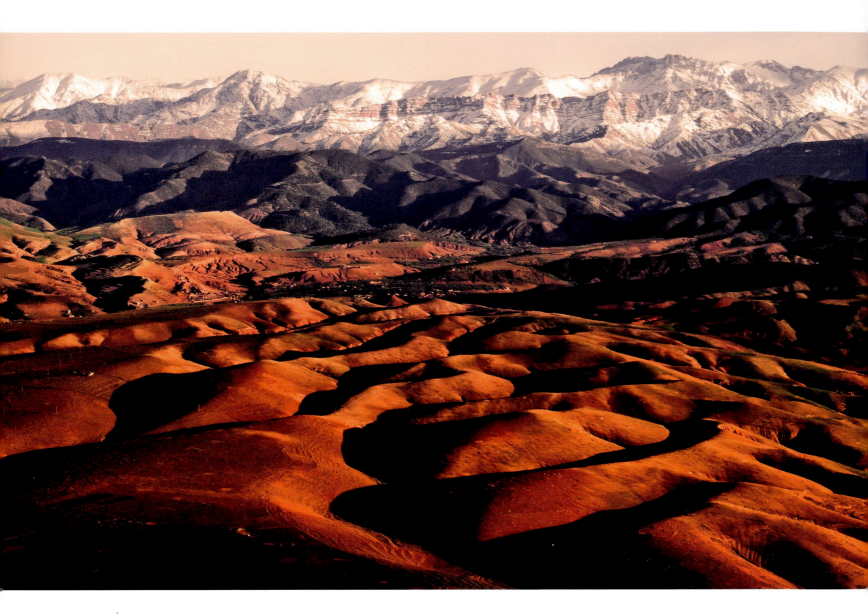

warmth). Enhancing the warm tones of sunrise and sunset by setting WB to either Cloudy (mild effect) or Shade (strong effect) will improve your images, as if an optical warming filter had been used.

Creatively, the diamond in the pack is the Fluorescent setting that I use frequently to enhance and sometimes to create blue skies. I came across the effects of using fluorescent WB while working on a project photographing the landscape under moonlight. Early attempts resulted in a sky that appeared a murky blue/gray in color. After some experimentation, I found that setting WB to Fluorescent Enhanced the blue tones to make them appear far more natural.

Get into the Habit: Setting WB In-Camera

I have to confess that for speed and simplicity, I almost always set WB on the camera to auto and then make any adjustments later during the RAW conversion process. As WB can be altered in the RAW state as if it had been altered on the camera at the time of shooting, I lose none of the quality of the image yet gain valuable time in the field. If I were to shoot in JPEG mode, of course, I'd have to change my ways.

PHOTO © CHRIS WESTON

Fluorescent and tungsten WB settings can be used to replicate the effects of the 80 series of blue filters.

PHOTO © CHRIS WESTON

Selecting the fluorescent WB setting has greatly improved the color of this landscape scene photographed using moonlight (p. 159–160).

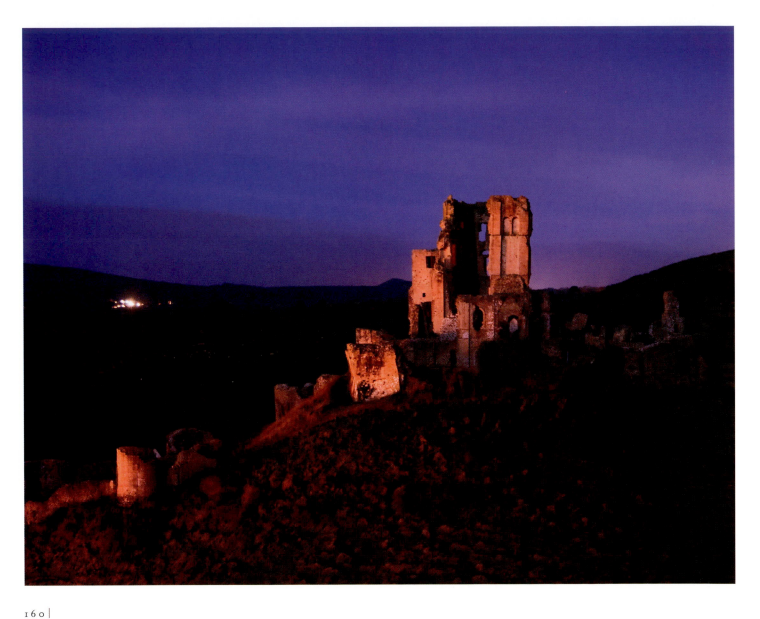

Customized WB Values

Many DSLR cameras have a custom setting in the WB menu that enables a custom Kelvin value to be entered for WB. Using this requires a certain level of knowledge of Kelvin values (which represent color temperature). If setting WB in-camera, which I tend not to do as I prefer setting WB in-computer, I often use this custom setting to apply a Kelvin value that isn't covered by the pre-set values. For example, I find that the Cloudy setting adds a little too much yellow to the resulting image and so I tone it down by setting the Kelvin value between those for the Daylight and Cloudy settings, which mimics more closely an 81A (i.e., very mild) warming filter, mirroring a practice I adopted habitually when using film.

If shooting in RAW image mode, white balance can be adjusted in-computer as if it had been set in-camera.

Tip

White balance is one of those settings that, when shooting in RAW mode, can be adjusted in-computer as if it had been applied in-camera. However, when shooting in JPEG mode, the camera will process the image, applying whichever WB value has been set on the camera, making it difficult to alter postcapture.

CHOOSING THE RIGHT LENS FOR THE OCCASION

Let me describe a familiar scenario. A photographer turns up at a scene, has a general look around, plonks down his tripod, attaches the camera—complete with zoom lens—and then zooms in and out to achieve the best framing. Of course, sometimes this approach to framing an image is unavoidable when it's impossible to change the position of the camera. However, such occasions are rare.

The root of the problem with this approach can be found in the laws of optics. When the focal length of a lens is changed by zooming in and out, or by moving between prime lenses, not only is the angle of view (how much of the scene is covered by the lens) altered but so too are spatial relationships.

The term "spatial relationships" refers to how objects at varying distances in the scene relate to each other in the image frame. For example, an object in the foreground can appear far from the background or on the same plane as the background depending on how they are photographed. In terms of spatial relationships, focal length is the controlling factor.

With a standard focal length lens (equivalent to around 50 mm), spatial relationships appear in print much as they do when viewed with human vision. This is because the angle of view of human eyesight is similar to that of a 50-mm lens (in the 35-mm/full-frame digital format). When focal length is altered toward the longer, telephoto end (70 mm and above), the space between objects is squashed, making objects appear to be closer together than they are. The effect of this is shown clearly in the image of the impala in the next illustration. In this photograph the animals appear to be standing in the shade directly under the acacia tree. In reality, they are about 50 yards back from the tree, out in the open. The use of a long telephoto lens (400 mm) has caused the space between them to close, creating a much flatter scene.

Conversely, when focal length is reduced toward the wide-angle end of the lens spectrum (35 mm and below), the apparent space between objects in the frame stretches, giving a greater sense of space. This is one reason that wide-angle lenses are suited to landscape photography, where creating a sense of space is often the aim.

Lens choice, then, should determine camera position rather than the other way around. That's to say, when choosing which lens to use for any given scene, the choice should be dictated by how you want to portray the relationship between objects in the scene—close together, far apart, or somewhere in between.

USING AUTO-FOCUS EFFECTIVELY

It was 10 years after the invention of auto focus (AF) that I finally converted from my fully manual 35-mm camera to an AF model. I mention this because it is important to appreciate that, while AF is a useful tool in modern

PHOTO © CHRIS WESTON

A long telephoto lens has flattened the spatial relationship between the tree in the foreground and the impala in the background. Although they appear to be on the same plane, in reality the animals are around 50 yards from the tree.

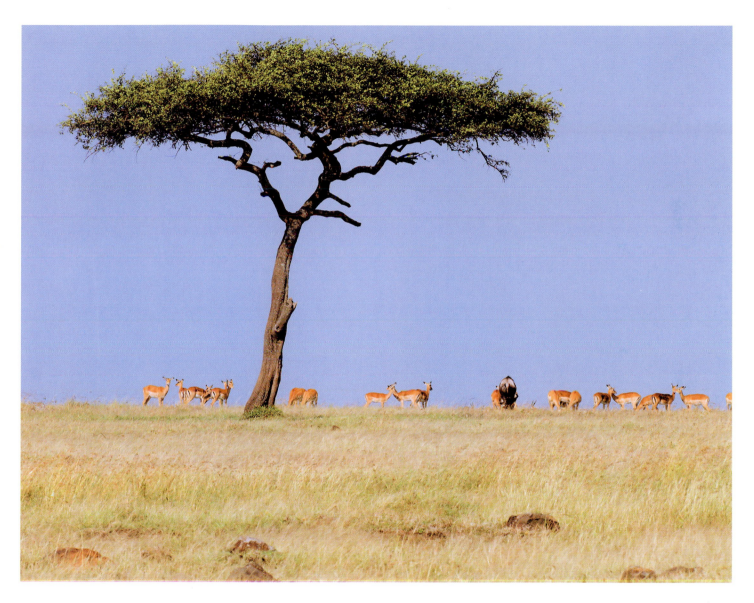

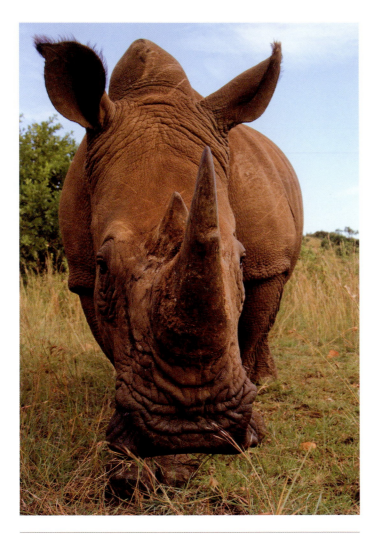

A wide-angle lens stretches spatial relationships, increasing the apparent space between objects, in this case giving prominence to the rhino's horn.

photography, it has the potential to foster laziness on the part of photographers.

In certain areas of photography, AF is a magical tool and there is no doubt that I have captured some wildlife images that would have been impossible without it. In other areas, it can be at best redundant, at worst a nuisance. The question is, when will it work for you rather than against you?

To Track or Not to Track

Most current DSLR cameras have two types of AF system: focus and lock (referred to by Canon as one-shot AF and by most other manufacturers as single or single-servo AF) or focus and track (which Canon calls artificial intelligence AI servo and everyone else calls continuous or continuous-servo AF).

In the default AF mode (focus and lock), the camera detects the point of focus and locks focus at that distance. This is ideal when the subject is static, since camera-to-subject distance (focus distance) is unlikely to change unless the photographer moves position. However, if the subject moves closer to or farther away from the camera, then it will fall out of focus because the camera is still focusing on the original (locked) focus point. This is one of the most common causes of out-of-focus images.

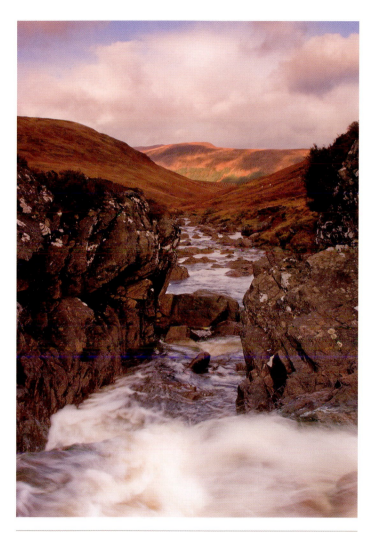

The default AF setting of focus and lock is ideal for static subjects, such as landscapes.

For moving subjects, the camera provides a second AF mode option: focus and track. In this mode, the camera detects the point of focus and focuses at this distance. However, it doesn't lock focus. Instead, using the AF target sensors visible in the viewfinder, it continues to assess the position of the subject and, if it detects subject movement, it will adjust the focus distance accordingly, thereby maintaining accurate focus.

For example, imagine you are photographing a car moving toward you. When first focusing on the car, its distance might be, say, 20 meters but, by the time you come to press the shutter, it will have moved closer to, say, 10 meters distance. With the camera set to focus-and-lock (default) mode, the focus distance would remain unchanged at 20 meters when the shutter was pressed, resulting in the car being out of focus by 10 meters. However, in focus-and-track mode, the camera would continually reassess subject distance, adjusting the focus distance so that when the picture was taken, the point of focus would be set to (in this example) 10 meters—the actual distance of the car.

Consequently, the appropriate AF mode setting depends largely on whether the subject is static or in motion. The focus-and-lock mode is ideal for static subjects, such as landscapes. However, when the subject is moving (e.g., wildlife), then focus and track is the more suitable option.

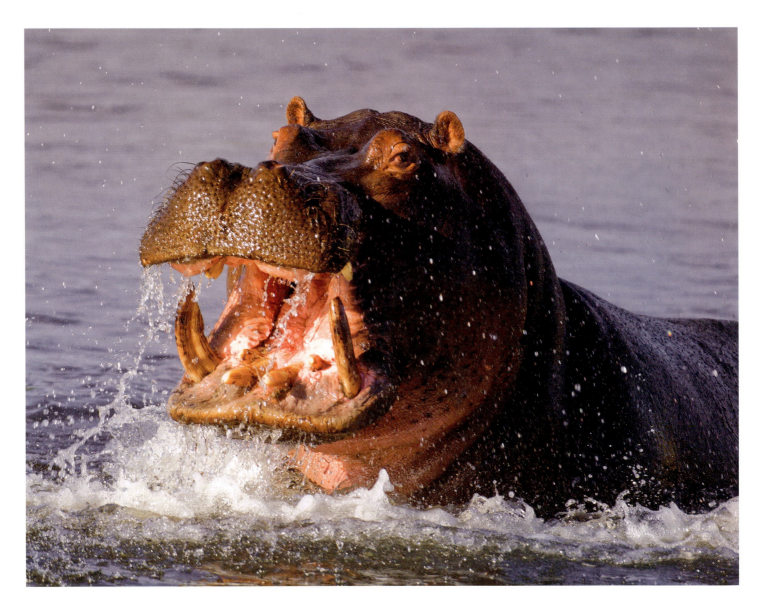

Targeting the Right Area

Another consideration is the area of the frame given over to detecting the focus point, referred to as the AF-area mode. The options open to you will depend to some extent on the specification of your camera. For instance, consumer-grade DSLRs typically have fewer options than more expensive semi-pro and professional specification models.

One option common to all DSLRs is single-area mode. In this setting, the user chooses one of the AF-target sensors (the square brackets or boxes visible in the viewfinder) as the active sensor and the camera will focus on whatever subject falls within the area covered by that target sensor. It's a simple solution and provides a certain degree of control to the user, particularly when focusing on off-center subjects that are static, which is typical, for example, when the rule of thirds is applied in landscape photography.

The limitation of this option is that the camera uses only information provided by the selected target sensor, with all other sensors being inactive. Should the subject move outside the area covered by the sensor, then the camera will re-focus

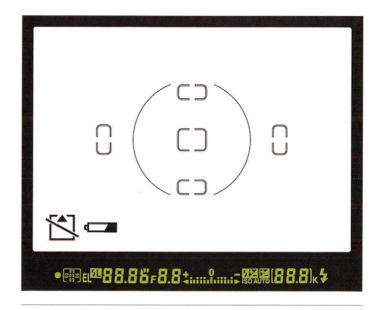

All DLSR cameras have multiple AF target sensors, which can be selected manually to aid focusing.

(in focus-and-track mode) on whatever remains within the pre-selected target area. The likely result is an out-of-focus main subject.

To combat this limitation, another available AF-area mode option is dynamic area (sometimes referred to as wide area). Here the user can pre-select the preferred active sensor, but should the subject move out of the initially selected area, one of the other AF target sensors, which are now active, will

PHOTO © CHRIS WESTON

For moving subjects, the AF focus-and-track mode is the best auto-focus option.

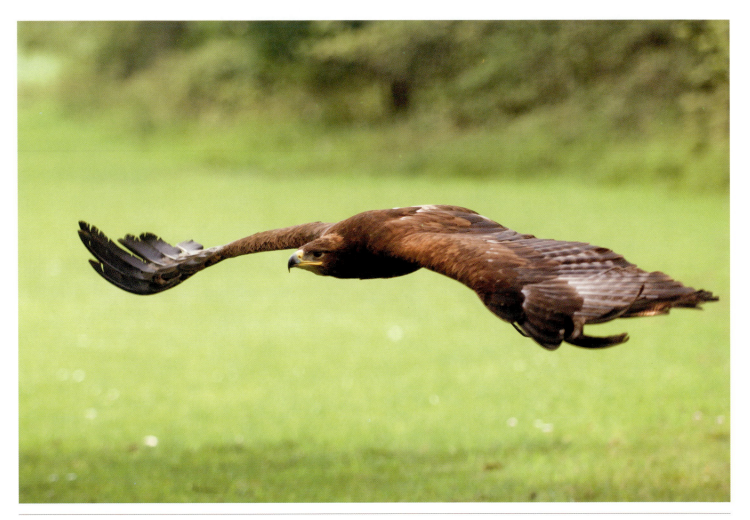

PHOTO © CHRIS WESTON

In dynamic-area (or wide-area) AF mode, all the AF target sensors are made active, enabling the camera to follow the movement of a subject and maintain accurate focus.

pick up the subject's movement and take over the AF pro-cess. This option is ideal where the subject is moving within the picture frame, such as when photographing birds in flight or moving wildlife.

With either option, it is important for the user to first select the most appropriate AF-target sensor, typically the one closest to the subject's position in the picture space. Equally important is defining the main subject. For example, in a landscape scene this might be a prominent feature, such as a bridge, building or rock formation. When photographing an animal or a person, however, it is important that focus is centered on the subject's eyes, requiring critical placement of the sensor position.

A third option available on some cameras is closest-subject AF-area mode, whereby the camera focuses on the subject closest to the lens, automatically selecting the appropriate AF target sensor. Often considered most suited to point-and-shoot photography, this option is particularly suited also to erratically moving subjects where no foreground is pres-ent, such as birds in flight.

Get into the Habit: Photographing Birds in Flight

Scotland-based wildlife and conservation photographer Pete Cairns has captured many stunning images of wild birds in flight. Here he describes his technique: "First, I set my [Canon] camera to AI-servo focus mode (continuous focusing). I select the center AF target sensor and set the drive mode to its fastest setting. I then use my experience to keep the subject within the frame, close to the center, exposing several frames in sequence. To some extent, I work on the law of averages—the more shots I take the more likely it is that a number of them are sharp. Often I select a middle-of-the-range shut-ter speed, around 1/60 second, in order to blur parts of the bird, e.g., the movement of the wings, which are moving more quickly than the bird is flying, while keeping the eyes and head sharp."

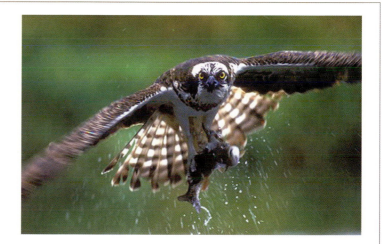

PHOTO © PETE CAIRNS

Scotland-based photographer Pete Cairns has spent many years practicing the skills needed to capture stunning images of birds in flight.

Taking Priority

Another AF option hidden away in the depths of the camera menu (on some DSLR cameras) is an AF-mode priority selection option. In the default setting—focus-and-lock mode—the camera only enables the shutter release when the subject is deemed to be in focus, minimizing (although not eradicating) the likelihood of taking out-of-focus pictures. In focus-and-track mode, priority is given to shutter release, and photographs can be taken whether or not the subject is in focus. Via the custom settings menu, these priority settings can often be altered to suit your personal preference. For example, I have changed the priority mode for focus and track on my Nikon cameras (continuous-servo mode) to focus priority, so that the shutter remains inactive until the subject is in focus, a mode I prefer when photographing wildlife action.

Not All AF Systems Are Created Equal

On the face of it, it would seem that all this technology has made photographing moving subjects trouble-free. For anyone who has ever tried it, you'll know how far from reality this statement is.

All AF systems suffer two major flaws: speed and response. To track a moving subject, the camera must first recognize that the subject is moving. Even in high-end cameras, this can take around 0.2 second, long enough for a bird in flight

or a sprinting cheetah to have disappeared from the frame. Second, in order to track a subject, the motors in the lens and/or camera that drive the AF system must do their job and, frankly, some are just not quick enough.

So, while theoretically the camera will manage the focusing on your behalf when focus-and-track mode is selected, in practice the system is unreliable. How unreliable will depend to some extent on the level of camera you use, as not all AF systems are created equal. This is one area where the higher cost of professional-specification cameras buys you extra potential. Although not always.

Predictive Focus

When AF fails to adequately track a moving subject, I use a technique known as predictive focus. This technique will work when it's possible to anticipate the position of the subject. I'm going to describe photographing captive birds at a falconry center as an example.

Imagine that the subject bird is being flown from a T-bar to the falconer's glove. From experience, I know that as the bird takes to flight it will drop down toward the ground and then fly straight and level before rising again to land on the hand. Because I know that the bird will pass through a certain point, I can manually set focus distance at that point (using

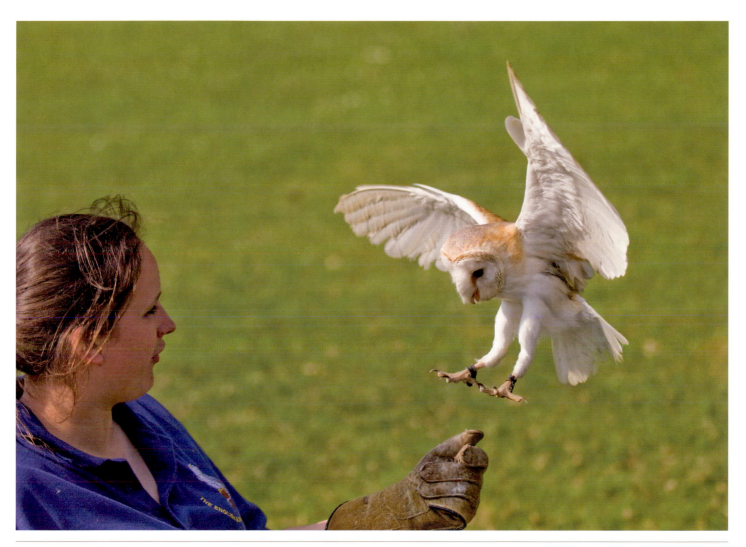

This image of a captive barn owl was shot during a falconry display, using the predictive focus technique.

AF with AF lock will also work). Then, as the bird begins its flight I can track it via the viewfinder and, when it reaches the predetermined position, fire the shutter. In practice, I will fire possibly three to five shots, beginning just before the predetermined point of focus, as a form of focus bracketing.

While this example uses a controlled scenario, the theory applies to any subject. The key is to be able to anticipate what the subject is going to do, which is why this point was covered in the very first of my seven habits.

When AF Is More Trouble than It's Worth

There are many occasions when AF proves problematic, and any advantages it provides when photographing moving subjects are lost. A good example is when photographing landscape scenes. Although AF can be used in landscape photography, often it is far simpler to use manual focus. Similarly, when photographing wildlife in dense undergrowth, the camera's AF system is just as likely to focus on the grasses as on the animal. Again, when faced with this type of situation, I always prefer to use manual focus.

All in all, I would guess that around 40% of the images I photograph in the wild are shot with the camera's focus mode set to manual.

How Auto-Focus Works

Practically all DSLR cameras use a system of auto-focus referred to as passive auto-focus. This involves an auto-focus sensor, typically a single-strip CCD. Light from the scene hits this CCD strip and the microprocessor in the camera assesses the values from each pixel and then compares intensity among adjacent pixels. Where there intensity difference between adjacent pixels is maximized, the camera determines that point as the point of best focus.

This creates some limitations, namely, passive AF must have light and a certain level of contrast in order to work. For example, if you attempt to photograph a blank wall or a large object of uniform color (e.g., a plain blue sky), then there is no variation in intensity that the camera can use to determine a focus point. In this case, the camera goes into AF hunt mode, where the lens continually attempts to focus without ever locking on a given position.

Also, when brightness levels drop too low, insufficient light causes the auto-focus system to fail, which is a reason that many AF systems require a maximum aperture no smaller than f/5.6 in order to operate effectively.

Using the AF Lock Button

In focus-and-track AF mode, pressing the AF-lock button will lock focus at the current focus distance, effectively deactivating focus-and-track mode.

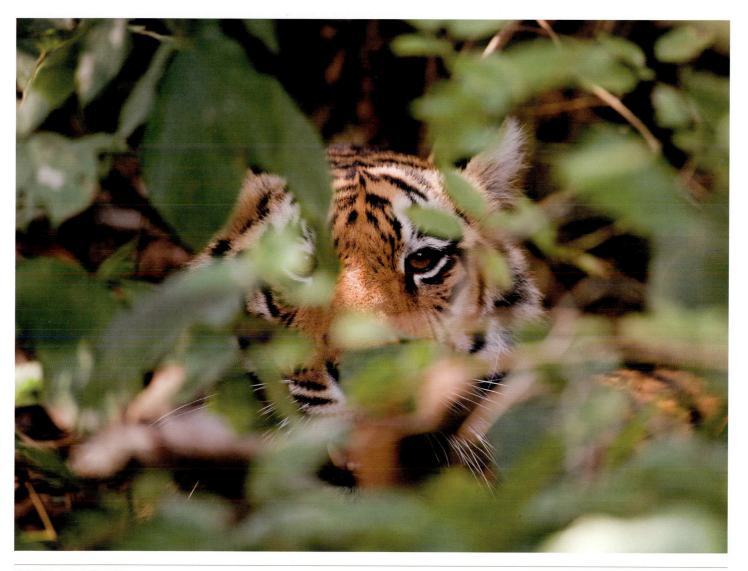

When photographing wildlife in dense undergrowth, manual focus is often the quickest and fastest method of focusing the camera accurately.

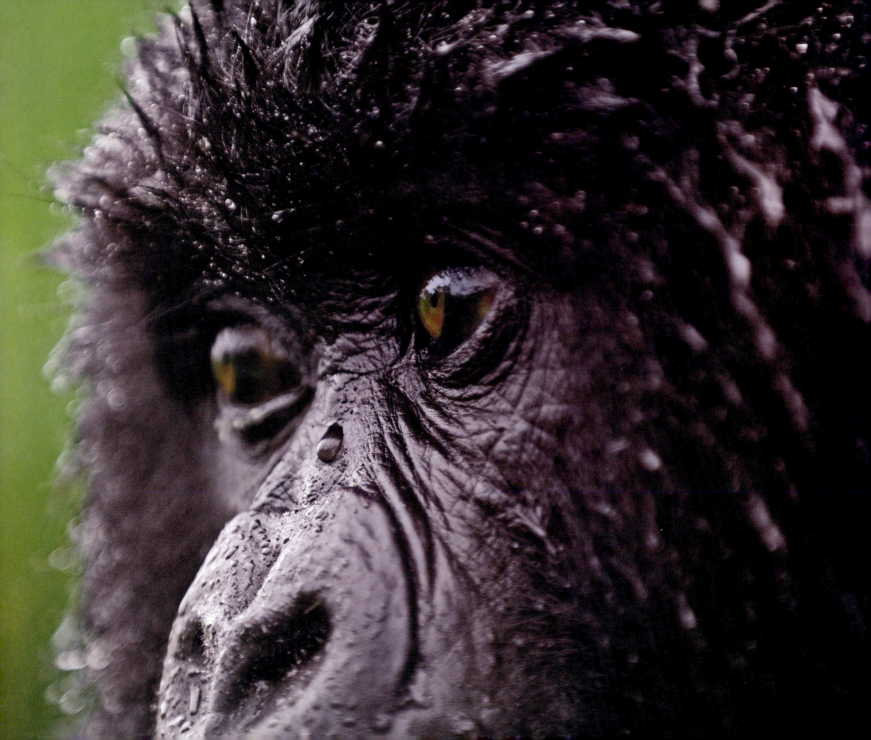

LEARN THE RULES (AND WHEN NOT TO APPLY THEM)

When painters paint pictures, they start with a blank canvas. They then mix paints and add things to the canvas in the form of lines, shapes, patterns, color and texture, in order to form an image. If there is something in the scene they do not want to show, they simply don't add it.

So if, for example, there's a whopping great telephone mast on a hillside, well, no matter; the painter simply doesn't paint it. If the sky is the wrong color, that doesn't matter either. The painter simply mixes paints to achieve the desired color. No clouds in the sky? No problem, the painter can add some. Painting is an art of addition.

Photography is the opposite. When you look through a viewfinder, your picture is already painted for you, in a fully formed scene in all its natural wonder and glory, complete with all the elements you need but jumbled in a random fashion. Your job as a photographer is to decide which elements and objects in the scene are important to your composition and which are not. The important ones need ordering; more important, the unimportant ones must be removed. Photography, then, is an art of *omission*.

In the end, painters and photographers arrive in the same place—an image that reflects their personal visualization. How the two groups get there differs. Painters add pictorial elements, photographers must take them out. This is what composition is all about and how photographs are *made*.

LEARNING THE ART OF OMISSION

All of the tools you need to remove visual information from the image space are right there in your hands. They are the controls of your camera. The physical and technical aspects of these controls (where they are and what they do) are described in previous chapters. Here I want to explain how to use them creatively.

In-Camera Cropping

The most obvious method of removing an object and/or detail from the image space is to physically crop it, by picking up your tripod and moving it closer to the subject (or moving your legs, if you're hand-holding the camera). I emphasize this method over simply staying put and using longer focal lengths to narrow the angle of view for the reason

PHOTO © CHRIS WESTON

The best photographs are designed, that is, the compositions are manufactured from visual elements. Where I stood to take this image wasn't decided by chance. I purposely positioned the camera in order to make visual use of the inverted triangle in the water in the foreground, which perfectly mirrors the shape of the mountain in the distance. Similarly, the inclusion of the large boulder on the right of the frame creates dynamism—a sense of visual energy—as it competes for attention with the mountain. The contrasting shapes—the sphere and triangle—cause this competitive relationship to occur.

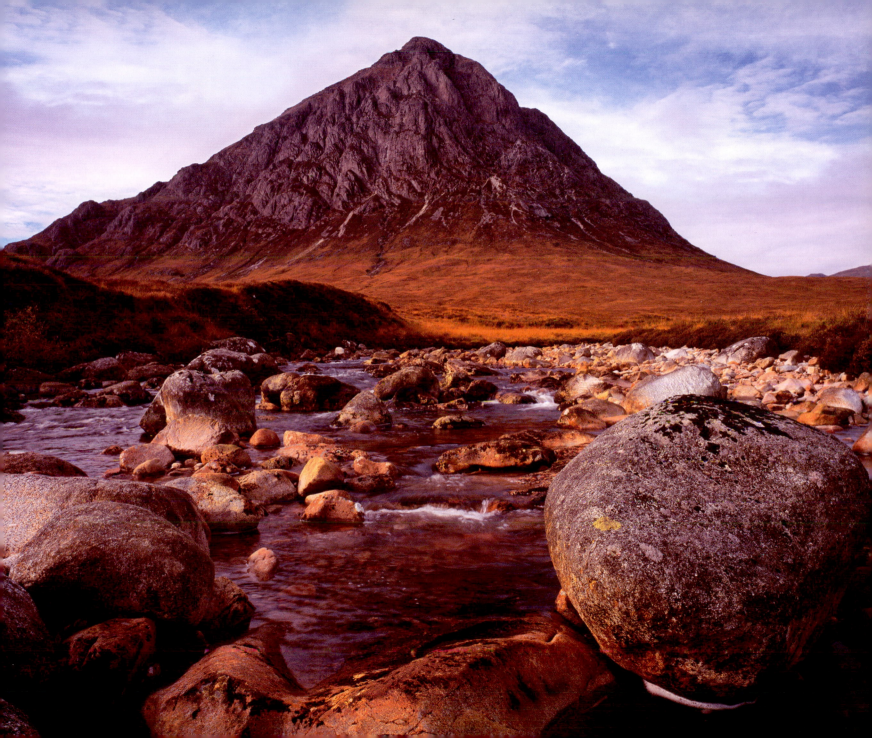

outlined in Habit 4 (relating to the impact on spatial relationships when focal length is altered).

Of course, using a longer focal-length lens to reduce the angle of view, thereby cropping peripheral detail from around the main subject, is a legitimate tool at your disposal and, where the impact on the relationships between two or more objects on varying planes is negligible or unimportant, it is an entirely appropriate method to use.

The following series of images clearly shows the effects of physically cropping information from the edge of the picture space. For the first image, I moved the camera closer to the subject, keeping focal length the same. As a result, edge detail has been cropped but the spatial relationship between the foreground and background object is unchanged, maintaining a sense of depth. For the second image, I kept my original position and switched to a longer focal-length lens. In this example, edge detail has again been cropped but, additionally, the manner in which the foreground and background objects relate (the spatial relationship) was also altered. The space between the two objects has been squashed, giving the appearance that they are closer together and making for a flatter image.

Both of the previous images are legitimate reproductions of the original scene, yet they are different. As an aside,

this example illustrates an important point about the art of photography, which can be illustrated by paraphrasing Ansel Adams. Photography is like music. Once you have the basic notes, they can be performed in many different ways. I have heard the choral section of Beethoven's Ninth Symphony played by the Royal Philharmonic Orchestra and by the 1970–1980s rock band Rainbow. The notes were the same, but each group's interpretation of those notes was very different. Neither style is right or wrong, simply different.

In digital photography, the notes to which Adams refers (the score) are represented by the visual data; the performance is represented by the interpretation of that data in the form of the processed photograph, that is, a print or digital display.

Focus and Depth of Field

When cropping is not feasible or undesirable, a different approach to removing pictorial detail must be taken. One such option is to blur it. Human beings are visual creatures,

PHOTO © CHRIS WESTON

Cropping in-camera is achieved by either moving the camera closer to the subject (p. 179) or by switching to a longer focal-length lens (p. 180). However, note how the spatial relationship between the foreground and background subjects changes from one method to the other.

In-Computer Cropping

It is, of course, possible to crop an image during in-computer processing via Photoshop (or a similar software solution). Minimal cropping will have little effect on image quality; however, any large cropping will significantly reduce the physical dimensions of the image and is best avoided, particularly if you anticipate producing large, high-quality prints.

PHOTO © CHRIS WESTON

The first image shows the full-frame composition. It was impossible to move the camera closer or to use a longer focal-length lens, so I resorted to cropping the unnecessary space in-computer. By doing so I have reduced the resolution from the original 12.2 million pixels to 6.3 million, almost half the original. This will have repercussions if the image is to be printed larger than 10 × 8 inches.

given that our primary sense is vision. In photography we can exploit this by using sharpness (focus) and apparent sharpness (depth of field) to emphasize and give order to objects in the picture space.

Let's look at an example. In the next image, the background is cluttered and distracting. However, using a wide-lens aperture has blurred detail in the background to such an extent that it has disappeared.

PHOTO © CHRIS WESTON

By selecting a wide aperture for this shot, I have managed to blur background clutter to the extent that it is no longer visible, thereby removing it from the picture space.

Because we are visual creatures, we focus our attention on objects that appear sharp and ignore out-of-focus detail. The more blurred the detail, the more our brain processes it out of our mind's eye. (By the way, this is also the reason that, in a wildlife photograph, an animal's eyes should, in most situations, appear sharp.)

As well as hiding or revealing objects, focus and depth of field can be used to determine the order in which we see multiple objects in the image space. For example, in the following image of gray seals, your attention is drawn to the young seal pup in the center of the frame as it is the sharpest object in the frame. Your eye then looks to the adult seal to the left of

the pup, and then to the one on the right and on to the seal in the foreground, before returning to the principal subject, the pup.

Emphasis isn't binary; instead objects and detail become less emphasized the more they are blurred. Therefore, using selective depth of field will create a sense of order where multiple objects appear in the image space. Thinking of composition in these terms makes more obvious the power of strong composition and the ability of a photographer to create images rather than being simply a recorder of events or moments.

Lost in Light

The third tool at your disposal for removing detail from a scene is exposure. When we think of exposure, typically we think in terms of revealing detail across the full tonal range. However, from a contrary perspective exposure can be used to hide unwanted detail. For example, shadow areas can be underexposed to make them detail-less black, while light tones can be overexposed to render them featureless white.

The effects can be subtle or pronounced. In the following image of the giraffe, for instance, I have created a high-key

PHOTO © CHRIS WESTON

Levels of depth of field within the picture space will determine the order in which we look at objects.

PHOTO © CHRIS WESTON

For this image of a giraffe, I have purposefully overexposed the background to remove all detail from the sky, an example of using exposure as a tool for omitting information from within the picture space.

effect, a very pronounced overexposure of light tones, by overexposing the bright, monotone sky. To achieve this, I took a meter reading from the sky and opened the exposure by 3-stops. Contrast was added at the processing stage to emphasize shape, pattern, and texture.

Natural history photographer, Niall Benvie, uses a different technique to achieve the same result. In a series of images of insects, Niall placed the subject on an opaque stand lit from below. The subject was then lit using a flash. Exposure was calculated for the subject based on the knowledge that the backlighting would overexpose the background to featureless white. Using this technique negated the need for postcapture processing. Art Wolfe is another photographer who exploits overtly the power of white space by intentionally overexposing highlights for artistic and creative effect.

At the opposite end of the exposure spectrum, an obvious example of using underexposure to remove visual detail is the silhouette. In a silhouette, shadow detail is underexposed to remove the design elements color, pattern and texture. In so

PHOTO © NIALL BENVIE

Niall Benvie used artificial lighting shining through an opaque background to create unique images of insects.

doing, line and/or shape become the predominant pictorial features. This is shown in the following landscape image, where exposure was biased towards the light tones of the river, resulting in underexposure of the darker tones of the land. In turn, this leads to greater emphasis of the meandering line of the river.

PHOTO © CHRIS WESTON

In this image, I have deliberately underexposed the shadow areas on either side of the river in order to emphasize the meandering line of its course—another example of using exposure as a tool for removing unwanted detail.

In macro photography with artificial light, sharp light fall-off from a small flash unit can be exploited to hide distracting background detail.

Another example of using underexposure to remove unwanted detail is found in close-up photography. The image above, photographed by macro expert, Paul Harcourt Davies, isolates the subject from a distracting background by exploiting light fall-off from his macro-flash. As light travels farther from a flash unit, it diminishes in strength, so foreground objects receive more light than background objects. By exposing for the foreground (more light requires a shorter exposure) the underlit background, which would need a longer exposure, is underexposed and rendered featureless black.

Get into the Habit: Pay Attention to the Detail

For professional photographer, Pete Cairns, composition in the digital age has a lot to do with attitude. "I lose count of the number of photographers I come across in workshops who pay little attention to the detail in a scene, based on a misguided theory that erroneous objects in the frame can simply be cloned out in Photoshop. My experience is that such a sloppy approach to composition and framing results in sloppy, poor images. What's wrong with getting up and moving a couple of feet if it removes the offending object from the picture space? As a professional, I have neither the time nor the inclination to spend hours in front of a computer removing trees from behind animals' heads when I could have achieved the same result in a couple of seconds in the field."

DESIGNING A PHOTOGRAPHIC IMAGE

When you look at a scene, you are viewing Nature's art. Now, there is nothing stopping you from simply recording that which Mother Nature presents. However, just because the scene appears a certain way doesn't mean that is the best way to photograph it. Determining how to arrange the objects in the scene is just as important as deciding how you manage the flow of light into the camera. This is what composition is all about.

For me, the process of composition begins by deconstructing the scene in front of me. When I look at a landscape or a wildlife subject, with my "photography head" on I no longer see an animal or a sweeping vista of majestic mountains, or trees or rivers or flower meadows or valleys. In essence, I no longer see the literal subject. Instead, I see shapes, lines, colors, patterns and texture. In my head, I separate out these basic building blocks, a process known as deconstruction, in order to decide how I want to use them.

Once I have separated them, I decide which elements I want to include in my composition and how I want them to relate to each other. Once this process is complete, I am better informed to choose camera position, focal length, exposure and exposure settings in order to capture the image I have visualized.

To illustrate this process, consider the following image, which was photographed in a large, dense wood. As I walked through the bluebells and the trees, I was looking for an inspirational composition. I noticed the shape of the fern, its dynamic nature, and the explosion of fronds that added energy to an otherwise static subject.

As an exercise, let's deconstruct the image. In the foreground, the gently curving lines of the fronds radiate into the lower mid-ground. In the lower mid-ground, the bluebells form a triangle pointing to the upper mid-ground and the base of the trees. The vertical lines of the trees then lead up through the remainder of the picture space. Note the language used in this description: "curving lines," "triangle," and "vertical lines."

The camera position for this image was chosen carefully and specifically to exploit and emphasize the design elements visible in the scene. Each of the elements has been chosen to work in harmony with the others in order to produce a compelling image.

The arrangement of objects in a scene, then, is the basis of composition. However, in order to master the art of composition, it is important to understand how we are psychologically affected by the design elements.

In this woodland scene, the design elements of line and shape play an integral role in the success of the image. The careful and considered placement of graphic components is what composition is really all about.

THE PSYCHOLOGY OF DESIGN AND ITS ROLE IN COMPOSITION

Photographs are two-dimensional, yet we see the world in three dimensions. Thinking of photography in terms of art, as opposed to a purely illustrative medium, for an image to be compelling we must replace this missing dimension with something else. That something else is emotion.

From an artistic standpoint, emotion is the third dimension in a photographic image. A photograph that elicits no emotional response will fail artistically. Therefore, it is incumbent on the photographer to use the visual information in the scene to capture an essence of what he or she felt at the time the photograph was made. The tools we have to achieve this are the basic elements of design.

Elements of Design

The five basic elements of design apparent in the natural world are line, shape, color, pattern and texture. Each of these has the power to evoke an emotional response and, in some instances, to provoke physical reactions. They can work individually or in unison, and exploiting their power enables

the photographer to affect the mood and emotion of the viewer. In photography, as in all forms of art, the elements of design are immensely powerful tools.

Line

Line is the most basic of the five elements and affects our basic responses. A line will lead the eye in its direction of travel, which can be used to dictate how the viewer proceeds visually through an image. For example, a horizontal line

draws the eye across the image space, typically in a left-to-right flow, accentuating space. A vertical line, however, leads the eye upward, emphasizing height.

Line is also associated with the horizon, and its position in the picture space determines the portion of the frame that receives the greatest emphasis. For example, when the

PHOTO © CHRIS WESTON

Compare these two images. In the first image, the horizontal format and the long line of the white wall in the foreground, move your eyes across the frame, from left to right. However, in the second image, the vertical line created by the structure of the lighthouse predominates and draws your eyes upward from bottom to top.

horizon line is positioned across the middle of the frame, equal weight is granted to both halves of the picture. This equality forms a natural balance that creates a feeling of serenity and stasis, an almost peaceful mood within the scene.

When the horizon line is lifted above or dropped below the middle, weighting and emphasis change. With a high horizon, emphasis is given to the foreground. Our eyes are led into the picture space, which creates a greater sense of depth.

PHOTO © CHRIS WESTON

With the horizon line placed in the middle of the frame, equal weighting is given to both halves of the picture space.

When the horizon is positioned in the lower portion of the scene, everything above it is accentuated, with the effect that the subject often stands out against the distant background.

The high placement of the horizon line in the coastal scene accentuates the objects and detail in the foreground (left). Conversely, where the horizon line has been placed low in the frame in the lake image (page 194), emphasis is greatest in the area of sky, drawing attention to the cloud formations.

Line and Visual Energy

When a horizontal line is enclosed within the confines of a frame, its energy extends sideways, drawing the eye along its line. Vertical lines insist that our eyes follow their journey from the foreground to the top of the picture space, accentuating height. Sloping lines create tension, their force fighting

to break the confinement of the enclosed frame, leading to a sense of dynamism, motion and visual energy.

The stark diagonal line of the wall in this image of a lighthouse creates dynamism and visual energy. Compared with the two photographs of the same lighthouse on page 191, you will notice how much stronger this image is.

Less dynamic than straight horizontal lines, curved lines nevertheless create a sense of visual energy, forcing our eyes to follow their route around the frame.

This image of a stack of sawn wood planks is full of energy, which is caused by the curved lines created by the round bundles.

Shape

Look at the following image, and note how many shapes are identifiable in the scene. Shapes are apparent throughout nature and evoke in us emotional responses. For example, triangles and polygons create a sense of strength and

This image is overflowing with shapes—the circles formed by the hand wheels and cogs, the semicircle mesh guard, the squares of the mesh itself, triangles in the cog teeth, and the triangle created by the angle of the steel girders, the long thin rectangle of the vertical girder, and so on. Shapes affect how we respond emotionally to a scene in the same way as all other elements of design.

stability, a form of permanence. Think of a pyramid—a solid, immoveable object. However, inverted, triangles lose their stability, becoming imbalanced as they stand precariously on

Note the combination of inverted and right-way-up triangles created by the shape of the cliffs, which adds to the tension and visual energy created by the rolling waves.

end. When viewed together in the same picture space, this conflict between balance and imbalance creates a tension that heightens visual energy.

Circles and spheres, on the other hand, contain their energy within, drawing attention to themselves. In this way, they are one of the more powerful graphic components and, when forming a background element, rather than being the principal subject, they must be used wisely to avoid taking over the picture.

This image, a composition of shapes and line and abstract in appearance, is actually a building in Morocco.

When two competing shapes are combined, visual energy is formed by the natural reaction of the eye, which cannot help but flit back and forth between the competing objects.

The circles created by the petals of this flower draw your eye into the center of the frame.

Compositionally, this can form a dynamic visual structure that radiates power. However, care must be taken to ensure that this dynamic strength doesn't distract the viewer from the primary subject.

In this image, the shape of the rectangular sign competes with the spherical garlic bulbs, causing the eyes to flit between them, thereby creating visual energy.

The Power of Color

Color is an immensely powerful element, having strong compositional and emotional overtones. It can be used simply to describe the surface appearance of an object, an obvious example being blue sky or green grass. More powerfully, color can be used to create visual illusions. For example, warm and cool colors can be used in combination to create a three-dimensional form and an increased sense of depth. Color also affects our emotions: Bright harmonious colors (e.g., yellow) suggest energy, joy and happiness, while jarring colors, such as crimson, may evoke a sense of danger, anxiety or alarm.

Mixing warm (yellow and red) colors with cool (blue) colors helps to create three-dimensional forms.

blue and orange, and yellow and purple. Combined in a photograph, these color pairings inject vitality and zeal into the composition. For example, red objects set against a green background will appear more vivid; the different wavelengths of red and green light cause our eyes to adjust focus, creating visual energy.

PHOTO © CHRIS WESTON

The crimson color of this thread in a Moroccan market evokes an emotional response.

One of the most important color relationships is shared between complementary pairs, which include red and green,

PHOTO © CHRIS WESTON

Combining pairs of complementary colors in a photograph will inject your images with vitality and zeal.

such as macro lenses, extension tubes, and bellows, enable photographers to isolate these subjects.

Texture in photography relates to visual texture, which is created by manipulating light in order to create an impression of texture, while the paper surface remains smooth. When used effectively, the appearance of texture will lend an image a three-dimensional appearance.

This image reveals the pattern in the underside of a leaf in a rainforest in Borneo. Pattern and texture can form the subject of an image.

Pattern and Texture

Not only can pattern and texture be used as elements within a composition, they can also form the subject of the image itself. This is particularly apparent in macro photography, where the high levels of magnification possible with equipment

Texture and pattern also play an important role in abstract imagery, where the idea that something identifiable must appear in the image is rejected, and instead internal structures are emphasized. Again, this is an area where macro techniques excel, although they are not essential.

> **Get into the Habit: Learning to See**
>
> Wyoming-based nature photographer, Jeff Vanuga, sees photography not as a technical process but an artistic one. "I think," he says, "that it's all too easy for photography enthusiasts to get caught up in equipment and technology. For me, photography is simpler. It is about shadows and light, shape and form and color. When I look at a scene, my instinct is to seek out the elements that together form our landscape—triangles, curves, lines, contrast, color that pops. The camera is simply a tool I use to put these elements together in a cohesive manner."

CREATING A SENSE OF DEPTH

Because a photograph has only two dimensions, depth must be created visually using depth indicators. Examples of depth indicators can be seen in the following sample images. For example, the convergence of lines is a clear indication that the wider spacing in the foreground is closer to the camera than the narrower spacing of the lines in the background. Overlapping foreground objects on top of background objects also creates the perception that the overlapping object is closer to the camera and the overlapped object farther away.

PHOTO © PAUL HARCOURT DAVIES

Macro specialist Paul Harcourt Davies used close-up photography techniques to isolate the patterns on the wings of this butterfly.

The converging lines of this pathway lead the eye into the picture space, creating a sense of depth.

Compare these two images. The image above is flat, lacking any sense of dimension. By standing farther back and using the lines in the pavement in the composition, I have created a sense of depth (left).

Overlapping foreground and background objects will create a sense of depth.

Earlier I stated that placement of the horizon line altered subject emphasis. In a similar way, the positioning of objects will create an illusion of depth. For example, objects in the bottom portion of the frame will appear closer than objects positioned higher up in the frame.

Including an object in the foreground of the image has created a sense of depth.

SIX RULES OF NATURE PHOTOGRAPHY ... AND WHEN TO BREAK THEM

The great American photographer Edward Weston (no relation) once said, "Consulting the rules of composition before

taking a photograph is like consulting the laws of gravity before going for a walk."

There are many rules in photography, all of which have a basis. But that doesn't mean they should be followed religiously. Learning why a rule exists and the effects of applying it enables you to appreciate the consequences of breaking that rule. In turn, this enables you to base your compositions not on the thoughts of others but on the personal story you are trying to tell.

Here are six of the common rules of photographic composition, along with the reasons you might want to break them.

The Rule of Thirds

No book on nature photography would be complete without mentioning the rule of thirds! The rule of thirds is a compositional tool, whereby the image frame is divided by equally spaced horizontal and vertical lines at one-third intervals (as shown in the following diagram).

Proponents of the rule claim that aligning a photograph so that the principal subject is positioned at one of the intersecting points creates more tension, energy, and interest than if the subject is positioned centrally.

Let me say first that the rule of thirds works. The principle behind it (the rule of thirds is a derivative of the golden

PHOTO © CHRIS WESTON

The lighthouse in this picture has been placed according to the much-vaunted rule of thirds.

mean, which is based on a mathematical formula) was used by ancient Greek and Egyptian architects in building design.

However, the rule of thirds also does something else. It opens up the picture space and helps to emphasize not just the main subject but also surrounding objects and detail. This is one reason it is popular in landscape photography, where the photographer often wants the viewer to see the entire scene.

But what happens if your aim is to isolate the principal subject from the background? In this instance, the rule of thirds works to the photographer's disadvantage because it opens up the background space. To isolate a subject within the frame, positioning the subject centrally will create a far better composition, not necessarily lacking in tension, energy or interest, as the next image shows.

Sloping Horizons

It is generally believed that a horizon should never be sloping. There is good reason for this. The horizon is our natural form of orientation. When we're lost, our first instinct is to seek out the horizon because it gives us a visual reference. Indeed, without a horizon it is very easy to become disoriented. I mentioned earlier in the book that my father was a pilot. Toward the end of his flying career, he was an instructor; the number of occasions that inexperienced pilots would end up flying their plane upside down after long periods without sight of the horizon was frightening.

Because it is our instinctive form of orientation, the horizon creates in us a sense of calm and composure. When we see it level in a photograph it evokes the same feelings. In a landscape photograph, this is typically a good thing, as landscape images tend toward harmony, tranquility, and serenity.

However, what if your aim is not peace and tranquility? A sloping horizon puts us off-balance because in nature the horizon is never sloping. To see it as such upsets our sense of well-being. If your aim is to create a sense of discord

PHOTO © CHRIS WESTON

Central placement of the subject doesn't mean that the image lacks tension or interest. Subject placement should be based on the objects you want to emphasize or isolate.

and imbalance, then it is entirely appropriate to slope the horizon. For example, consider the next two images. In the first, where the horizon is level, you feel a sense of quietude. In the second image, however, there is a strong sense of motion and energy. All that has changed physically is a slight twist in the orientation of the camera. However, the emotional change between the first image and the second is stark.

Compare these two images. The first image has a sense of tranquility, while the second is more dynamic. The only thing that has changed between them is the position of the camera, which I tilted around 30 degrees to slant the horizon.

Get into the Habit: On the Straight and Level

Landscape photographer David Tarn always uses a spirit level attached to the accessory shoe on the camera to ensure that the camera remains level. He says, "I find it essential, particularly when photographing a scene where one's instinct is to straighten an apparently sloping horizon, such as a curving shoreline of a lake, when to do so would alter the appearance, most times for the worse, of other elements in the scene. For me it is important to maintain a natural perspective. On a side note, when using a tripod in soft ground, such as sand, I always re-check the spirit level immediately before taking the picture, just in case one of the tripod legs has sunk, angling the head."

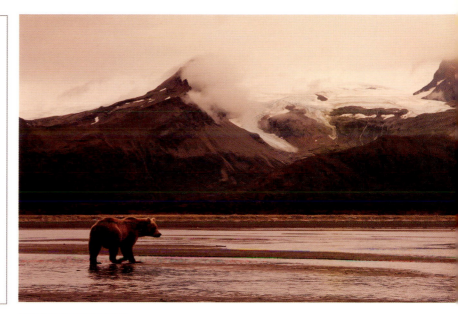

PHOTO © CHRIS WESTON

By using a wide-angle lens to include more of the surrounding detail, I have created a wildlife image with a very different appeal than a straight, frame-filling portrait shot.

Fill the Frame

The rule says that once you have determined the main subject, fill the frame with it and get as much detail as you can. Again, it is important to understand the effects of following the rule. When a subject fills the frame, it is emphasized and isolated from the background. The image becomes all about the subject and nothing else.

Reducing the size of the subject to include a larger portion of peripheral information changes the message the photograph relates. Consider the following example image: It would have been easy to fill the frame with the zebras but the resulting image would have been uninspiring. By standing back and including the wall of the caldera with the zebra so small, the composition becomes far more striking and the message very different.

Photograph at Eye Level

In wildlife photography, in particular, the general rule is to photograph the subject at eye level, making the image more engaging. This rule is based on psychology and relates to

theory that is referred to as the parent–child relationship: Parents look down at children and have control over them, while children look up at parents and are subordinate to them. (I have to say that as a parent of a four-year-old, I am beginning to doubt this particular theory!) This relationship is transferred to a photograph when an animal is photographed from significantly above or below eye level.

The theory goes on to say that when we communicate at eye level (adult to adult), the relationship changes to one of equal status. Neither party is submissive to the other. When applied to wildlife, this makes the photograph more engaging.

However, there are times when abandoning the rule works equally as well, such as when the aim of the picture is to instill a sense of power or evoke a feeling of inferiority. Indeed, one of my most commercially successful images was photographed looking directly down on my subject.

Flow Should Lead from Left to Right

Because in the Western world we read from left to right, there is a school of though that suggests we should design photographs with the same direction of flow. In doing so, the eye follows an inherent, natural course through the picture space.

PHOTO © CHRIS WESTON

This image, which defies the rules of photographing wildlife at eye level, is my best-selling print.

PHOTO © CHRIS WESTON

These are the same image, flipped in Photoshop. Note how the eyes' response to the two different compositions alters. In the first, your eyes follow the giraffe's line of sight out of the frame to the right. In the second, however, the eyes are led back into the picture space.

However, by reversing the flow, particularly when a subject is placed at the edge of the frame, the eye can be led back into the picture space, rather than being allowed to exit it. To illustrate the point, the next two images show how this works in practice.

Wait for Ideal Conditions

I lead a number of photo workshops every year and, unfortunately, I cannot control the weather. Occasionally, there are times when conditions are less than ideal. I look at the glum faces of my students, who I'm sure are wondering what on earth we're going to do with our time. I tell them, there is no such thing as bad weather. Every situation will lead to arresting images if photographed with a positive attitude. My attitude doesn't revolve around how I am going to keep dry or warm or from being swept of a cliff by the wind. Instead, I ask myself how I might use these conditions to my advantage. Two of my best-selling images—one a landscape and

the other a wildlife image—were photographed on two of the worst weather days I have ever suffered in the field.

Jeff Vanuga agrees. "I shoot with the weather, not against it," he says, when asked what he considers to be ideal conditions for nature photography. He continues, "In many ways the digital medium has brought us 24/7 photography. I shoot through the night, in all conditions, using whatever light is available, including moonlight. When I look back on some of my favorite images, many of them are shot on days when most people would stay indoors."

The moral of this story is that all conditions are ideal, just maybe not in the way you'd originally imagined!

PHOTO © CHRIS WESTON

This image, which has appeared on the cover of a book and has sold numerous art prints, was taken on one of the worst weather days I have ever experienced in the field.

CAPTURE THE MOMENT (PUTTING EVERYTHING INTO PRACTICE)

Much of what has been discussed thus far in the book was concentrated on the theoretical aspects of photography: the need for planning, the importance of knowing how your camera works, being able to read a scene with a photographic mind, and how to apply camera controls in order to compose and record a scene as you visualize it.

The next and most important habit to adopt is putting all the theory to work where it matters most—out in the field.

WHAT MAKES A COMPELLING IMAGE?

Photography is a communications art form. When you make a photograph, you are in effect saying to the person or persons who see it: "This is what I have to tell you about this place, or about this subject." As a photographer, you are also a storyteller.

Like all stories, your photographs can be fictitious or documentary. Either way, the messages they send should be unambiguous, devoid of distracting and erroneous subplots. They should be educational, entertaining, or both, telling us facts we didn't know or eliciting an emotional response—laughter, happiness, joy, sorrow and so on.

And, they should be interesting, have something relevant to say that hasn't been said before, or at least say the same thing in a new and different way. For example, if I were to tell you a joke you'd heard a thousand times before, you'd almost certainly groan. Why? Because the joke probably wasn't funny in the first place, it certainly isn't funny the thousandth time around. The same is true of photographs. If you photograph a scene or subject the same way as thousands of people before you, when you show that photograph, what do you think the common response will be?

So, the answer to the question, "What makes a compelling photograph?" is: You do, if you tell your story visually in a clear, concise, different, revealing and evocative way.

TWO QUESTIONS TO ASK BEFORE PRESSING THE SHUTTER

There is hardly a subject left on earth that has never been photographed. There are many that have been photographed literally millions of times (e.g., the Grand Canyon, the Empire State building, the Eiffel Tower, Sydney Harbor). Therefore, devoid of completely new subjects, we must learn to photograph things in new and compelling ways.

There is a technique that I use to try and ensure my photography remains compelling, even after the many years I've enjoyed taking pictures. Before even beginning the process of framing an image in the viewfinder, I ask myself the

I photographed this image while leading a photo safari in Zimbabwe in 2007. We were sitting at a waterhole watching the wildlife come and go. Off to one side, this family of giraffes was milling around. On the face of it, there was nothing particularly interesting to photograph and most people soon gave up. I decided to experiment. Rotating the camera during exposure, keeping the giraffes at the central axis, is what creates the effect. The result won't be everyone's cup of tea. Some like it, some don't. However, it *is* different and I sold it as an art print during a recent exhibition, so it can't be all bad!

question, "How can I photograph this scene differently?" I often practice this aspect of the technique when leading a group of photographers. By watching what each photographer is doing, I can fairly easily gauge the image they are making. I then ask myself the question, "How would I do it differently from this person?" Indeed, on most of the longer photo safaris I lead, I typically spend at least one day where I photograph alongside the group and then show the results on-screen at the end of the day, comparing how I visualized the scenes we encountered with how others saw them. I don't do this to boost my ego. I do it simply to reveal how the same subjects can be interpreted very differently through different individuals' eyes.

The second question I ask before pressing the shutter and while looking through the viewfinder is, "How will I caption this image?" Essentially I am asking myself, "When I get back to the studio to edit and process this image, what caption will I enter into the metadata?" If the only answer I can conjure is the name of the place or species, I won't waste my time making the photograph. This is a record shot, and there are more than enough of those in the world.

It's worth mentioning that I try not to take too long over this second question, in case by the time I come up with an answer, whatever I was photographing has long since disappeared from view!

DEFINING YOUR SUBJECT

In order to manufacture something, it is essential for the end product to be a known quantity. After all, it would be pretty silly to go to the expense of designing, building and equipping a manufacturing plant if the nature of the product to be made was unknown.

The same theory applies to photography. If you don't know the subject of the photograph, how can you begin to decide what equipment and techniques will be needed to make it, and how it should look? Defining your subject, then, is the very first part of the photographic process.

At first glance, the nature of the subject may seem obvious. After all, a cheetah is a cheetah, isn't it? A mountain is a mountain. But to think in such simple terms is to limit the ambition of your photography. For example, refer to the

PHOTO © CHRIS WESTON

As an exercise, look at this photo and think of as many captions as you can. How many did you come up with? Before pressing the shutter, I ask myself the question, "How would I caption this image?" When the only answer to that question is the species or object name, I don't bother to take the photograph, choosing instead to wait until a more compelling moment occurs.

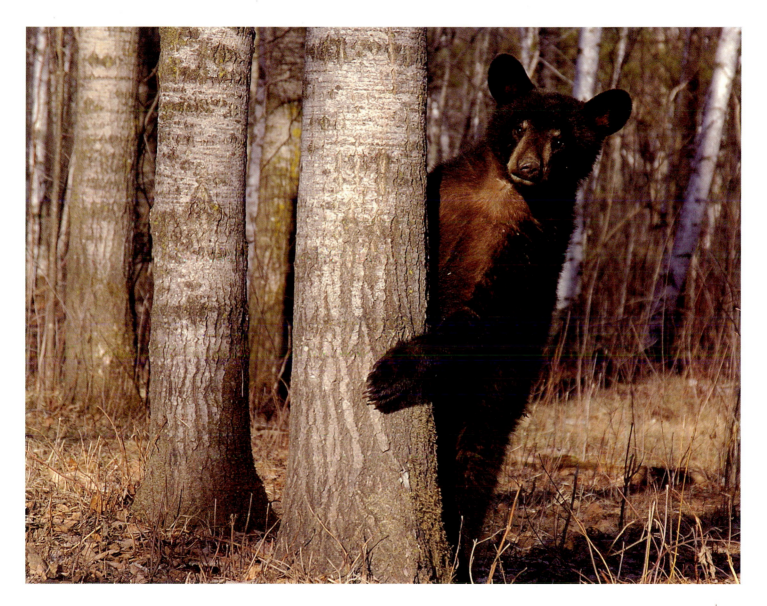

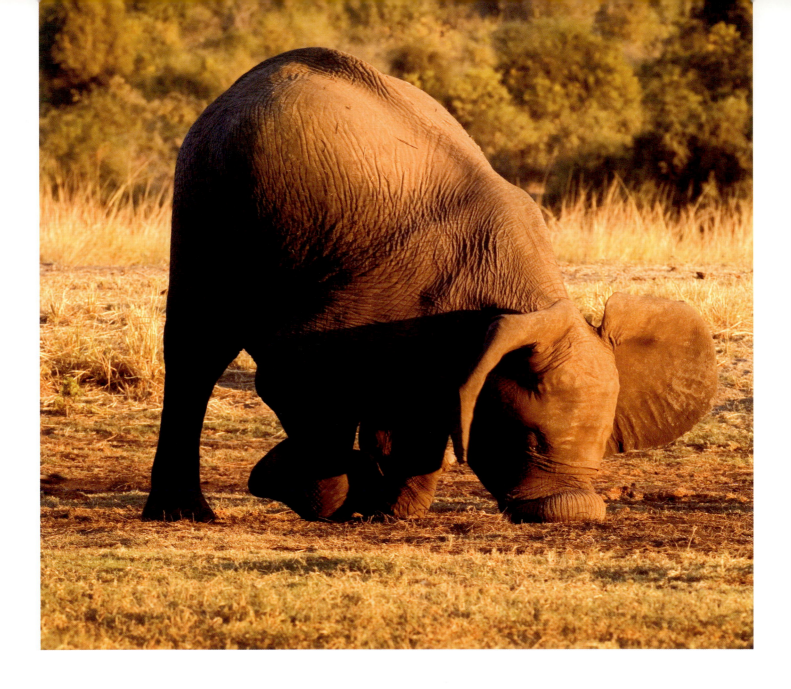

image of the hippopotamus (page 221). The literal subject of this image is "hippo." But that's not what I saw when I made this photograph. It was a particularly miserable day, overcast and very low light. What struck me, then, as I contemplated abandoning the shoot for the day, was the shape of the hippo's head and the texture on the crown of its head.

The subjects of this photograph are shape and texture, and I chose my equipment, camera settings and composition based on revealing these two aspects of the animal. Some obvious visual elements stand out. First is the high-key effect, created by overexposing the light background to remove detail in the water, which has the effect of isolating the animal and removing the context of habitat. Second, by shooting in

black-and-white (B&W) mode, I have removed color, which helps to accentuate the remaining design elements—shape and texture (line and pattern are not present).

I talked about another example of defining your subject on page 19, where I used a slow shutter speed to blur the motion of a herd of wildebeest to create a sense of movement. Movement was the theme and subject of the images, which were photographed during the great wildebeest migration in Africa.

Defining your subject, then, is a step in the process of creating compelling images. By using your imagination and thinking outside the box, it is possible to conjure themes and ideas that fit the requirements of compelling images.

Shooting in B&W Mode

Not all digital cameras have a B&W mode (it's usually found in the image optimization menu). Even if your camera does, it is advisable to shoot in normal (color) mode and make any transition to B&W using image-processing software, such as Photoshop, which has the advantage of more extensive control over tone mapping. In the example of the hippo image, I used the function on the camera specifically to fit the rules of a competition for which the image was intended.

THE MAKING OF 15 BEST-SELLING IMAGES

The remainder of Habit 6 is given over to describing the specific techniques used and the individual approach employed in making a series of compelling images.

Near the end of a long day in Africa, I stopped at a well-known waterhole close to camp. I had visited the location several times in recent years and knew exactly what to expect. To be honest, I was there as much for the experience and enjoyment of the moment as I was for photography. The light was poor, a combination of a setting sun and overcast weather, and I didn't expect to get anything new image-wise.

I noticed a hippo loitering close to the edge of the waterhole. I had never really paid much attention to hippos' heads before, but since that was all I could see I began to notice the contours created by the bone structure, and the coarseness of the skin. The idea of shape and texture took hold and I picked up the camera.

I decided to shoot in black and white mode, the extraction of color helping to emphasize the other design elements. To give further prominence to the head, I used a high-key effect by overexposing the light-toned water, thereby removing distracting detail to isolate it from the background. This was achieved by taking a meter reading for the water and overexposing the recommended EV by 1.5-stops,.

To finish the shot I fine-tuned the level of contrast using Photoshop.

Shooting information: spot metering, manual exposure, 1/250 second at f/5.6, ISO 400, focal length: 600 mm.

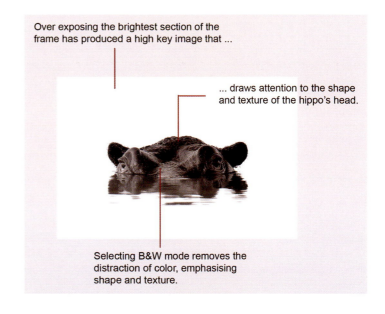

Over exposing the brightest section of the frame has produced a high key image that ...

... draws attention to the shape and texture of the hippo's head.

Selecting B&W mode removes the distraction of color, emphasising shape and texture.

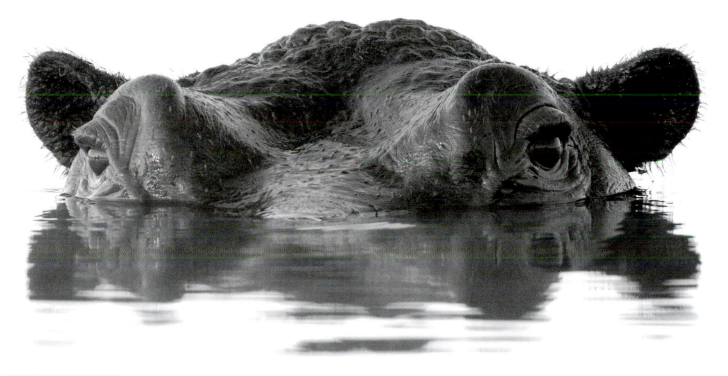

For me, lighthouses are buildings of the night—that is when they come to life. And so I resolved to make this a night shot. I specifically chose a night when the moon was full and timed my visit to coincide with the moon being positioned to the left of the structure, as seen here. This would throw light onto the side of the tower, creating shadows that add form and dimension.

I used a sturdy tripod to ensure that the camera remained steady throughout the long exposure, and framed the scene to create a dynamic composition, largely a result of the stark diagonal line created by the foreground wall.

Calculating exposures for this type of photography is always subject to a certain amount of guesswork, but I had done some experimentation in preparation and knew that an exposure of around 30 minutes was required. In the end I took two shots, bracketed 1-stop.

Shooting information: spot metering, manual exposure, 30 minutes at f/22, ISO 100, focal length: 90 mm.

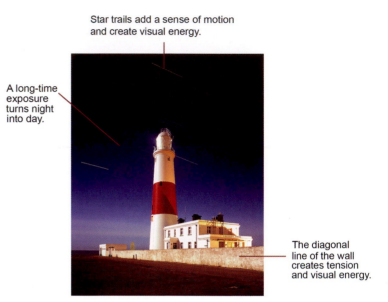

Star trails add a sense of motion and create visual energy.

A long-time exposure turns night into day.

The diagonal line of the wall creates tension and visual energy.

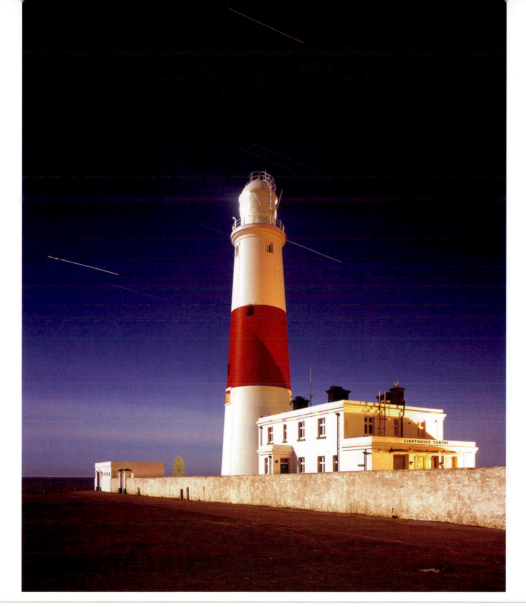

Portland Bill lighthouse on the World Heritage Site–designated coast of Dorset is one of the most photographed buildings in England. So when I was commissioned to shoot a series of images for a calendar, it became a test to see whether I could photograph it differently.

What I find most striking about this scene is the very apparent figure-8 shape of the twin bays, which, photographically, produces a strong, graphic composition. So, when framing the scene, I concentrated on making this central to the image. In design, circles are used to contain life and the effect is similar in photography, in that they draw attention into their center and hold it within.

The shot was made at 1:00 AM. I set the camera on my sturdiest tripod and shielded it from the buffeting wind. I used a spirit level attached to the camera's accessory shoe to ensure that the horizon was level, and based my exposure on previous experiments, setting the camera to bulb and manually timing a 30-minute exposure. I fired the shutter with a remote cable release.

Earlier experimentation and testing also revealed that under moonlight conditions, setting white balance to a Kelvin value close to the pre-set fluorescent setting intensifies the blue of the sky. In this instance, I set a Kelvin value of 4,200.

Shooting information: spot metering, manual exposure, 30 minutes at f/22, ISO 100, focal length: 24 mm.

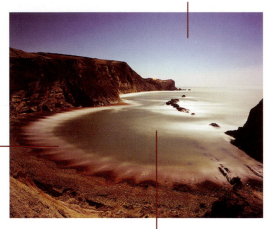

This landscape scene is lit entirely by moonlight.

A long-time exposure gives the ebbing tide an ethereal feel.

Notice the figure-8 shape, which draws and holds attention to the centre of the frame.

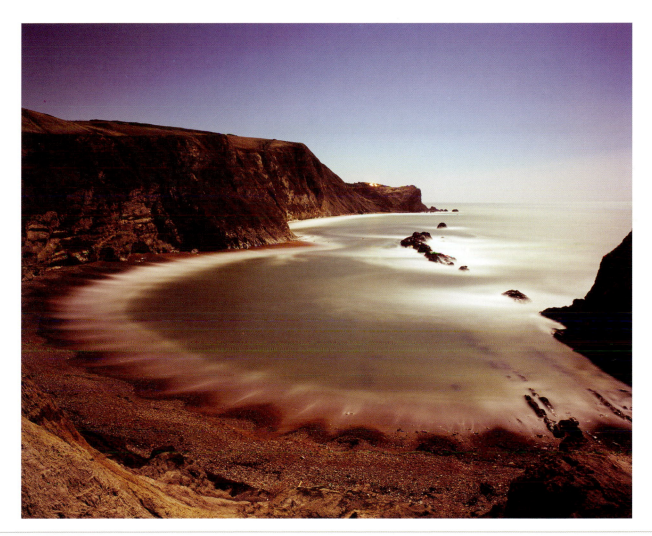

PHOTO © CHRIS WESTON

I find moonlight to be a beautiful source of light for photography. It is direct yet soft, which creates some interesting photographic effects. This image forms part of a set of my local landscape that I produced for a 2007 assignment, and is an example of how to look at common scenes and objects in new and different ways.

Over the past couple of years, I have been working closely with a lion rehabilitation center in Zimbabwe. As part of the rehabilitation program, every morning the lions are walked on the open plains of a wildlife reserve and I had the good fortune to accompany them. Toward the end of this particular exercise session, the three lions we were accompanying grew tired and rested on a nearby rock outcrop.

Being so close to animals that are more often seen from a distance provides one with an opportunity to study their features more closely. I was particularly taken with the pattern and texture of the lion's whiskers and wanted to make this the subject of my image.

I chose a medium focal-length lens to crop tightly on the area of the mouth and to remove distracting detail from around the scene, and selected a wide aperture to minimize depth of field. The resulting narrow zone of sharpness isolates the pattern of the whiskers from background detail, leaving little doubt as to the subject of the image. However, I chose to include the nose within the frame to give the image context.

Shooting information: multisegment metering, aperture-priority AE, 1/320 second at f/2.8, ISO 200, focal length: 200 mm.

A very tight crop, using a medium focal length lens at close range ...

... accentuates the pattern and texture of the lion's jaw.

A wide aperture minimises depth-of-field, drawing attention to the lion's whiskers.

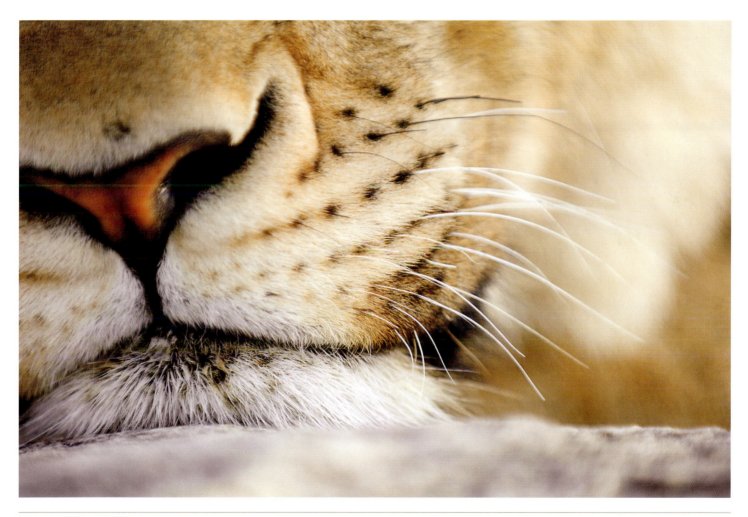

This is one of my favorite pictures of 2007 and has been a best-seller commercially.

To get such an unobstructed view meant clambering through some dense bush away from the main tourist track that follows the line of the falls toward the Zambian border. It was worth the effort, as I emerged from the undergrowth to be greeted by this stunning scene.

In order to capture the sheer power of the falls, I selected a fast shutter speed, so that detail was captured in the cascading water. To the left of the scene, sunlight highlights the swirling mist out of which leaps one of the myriad rainbows lining the length of the chasm. I enhanced the vividness of the rainbow with the use of an optical polarizing filter.

Shooting information: spot metering, aperture-priority AE, 1/125 second at f/8, ISO 200, focal length: 42 mm.

Polarizing filter enhances the vivid colors of the rainbow.

Fast shutter speed captures the frenzy of the tumbling water.

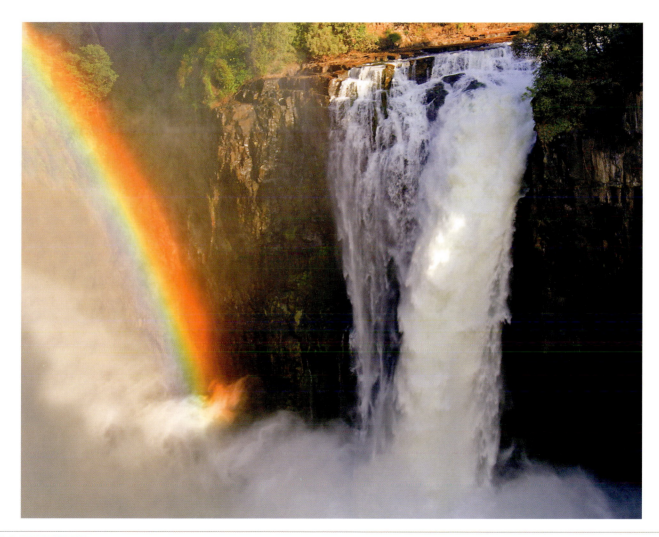

Most people today see Victoria Falls from the Zambian side, preferring to avoid the current turmoil in Zimbabwe. However, arguably the better views of this wonder of the natural world and the best photographic opportunities are in Zimbabwe, and it is in Zimbabwe that this image was captured.

Motion blur to depict a sense of movement is one of my favorite styles of wildlife photography, and I resorted to this technique here. Avocets spend much of the time on the move, wading in shallow water with heads bowed in a search for food, aided by their long, curled bills.

Initially, I needed to isolate an individual bird—not easy when there are over 1,200 grouped closely together on a small lagoon. Having located a suitable subject, I selected a slow shutter speed and used a panning technique that I have practiced and developed over the years, which involves panning the camera at a speed only slightly faster than the subject is moving.

The effect is to create two degrees of blur: heavy background blur, caused by the fast motion of the camera against the static background, and a gentler blurring of the subject, created by the relatively slow pan of the camera in relation to the movement of, in this case, the bird.

The result is an artistic interpretation of the subject that sets the image apart from documentary and straight portrait images.

Shooting information: spot metering, aperture-priority AE, 1/20 second at f/24, ISO 200, focal length: 800 mm.

A slow shutter speed blurs the appearance of movement ...

... creating an artistic interpretation of the moment.

PHOTO © CHRIS WESTON

Having spent the best part of three days photographing avocets from a hide, I was beginning to wonder just how many more shots of these birds I needed. To pass the time, I decided to indulge myself with a few experimental techniques.

My son and I were there one Sunday afternoon with a bag of stale bread when I noticed how the seagulls would scatter in mad flight and swoosh down to take food from the hand. As I watched them, I formulated an idea.

Leaving my son with my wife, I rushed home and grabbed the camera bag, making sure that the flash was packed. Back at the reserve, I chose a wide-angle lens to ensure that the bird had enough room within the frame and so as not to clip a wing tip. I then set the camera to slow-sync flash mode and set a shutter speed of 1/30 second. The idea was to use the flash to freeze the motion of the bird while capturing an element of blur in the rapidly moving wings, which would give the image a more dynamic and energetic feel.

Additionally, using the experience I'd gained from my project photographing the landscape in moonlight, I set WB to the fluorescent pre-set value, knowing that this would cause the sky to take on a blue cast, as opposed to its natural dull-gray color.

All that was left was to convince my wife to suffer the sharp pecks as I waited for the perfect photo moment.

Shooting information: center-weighted metering, shutter-priority AE, 1/30 second at f/11, ISO 100, focal length: 22 mm.

Selecting the Fluorescent pre-set White Balance option has altered the color of the sky, giving it it's blue cast.

Slow-sync flash freezes the motion of the bird in flight ...

... but enables the wings, which are flapping faster than the speed of the flash, to remain slightly blurred, creating a sense of motion.

About five minutes from my house is a Royal Society for the Protection of Birds (RSPB) nature reserve, one of the largest natural reed beds in the UK and a haven for birds of all varieties. I like to take my young son there to feed the ducks and get him involved with nature.

Selecting a white balance setting of shade (similar to adding a strong 81-series "warming" filter) has enhanced the warm glow of the early morning light. For the exposure, I spot metered the quarter-tones (top left of the image) and applied plus 1-stop exposure compensation to keep tonality true. I fine-tuned contrast levels using Photoshop to darken the shadow areas, keeping true to my digital mantra: Expose for the highlights, process for the shadows.

When I visualized this scene, I saw it as a panoramic, and so, when composing the image in camera, I did so with a view to cropping the image in-computer. The skill here was to ensure that the area of the scene I wanted included was positioned accurately in the frame.

Shooting information: spot metering, aperture-priority AE, 1/160 second at f/5.6, ISO 100, focal length: 200 mm.

The color of the early morning light is enhanced by selecting the Shade pre-set white balance option.

The image has been cropped to create a dramatic panoramic-format image.

PHOTO © CHRIS WESTON

In Africa, during the winter there is a window of perfect light that lasts from around 6:45 to 7:05 in the morning. This shot was taken (according to my camera) at 6:58 AM as I was driving in Kruger National Park in South Africa.

It was the sense of alarm, of mass panic, that I wanted to capture. A fast shutter speed would have failed to reveal the sense of chaos that ensued when the birds took flight, and so I selected to use motion blur and set an appropriately slow shutter speed. As it was difficult to predict what the birds would do, I also set the camera to continuous shooting at five frames per second. To enhance the sense of panic, I purposely chose a tight crop, selecting a medium focal-length lens, visually caging the birds within the frame.

When the moment came, I fired a burst of five frames, of which this, the second of the five, is the best.

Shooting information: multisegment metering, shutter-priority AE, 1/90 second at f/5.6, focal length: 180 mm.

A tight camera crop focuses attention on the movement of the birds.

Timing is everything, to reveal the patterns visible in the markings on the feathers and to capture the vivid color of the beaks.

A slow shutter speed blurs the motion of the birds' wings as they scatter in flight.

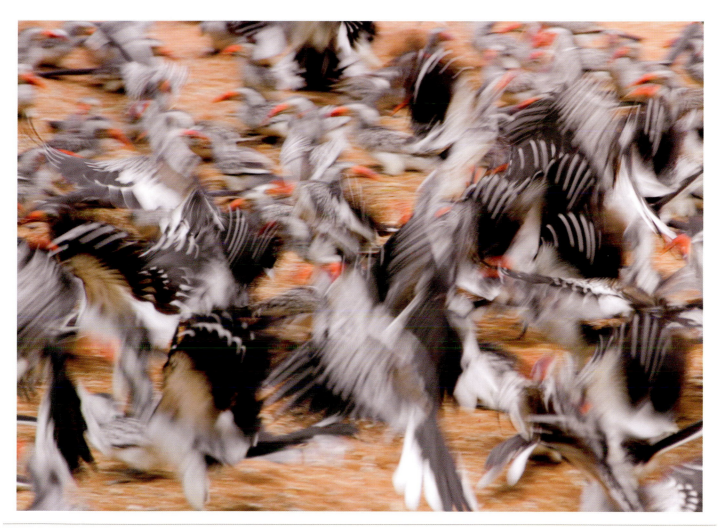

PHOTO © CHRIS WESTON

Red-billed hornbills, or flying chilies, as they're affectionately known, are common in southern Africa. At this particular location, there were literally hundreds, mostly scrabbling along the ground seeking morsels of food. But any unfamiliar sound would set them scurrying for the safety of the air, before they settled again.

First of all, I needed the fastest shutter speed I could muster. To achieve this, I simply set the widest aperture that my lens allowed and cranked up the ISO value to 400. With this particular camera (a Nikon D2X), I prefer to avoid using ISO values above 200, but for this shot, needs dictated otherwise.

The lens was my favorite Nikon 200–400-mm AF-S telephoto zoom, very fast and, with vibration reduction switched on, possible to hand-hold.

For focusing, I used a makeshift version of a kind of auto-predictive focus, which I practice regularly with moving wildlife. First, I anticipated the point at which I'd make the exposure and framed the scene accordingly. Carefully watching the cheetah move into the space I'd framed, I waited until the final moment before activating the AF motors. Had I done this earlier in hopes of using AF tracking, the camera's AF system would simply have been too slow to keep pace with the animal.

At the point I wanted to make the image, with the AF-target sensors carefully positioned on the cat's eyes, I activated AF and fired the shutter simultaneously. It's a precision technique, as the second and subsequent shots are nearly always blurred.

Shooting information: spot metering, aperture-priority AE, 1/2,000 second at f/4, ISO 400, focal length: 400 mm.

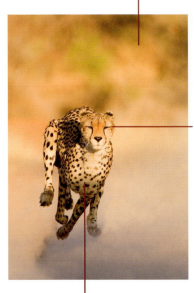

A long focal length lens and narrow aperture blur background detail, emphasizing the subject.

Focus point is positioned on the cheetah's eyes.

A fast shutter speed freezes the motion of the sprinting cheetah.

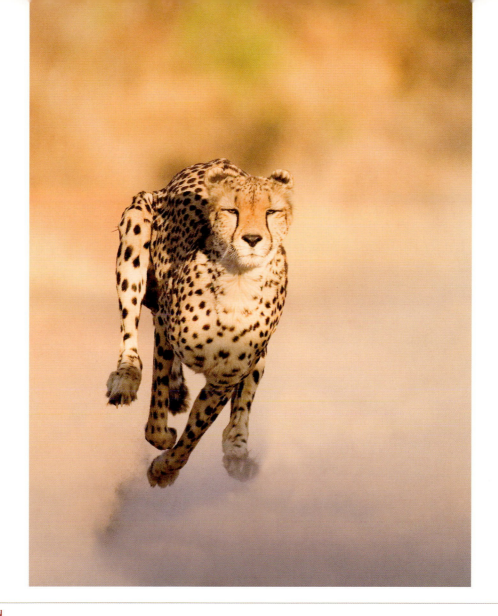

Capturing a sharp image of a cheetah in mid-sprint is one of the most challenging tasks in wildlife photography. The sheer speed of the world's fastest land mammal, coupled with the erratic manner in which these big cats cover ground, present all sorts of difficulties that a photographer must overcome.

The most important aspect of this image, something critical to its success as a photograph, is the composition. The location is a forest in the Scottish Cairngorms, and it's the autumn season. Despite the simplicity of the image and the apparent randomness of the site, I spent several hours scouting the area until I found what I was looking for.

The secret to this image is the gap in the trees at the back of the woods, about four-fifths of the way across the frame. This space provides a visual corridor into which the eyes wander, leading the viewer directly into the forest and through the picture space. To the left of the gap, the prominent trees add to the sense of depth, an effect created by the gentle darkening of tone the deeper into the forest you travel.

Panning the camera during exposure in a vertical orientation has given the finished image a more ethereal and artistic look, while the vertical framing accentuates height and adds to the sense of perspective.

Shooting information: multisegment metering, aperture-priority AE, {1/2} second at f/16, ISO 100, focal length: 95 mm.

Panning the camera vertically during exposure creates an artistic rather than literal image.

Vertical frame orientation accentuates height.

The gap between the trees - converging lines - draws the eye into the scene.

On the face of it, this is simply an image made using a well-known technique of vertically panning the camera during exposure. However, there is far more to it than that.

When the birds come into land they have to run a gauntlet of baying residents who will protect their own spot of ground from any would-be intruder. This behavior makes the whole process a fascinating spectacle to observe, and to photograph.

Finding a suitable position to photograph this spectacle is not difficult on Bass Rock. Trying to isolate a single bird from the thousands that speckle the sky is challenging. The white specks around the tail of the bird in the picture are not loose feathers, as they at first appear, but are far-off gannets.

Once the scene is set, the rest is down to camera technique. A fast shutter speed freezes the movement of the bird, which I have framed carefully to include the reaction of the birds on the ground. In the bright sunlight, metering for the predominantly white birds was challenging. I decided on center-weighted metering and adjusted the exposure using the compensation function on the camera.

For focusing I had the camera set to continuous-AF and dynamic AF-area mode, and allowed the camera to track the bird as it came into the frame. I fired a burst of three images, of which this is the best.

Shooting information: center-weighted metering, aperture-priority AE, 1/4,000 second at f/4, ISO 200, focal length: 55 mm.

A fast shutter speed freezes the movement of the gannet' flight.

Note the level horizon line.

The inclusion of the birds in the lower section of the frame reveals information about the behaviour of these birds.

The Bass Rock in Scotland is one of the world's most important seabird colonies. Every year around summer the Rock is teeming with literally thousands of gannets packed densely into every square foot of available natural real estate.

The location is the Ngorongoro Crater in Tanzania, a wildlife haven. The crater is formed from a collapsed caldera, the walls of which are over 600 meters high. Sitting in my safari vehicle at the base of the crater, it is quite an experience and it was this sense of scale and perspective that I wanted to capture.

Referring to the text on defining your subject (see Habit 1), this is another perfect example of this rule at work. My subject for this image is not zebra or wilderness, but rather perspective. The shot was relatively easy to make. By positioning the zebra low in the frame, I have ensured that emphasis is given to the upper portion of the picture space, which accentuates the feeling of height. The smallness of the zebra—a subject whose size we can associate with—is what gives the image its perspective.

Shooting information: multisegment metering, aperture-priority AE, 1/400 second at f/8, ISO 200, focal length: 190 mm.

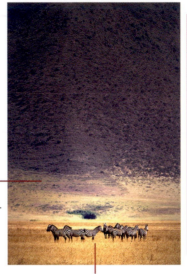

Vertical frame orientation accentuates the height of crater wall.

Overall, the composition creates a sense of place.

Positioning of the zebras emphasizes the upper portion of the image space.

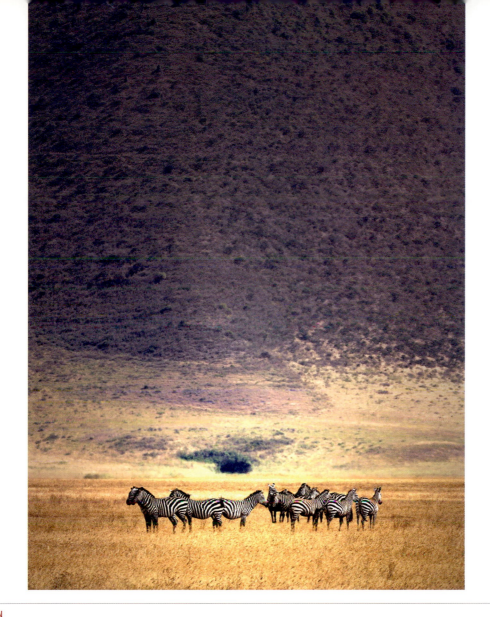

It would have been so easy to crop tightly on the zebra at the bottom of the frame of this image and create a standard record shot of a herd of zebra in Africa. A little thought, however, transformed the image into one of my best-selling art prints.

Having visualized the image in the UK, when I arrived in Alaska I knew exactly what I was looking for and headed straight out to try and find it. True to my belief (that it is easier to find a picture when you know what it is you're looking for), I bagged the shot on the first day.

Several aspects of the image are critical to its success. Perhaps most importantly is the relationship between the bear and the viewer, which is intensified by the eye-level perspective. A fast shutter speed has frozen the movement of both the bear and the splashing water, adding a sense of real drama. Finally, the focus point was critical, and I used the continuous AF function of the camera with a manually selected single AF-point focused directly on the right eye.

Despite appearances, the bear, which looks intent on charging straight for me, is barely aware of my presence. Instead, he is far more interested in the salmon underfoot, which comprise most of his diet at this time of year.

Shooting information: multisegment metering, aperture-priority AE, 1/250 second at f/8, ISO 100, focal length: 800 mm.

A wide aperture blurs background detail, effectively removing distractions from the frame.

Getting down to eye level adds to the intensity and drama of the moment.

A fast shutter speed freezes the movement of the bear and the splashing water.

Central positioning of the bear isolates it from the background, drawing and holding ones attention.

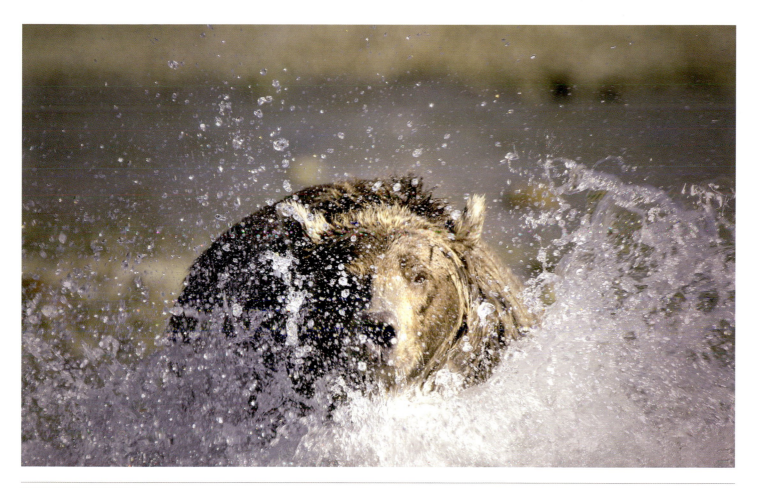

PHOTO © CHRIS WESTON

On my third visit to Katmai National Park in Alaska, this was the image I went to shoot. Having already spent two seasons with the bears, I was getting to know their behavioral traits and I conceived the idea for this image in my office at home.

The most challenging aspect when composing this image was to get the camera in a position where enough of the standing stones are visible for their purpose to become apparent. In all, I spent around an hour just setting the shot and maneuvering the camera through every conceivable angle.

The prominent stone in the foreground is critical in that it not only adds a sense of drama but also is the basis for adding depth and perspective. Timing was also critical and evening side lighting adds not just warmth but form and a sense of three dimensions.

Technically, depth of field is the key component of the image. It was essential that every stone from foreground to background be sharp. I used a depth-of-field and hyperfocal distance chart for my 24-mm lens in order to calculate the focus point, which is positioned approximately at the right of the base of the foreground rock. To finish the image, the light scattering of clouds adds interest to an otherwise dull sky.

Shooting information: spot metering, manual exposure, 1/30 second at f/32, ISO 100, focal length: 24 mm.

Clouds add interest to the sky.

The prominent foreground object is striking, adding drama to the scene and creating a sense of depth.

A wide-angle lens and narrow aperture help to maximize depth-of-field.

This image is all about depth and technique, and was shot at a disused quarry that has been turned into a minor tourist attraction close to my home in Dorset.

PRACTICE (MAKES PERFECT)

Imagine how good a golfer Tiger Woods would be if he never practiced his strokes. Making great photographs is a skill; more precisely, it involves a series of skills—calculating exposure, focusing, camera handling, and composition, among others. The more you practice these skills, the better photographer you'll be.

Of course, time and motivation play a significant part, especially when it's not your job. I, for example, am a very poor golfer, not because I am incapable of hitting a small ball with a big stick but because I have little inclination to do so and much less time to practice. I am a better cyclist because I enjoy riding a bike. However, I'm not as good as I could be because I don't do it often enough.

To become good at photography requires a level of regular input. Few photographers espouse this point better than Heather Angel, the doyen of British nature photography, who, every day of the year, will pick up her camera and take a photograph. It doesn't always matter of what, nor will she necessarily keep the photo she takes. It is simply the practice of picking up her camera and using it that exercises her photographic mind and maps her muscles to the practice of photography.

When photography must fit in around work commitments, family responsibilities and social needs, it can be difficult to give it the attention you'd like. So, in this final section of the book, I have mapped out an exercise plan that I hope will keep you motivated and inspired, and encourage you to do what photography is really all about ... and that is, to take pictures and lots of them!

ARMCHAIR EXERCISES TO KEEP YOU PHOTOGRAPHICALLY FIT

For the times it's impossible to get outdoors, you can still practice your photography sitting in the comfort of your armchair:

Exercise 1: Weapons Training

Have you ever seen one of those movies where army recruits are taught to dismantle and rebuild a weapon blindfolded? Well, this is the photographic equivalent.

With your camera in hand, identify the common controls that you use all the time. These are likely to be but are not limited to shutter speed and aperture adjustments, ISO setting, exposure compensation, focus mode, metering mode, selection of the active AF sensor, and drive mode.

In turn, practice using them to adjust their relevant values. For example, in which direction do you rotate the command dial to increase exposure? Is manual focus mode switch

up or down? How many clicks and in which direction do you rotate the command dial to set plus 2-stops exposure compensation?

Once you've tried this a few times and think it's fixed in your mind, think of a setting and a value and try to set it exactly, with your eyes closed.

This exercise may seem obsessive, but it's what I do every time I acquire a new camera body because knowing how to use the camera instinctively is often the difference between getting the shot and the proverbial one that got away.

Exercise 2: Get into the Deconstruction Business

This one is less likely to have friends and partners thinking you've gone around the bend.

Pick up a photography picture book, something you're likely to find on a coffee table, as opposed to a how-to book. The subject is irrelevant, but it's probably best to start with one that covers a subject you're interested in.

Choose an inspiring image. Now, following the technique described in Habit 5 ("Designing a Photographic Image"), deconstruct the image and try to define how the photographer took the picture. Where did the photographer stand? What lens was chosen? What are the direction and quality of light? How was the image composed? What influenced the composition? In essence, what makes this image a success?

Never stop deconstructing other photographers' images. It's a great way to learn the fundamentals of photography.

Exercise 3: The Time Traveler

One of the problems with digital photography is that we've learned to be judge, jury and executioner with our work. We've become slaves to the little button with the trashcan icon on it. But here's the thing: Every time you delete an image, you're throwing away vital information, information that will make you a better photographer.

Every one of those images tells you how not to take an image. And, every time you learn how not to do something you are one step closer to learning how to do it successfully. Someone once asked Thomas Edison whether he felt like giving up the thousandth time he failed to invent the light bulb. "I didn't fail a thousand times," he replied. "I simply found a thousand ways it didn't work." There's a lesson for us all in that statement.

So it's time to be your own worst critic. Select a half-dozen images that you are inclined to delete. Using the same deconstruction techniques used in Exercise 2, look at each of

the selected images and note what you would do differently. What would you change if you were able to go back in time?

Exercise 4: The Film Critic

Here's an excuse to sit in front of the TV and watch your favorite movie.

1. Play a DVD of a film or television drama.

2. At a random moment, press the pause button.

3. Look at the scene and ask yourself the following questions:
 - How is this scene lit—from what direction and angle, hard lighting or soft?
 - How are the characters composed?
 - To what lens aperture is the camera set?

No film or TV production is put together on a whim. Everything you see has been carefully choreographed and meticulously planned for creative effect. See if you can work out what decisions the director made.

TEN PHOTO WORKOUTS TO GET YOU SHOOTING LIKE A PRO

The following workouts are designed to develop both your technical and creative skills.

Workout 1: White Balance

This one is more specific to users who prefer to shoot in JPEG mode, but is useful to understand even for RAW shooters.

1. For the purpose of the exercise, set your camera to RAW image mode.

2. Set the WB setting to auto-WB.

3. Photograph a scene outdoors (the subject is largely irrelevant).

4. Open the RAW file using RAW conversion software, such as Adobe Camera Raw (ships with Photoshop) or the proprietary software that came bundled with your camera.

5. Using the WB drop-down menu, click through each of the WB options and note the effect on the image.

This will help you to visualize the effects of the different WB settings and will aid visualization (see Habit 1).

Workout 2: Gray Card Test

This is a great one for visualizing exactly how a camera's light meter works.

1. At an art store, buy three pieces of A4-size card, one white, one black and one medium gray.

2. On an overcast day (for even lighting), place each piece of card flat on the ground.

3. On your camera, set metering mode to center weighted or spot metering and exposure mode to aperture priority (A or Av). Set a mid-range aperture (the actual aperture value is unimportant).

4. Frame each piece of card in turn so that it fills the frame and take an image.

5. Review each image using either the camera's LCD monitor or a computer. Note how each image looks roughly the same shade of gray.

6. Now re-shoot the cards, this time applying plus 2-stops exposure compensation for the white card and minus 2-stops exposure compensation for the black card. Set ±0 exposure compensation for the gray card.

7. Review each of these new images and note the difference in tone.

Workout 3: The Water Test

This is a useful exercise to gauge how different shutter speeds affect the appearance of motion.

1. Find a water tap in plain sight. Set up your camera on a tripod in the vertical format. Turn on the water and frame the image so that the flowing water fills most of the frame.

2. Set the camera to shutter priority (S or Tv) mode.

3. Starting at a shutter speed around 1/1,000 second, take an image of the flowing water.

4. Reduce shutter speed in 1-stop increments to a value around 1 second, taking a new image for each new shutter speed. This should produce 10 exposures.

 (Note: If the level of light is too low or too bright to set the necessary shutter speed, try adjusting ISO to increase or reduce amplification.)

5. Review the exposures on a computer and note how the effect of the water changes from image to image.

Assessing shutter speed in this way will help you to determine more quickly the correct shutter speed to use for different effects when photographing moving subjects in the field.

Workout 4: Assessing Depth of Field

This workout will help you to visualize how lens aperture affects how much of the scene in front of and beyond the point of focus appears sharp.

1. In a yard or driveway, set your camera on a tripod. Select a focal length of 50 mm.

2. Place three objects on the ground, one 7 feet from the camera, another 10 feet from the camera, and the third 20 feet from the camera.

3. Set the exposure mode to aperture priority (A or Av), and set the aperture at its widest setting (most likely somewhere between f/2.8 and f/5.6).

4. (If the light level is too low, increase ISO.)

5. Set focus mode to manual and focus on the middle object. Take an image at the widest aperture setting.

6. Reduce the lens aperture in 1-stop increments to a maximum value of f/22, taking a new image at each new aperture setting. Take care not to change the original focus setting during this process.

7. Note how the sharpness of the nearest and farthest objects changes as lens aperture is reduced until, at f/22, all three objects appear sharp.

Being able to accurately calculate depth of field will limit the need to simply set the smallest aperture (see Habit 4) to maximize depth of field, and enable you to use selective depth of field to alter points of emphasis (see Habit 4).

Workout 5: Noise Abatement

Test your camera to see how it copes with high ISO noise, and to assess the maximum ISO value to use for high-quality images.

1. Set your camera on a tripod and frame a scene that contains areas of dark tones.

2. Set exposure mode to aperture priority and metering mode to multisegment metering. Select a mid-range aperture setting (e.g., f/8).

3. Turn off the noise reduction function in the camera menu.

4. Set ISO to its lowest value (typically 100 or 200) and take a picture.

5. Without moving the camera, adjust ISO value upwards in increments of {1/3}- or {1/2}-stops, whichever you have set on the camera, taking a picture for each adjustment.

6. Now turn on noise reduction in the camera menu and repeat steps 4 and 5.

7. Once you have taken the full series of images, view them on a computer at 100% (actual pixel) size. Turning off any in-computer noise reduction.

8. Pay particular attention to the shadow areas to see at what ISO value noise becomes apparent.

Workout 6: Hula-Hoop

This is an exercise in creative thinking and is similar to an exercise described by Freeman Patterson, one of Canada's most celebrated nature photographers. You'll need a hula-hoop and a pair of dice.

1. Head out to one of your favorite photographic locations close to home. Stand in a prominent position.

2. Throw the dice and make a note of the score.

3. Throw the dice again and double the score. Note the score.

4. Throw the dice a third time and treble the score. Note the score.

5. With your hula-hoop, in relation to a clock face, walk in the direction indicated by the first score a number of paces equal to the second score (e.g., if the first score is 5 and the second score is 16, walk 16 paces in the direction of 5 o'clock).

6. Drop your hula-hoop to the ground and step inside it.

7. Without moving the hula-hoop or leaving its confines, take a number of images equal to the third score.

What this exercise will do is get you to think beyond the obvious photographs, training your eyes and mind to see images within images.

Workout 7: Take One Lens

This is another exercise in creative thinking and will get you moving. No hula-hoops required!

1. Head to one of your favorite photographic locations close to home.

2. Choose a single prime lens; the actual focal length doesn't matter. If you don't use prime lenses, take a single zoom and choose one focal length to work with. (No cheating!)

3. Photograph 36 images (equivalent to a whole roll of film) using just this focal length.

This exercise will encourage you to move about your subject, looking for different angles and perspectives.

Workout 8: Breaking Rules

UK-based South African photographic artist Steve Bloom believes that rules were meant to be broken and encourages experimentation and camera play. Here's a workout to set you on your way.

All at once or at different times, take a set of images for each of the following "rules" of outdoors and nature photography.

1. Shoot with the light behind you.

2. Always hold the camera steady.

3. Keep horizon lines level.

4. Animals' eyes should always be sharp.

Now take a set of images for each "rule" that breaks that rule.

1. Shoot into the light, varying exposures between exposing for the highlights and then for the shadows.

2. Take a set of four images: moving the camera vertically during exposure, moving the camera horizontally, moving the camera diagonally, and rotating the camera around the lens axis.

3. Take a set of three images where the horizon is sloping to create a sense of discord and visual energy.

4. Take a set of images where the point of focus is away from the subject's eyes.

You can extend this exercise by choosing any of the rules relating to technique or composition in photography and going out of your way to break them.

Workout 9: Get into the Swing of Things

Here's an exercise I enjoy when I want to have some fun with the camera.

1. Attach a cable release or infrared remote trigger to your camera.

2. Set the camera to continuous AF and closest-subject focus mode.

3. In aperture-priority exposure mode, set the lens aperture to a high mid-range value (e.g., f/16).

4. Go for a walk in a scenic location.

5. Hold your camera securely by its strap, dangling down by your side or in front of you.

6. As you walk, with the camera swaying, take a series of images, whenever the moment grabs you.

This exercise can be repeated when you're the passenger in a moving vehicle and the vehicle is being driven in a nonrestricted or regulated area. For example, I often try this technique when traveling in an open 4 × 4 vehicle cross-country.

Workout 10: Two's Company

This workout will help you to think laterally about the subjects that you are photographing and to see common objects and scenes in new and unique ways.

1. Join with a friend or group of friends for a day or weekend of photography.

2. Head out to a well-known photographic landmark.

3. Stay within a few feet of each other while taking photographs. Plan to take a minimum of 36 photographs each, but don't compare notes or look at each other's images during the course of the shoot.

4. When the shoot is complete, gather around a common PC or workstation to view and describe each image. Compare the differences in the pictures and get each photographer to describe how he/she made the image.

SIX PHOTO PROJECTS TO INSPIRE YOU

When celebrated wildlife and nature photographer Jim Brandenburg took a break from shooting for *National*

Geographic magazine a few years ago, he went in search of a project that would re-stimulate his creative senses and inspire his photography.

He came upon the idea of photographing just a single image every day for the 90 days of fall. The location he chose was the landscape around his home. After completing the project, it sat untouched in a drawer in Jim's office. Then he happened to show it to a friend at *National Geographic*.

The project featured in the magazine and went on to become a book, titled *Chased by the Light*. Significantly, Jim recognizes that it changed his approach to photographing nature and, ultimately, his photographic career.

At times, we all need to be motivated or inspired. Here is a selection of project ideas to encourage you to get out with your camera and to give your image making a sense of purpose.

Project 1: A Day in the Life of My Garden

Description: Spend a day and night photographing the fauna and flora that inhabit the backyard/garden. (If you don't have a garden, ask a friend if you can fulfill the project in her or his garden.)

Objective: Produce sufficient material for submission to a local magazine for publication.

Time scale: Two 12-hour periods.

Time Planner

Task No.	Description	Due Date	Completion Date
1	Set up hide		
2	Set up feeding station		
3	Animal acclimatization period		
4	Day shoot		
5	Night shoot		
6	Process images		
7	Prepare and send submission		

Special equipment needed: Bird hide and feeding station, off-camera flash and connecting cords (for night), macro lens or close-up attachments.

External resources: None.

Project 2: A Year in the Life of "X" Animal

Description: Photograph the behavior, biology and changes in habitat of a wildlife species.

Objective: Produce 12 strong images and create a calendar.

Time scale: 12-months.

Time Planner

Task No.	Description	Due Date	Completion Date
1	Choose a species and location		
2	Prepare research on species, including learning behavior and body language signals		
3	Prepare shoot—month 1		
4	Prepare shoot—month 2		
5	*Continues …*		

Special equipment needed: Will depend on the species chosen but may involve using long focal-length lenses, camouflage clothing, hides/blinds, and so on.

External resources: May require permission from landowners.

Project 3: The Four Seasons

Description: Photograph the same location from the same perspective in each of the four seasons.

Objective: Produce a set of four images (one per season) to mount and frame.

Time scale: 12 months.

Time Planner

Task No.	Description	Due Date	Completion Date
1	Choose a scenic location, taking into account changes in light and habitat throughout the year		
2	Decide on a shooting position		
3	Spring shoot		
4	Summer shoot		
5	Autumn shoot		
6	Winter shoot		
7	Select and process images		

Special equipment needed: None.

External resources: Secure any necessary access rights.

Project 4: Color

Description: Photograph a series of images where the principal subject is color. (The subject color could be interchanged with pattern or texture.)

Objective: Produce a set of images for submission to *Outdoor Photography/Outdoor Photographer* magazine.

Time scale: 3 months.

Time Planner

Task No.	Description	Due Date	Completion Date
1	Choose the subject		
2	Make weekly field trips		
3	Review and edit images		
4	Prepare submission material		

Special equipment needed: Macro/close-up equipment (if interchanging with texture).

Project 5: BBC Wildlife Photographer of the Year

Description: Shoot a minimum of three images for entry in the competition.

Objective: Win Highly Commended Award in at least one category.

Time scale: Project must be completed at least 1 week before the official closing date.

Time Planner

Task No.	Description	Due Date	Completion Date
1	Get competition entry form		
2	Read competition rules		
3	Research previous year's winners		
4	Decide on category/categories		
5	Plan field trips		
6	Execute field trips		
7	Edit and prepare images		
8	Post entry via secure delivery		

Special equipment needed: Dependent on the subject.

External resources: Secure any necessary access rights.

Project 6:—Hometown

Description: Produce a set of images recording iconic symbols, and natural and/or urban beauty of your hometown.

Objective: To produce a set of quality images to sell as postcards/greetings cards.

Time scale: 12 months.

Time Planner

Task No.	Description	Due Date	Completion Date
1	Derive a shooting list of "must have" subjects/locations		
2	Research the competition		
3	Plan field trips (time of year/lighting/weather)		
4	First set of images complete		
5	Market testing		
6	Second set of images complete		
7	Third set of images complete		
8	Fourth set of images complete		

Special equipment needed: None.

External resources: Secure any necessary access rights, photography licenses.

PLANNING YOUR OWN ASSIGNMENTS

The example projects listed are provided to get you thinking in terms of having a focus for your photography, that is, a reason to go and take pictures. Some of these you may find sufficiently inspiring. I hope you do. However, it is just as easy, and perhaps more appropriate, to develop and execute your own ideas.

To help you in this goal, I have designed a blank project form, which is reproduced here. Please feel free to photocopy this form and use it to plan your own assignments.

Project Form

Photographer's name:

Project title:

Description (what does the project entail?):

Project objective (what is the measurement of success?):

Personal objective (what do you hope to learn from the project?):

Time scale (how long will the project take to complete?):

Equipment needed (list all the equipment you think you'll need):

Special requirements (list all the specialist equipment you'll need):

External resources (list any people or organizations you'll need to involve; include contact details):

Name/Organization	Telephone	E-mail

Planner (List all the actions you will need to complete and the date by when they need to be completed. As each action is completed, note the completion date. This will help to ensure your project stays on track):

Task No.	Description	Due Date	Completion Date

Index

A

Adams, Ansel, 16
AE, *see* Auto-exposure (AE)
AF, *see* Automatic focus (AF)
Africa, 4, 10, 25, 134, 219, 235, 237, 245
Airports
 Africa story, 25
 and equipment packing, 22–24
Alaska, 5, 9, 11, 16, 246, 247
Amplification, *see* ISO
Amplification noise, definition, 150
Angel, Heather
 biography, xi
 and practice, 252
Angle of view
 and camera's eye view, 94–95
 characteristics, 95
 photo examples, 96–97
Animal behavior, and shot prediction, 10–14
Aperture
 and depth of field, 117
 and image quality, 109
 and light intensity, 85
 in light management, 108–109
 and reciprocity law, 109
Aperture priority
 AE mode example, 146
 basic concept, 47–48
 mode choice, 145
Aperture range, maximum, 67–68
Artistic effect
 and depth of field, 114–116

and shutter speed, 112–113
and white balance, 151, 152–161
Art of omission
 exposure, 185–188
 focus and depth of field, 178, 183–185
 in-camera cropping, 176–178
 in-computer cropping, 181–182
Auto-exposure (AE)
 and metering, 119, 121
 wildlife photo example, 146
Automatic focus (AF)
 basic concept, 172
 basic considerations, 162, 164
 customized options, 170
 disadvantages, 172
 dynamic-area mode, 168
 expert advice, 169
 lens controls, 71
 lock button, 172
 operation, 54–56
 predictive focus, 170–172
 system flaws, 170
 and targeting, 167, 169
 tracking, 164–165

B

Beanbag, for stabilization, 80
Behavior, and shot prediction, 10–14
Benvie, Niall
 biography, xi
 exposure advice, 186
 ISO advice, 149

Benyus, Janice, 12
Best-selling images
 Africa zebra, 244–245
 Alaska bear, 246–247
 avocets, 230–231
 Bass Rock, 242–243
 bird reserve, 232–233
 cheetah, 238–239
 disused quarry, 248–249
 hippo, 220–221
 Kruger National Park, 234–235
 lighthouse, 222–223
 moonlight, 224–225
 red-billed hornbills, 236–237
 Scottish Cairngorms forest, 240–241
 Victoria Falls, 228–229
 Zimbabwe, 226
Black-and-white (B&W) mode
 contrast, 91–94
 shooting in, 219
Bloom, Steve
 biography, xi–xii
 rule-breaking exercise, 257–258
Body language, and shot prediction,
 10–14
Bracketing, exposures, 134–137
Brandenburg, Jim
 biography, xii
 creative projects, 258–259
Brooks River, 11
B&W mode, *see* Black-and-white (B&W)
 mode

C

Cairns, Pete
 advice on details, 188
 autofocus advice, 169
 biography, xii
Camera body, in light management, 107
Camera controls
 function, 31–33
 sample settings, 220–249
Camera handling
 hand-holding, 71–75
 and optical stabilization technology, 75
 stabilization advice, 76
 supports, 77–80
Camera operation
 advanced menu options, 66
 B&W mode, 219
 center-weighted metering, 44
 color mode, 61–63
 color space, 59–61
 equipment familiarity, 56
 exposure mode, 46–50
 focus mode, 54–56
 highlights information screen, 53
 histogram screen, 50–53
 hue, 64–65
 image files, 34
 image optimization, 59
 ISO concept, 39–41
 JPEG files, 35–36
 lens controls, 71
 lens definitions, 66–70
 menu system basics, 56–57
 metering mode, 41–42
 multisegment metering, 42–44
 overview, 30–31
 playback menu, 58
 RAW files, 36–38

 saturation, 64–65
 set-up menu, 57–58
 sharpening, 65–66
 shooting menu, 58–59
 spot metering, 44–46
 tone, 63
Camera's eye view
 basic concept, 94
 composition, 102
 focal length, 94–95
 perspective, 98–100
Camera skills
 exercises, 252–254
 movement exercises, 252
Canon, 42, 56, 66, 68, 70, 71, 75, 95, 128,
 164, 169
CCD, *see* Charge-coupled device (CCD)
Center-weighted metering
 basic concept, 44
 and exposure, 142, 144
Charge-coupled device (CCD)
 autofocus concept, 172
 and noise pollution, 150
Chased by the Light, 259
Circles, in image design, 196
CMOS, *see* Complementary metal oxide
 semiconductor (CMOS)
Color
 in image design, 198–199
 photo projects, 260
Color mode, operation, 61–63
Color space, and menu settings, 59–61
Color temperature
 definition, 38
 light, 90
 and white balance, 153, 158
Complementary metal oxide semiconductor
 (CMOS), and noise pollution, 150

Composition, expert advice, 102
Conditions, photography rules, 209–210
Conservation photography
 birds in flight, 169
 visualization for, 19
Contrast
 basic concept, 91
 B&W, 91
 dynamic range, 91–94
 high-contrast scenes, 131–132
 and light quality, 86–87
Cornish, Joe
 biography, xii–xiii
 composition advice, 102
 research and planning advice, 15
 tripod advice, 79
Creative decisions, camera exercises, 260
Creative thinking, camera exercises, 256–257
Cropping
 in-camera, 176–178
 in-computer, 181–182

D

Davies, Paul Harcourt
 biography, xiii
 exposure advice, 188
 image capture advice, 15
Depth of field
 for artistic emphasis, 114–116
 basic concept, 117
 camera exercises, 255–256
 maximization, 117–118
 as omission tool, 178, 183–185
Depth indicators, in image design, 201–203
Design, *see* Image design
Digital single-lens reflex camera (DSLR)
 advanced menu options, 66
 autofocus targeting, 167

autofocus tracking, 164
automation, 106–107
color mode, 63
and contrast, 93
dynamic range, 129
HDR imaging, 134
histogram reading, 52
image optimization settings, 59
menu options, 57
metering mode, 41–42
program modes, 46–47
RAW + JPEG mode, 38
tone capture, 137–138
Direction of flow, photography rules, 208–209
DSLR, *see* Digital single-lens reflex camera
 (DSLR)
Dynamic-area autofocus mode, photo
 example, 168
Dynamic range
 contrast, 91–94
 current cameras, 129
 scenes, 130–131, 133

E
Emphasis, and light, 111
Equipment
 Africa airport story, 25
 and airports, 22–24
 familiarity with, 56
 photobag choice, 25–27
Estes, Richard D., 12
EV, *see* Exposure value (EV)
Exercises
 camera skills, 252–253
 creative decisions, 260
 creative thinking, 262–263
 depth of field, 255–256
 group shooting, 258

lenses, 257
light meter operation, 260–261
moving camera, 258
noise abatement, 256
photo deconstruction, 253
photo projects, 258–261
rule breaking, 257–258
shutter speed, 255
white balance settings, 254
Exposure
 bracketing, 134–137
 and center-weighted metering, 142, 144
 dynamic range effects, 129
 expert advice, 186, 188
 and hand-held metering, 144
 HDR imaging, 134
 high-contrast scene management,
 131–132
 ISO relationship, 145–149
 and light metering, 140–141
 mode choice, 145
 and multisegment metering, 141, 144
 noise pollution, 150–151
 noise-reduction software, 151
 as omission tool, 185–188
 Photoshop corrections, 139–140
 scene dynamic range, 130–131
 shooting examples, 220–249
 and spot metering, 141, 143–144
 and tones, 137–138
 underexposure, 138–139
Exposure compensation
 basic concept, 118–119
 calculation, 128–129
 expert advice, 128
 metering basics, 119–121
 spot metering, 122–127
 tonality, 121–122

Exposure mode
 aperture priority, 47, 48
 basic concept, 46
 program mode, 46–47
 shutter priority, 47–50
Exposure value (EV)
 in light management, 107
 multisegment metering, 44
 and reciprocity law, 110
 spot metering, 44
Eye level, photography rules, 207–208

F
Fill the frame, as photography rule, 207
Flow, photography rules, 208–209
Fluorescent setting, and white balance,
 158–161
f/numbers
 and lens aperture, 108
 math definition, 109
Focal length
 and camera's eye view, 94–95
 and in-camera cropping, 178
 and lens choice, 162
 lens definitions, 67
 and perspective, 98–100
 shooting examples, 220–249
Focus-and-lock
 basic concept, 54, 56
 considerations, 164–165
Focus mode
 as omission tool, 178, 183–185
 operation, 54–56
Focus-and-track
 basic concept, 56
 deactivation, 172
 photo example, 166
Format, types, 95

Four-thirds format, 95
f/stops
 and lens aperture, 108
 scene dynamic range, 130–131
 shooting examples, 220–249
Fujicolor Pro 160S, and color mode, 61
Full-frame digital format, 95

G
GND, *see* Graduated neutral density (GND)
 filters
Golden mean, 204
Google Earth, for visualization, 16–18
Gosling, Steve
 GND filter advice, 131
 hand-held meter advice, 144
 scene dynamic range example, 133
Graduated neutral density (GND) filters,
 and exposure, 131–132

H
Hand-held meter
 expert advice, 144
 and exposure, 144
 and scene dynamic range, 133
Hard light, definition, 86
HDR imaging, *see* High-dynamic-range
 (HDR) imaging
Heat-generated noise, definition, 150
High-contrast scenes, management, 131–132
High-dynamic-range (HDR) imaging, basic
 concept, 134
Highlights information screen, operation, 53
Histograms
 and exposure bracketing, 134
 reading, 50–53
Horizon
 in image design, 191–193
 sloping horizons, 205–207

Horizontal lines, and visual energy, 194–195
Hue, menu operation, 64–65
Hyperfocal distance, and depth of field,
 117–118

I
Ideal conditions, photography rules,
 209–210
Image capture
 compelling images, 214
 pre-shot questions, 214–216
Image design
 basic process, 189
 color element, 198–199
 depth creation, 201–203
 elements, 190–191
 line element, 191–193
 line and visual energy, 194–195
 pattern and texture elements, 200–201
 sample best-sellers, 220–249
 shape element, 195–197
Image files
 JPEGs, 35–36
 overview, 34
 RAW files, 36–38
Image optimization, settings, 59
Image quality, and lens aperture, 109
Image stabilization (IS), definition, 68
In-camera cropping, as omission tool, 176–178
In-computer cropping, as omission tool,
 181–182
Infinity, and depth of field, 118
Insects, expert advice, 15
Internet, for research, 7–8
IS, *see* Image stabilization (IS)
ISO
 and aperture priority, 47
 basic concept, 39–41, 145, 147

digital *vs.* film, 147–149
 expert advice, 149
 metering mode, 41–42
 multisegment metering, 42–44
 noise pollution, 150–151
 noise-reduction software, 151, 152, 153
 and program mode, 46–47
 shooting examples, 220–249
 shooting menu, 58

J
JPEG files
 advanced menu options, 66
 histogram reading, 52–53
 noise-like artifacts, 151
 overview, 34
 shooting menu, 59
 and tone, 63
 and white balance, 39, 161

K
Katmai National Park (Alaska), 5, 9, 11, 16,
 247
Kelvin value
 definition, 38
 sample image, 224
 and white balance, 161
Kodak Gray Card, for tonality assessment,
 129
Kruger National Park (South Africa), 12,
 234–235

L
Landscape photography
 artistic process, 201
 autofocus, 55, 169, 172
 B&W, 91
 and camera handling, 30

color mode, 62–63
composition advice, 102
depth of field, 114
direction of light, 89
exercise, 253
exposure, 187
focal length, 162
focus-and-lock mode, 165
focus mode, 54
HDR imaging, 134
high-contrast scenes, 131
ideal conditions, 209–210
image design, 189
manual exposure mode, 145, 147
metering, 119, 143, 144
planning advice, 15
program mode, 47
Rule of Thirds, 204
sloping horizons, 205
spirit level, 207
spot metering, 46
targeting, 167
time and motion, 111
Velvia film, 62
white balance, 153, 158
Lenses, *see also* Camera's eye view
camera exercises, 257
controls, 71
definitions, 66–69
and light intensity, 85
manufacturer definitions, 70
shot decision examples, 163, 164
shot decisions, 161–162
stabilization advice, 76
Light
color temperature, 90
depth of field effects, 114–116
direction, 87–89

for emphasis and order, 111
intensity, 85–86
as omission tool, 185–188
painting with, 110–111
quality, 86–87
time and motion appearance, 111
as tool, 85
Light management
basics, 107
lens aperture, 108–109
reciprocity law, 109–110
shutter, 107–108
Light meter
camera exercises, 254–255
center-weighted metering, 44, 142, 144
and exposure, 140–141
for exposure compensation, 119–128
mode overview, 41–42
multisegment metering, 42–44, 141, 144
shooting examples, 220–249
spot metering, 44–46, 141, 143–144
Line element
in image design, 191–193
and visual energy, 194–195

M

Magnification, and camera's eye view, 94–95
Manual exposure mode
function, 50
landscape photo example, 147
mode choice, 145
Manual focus (MF), operation, 54
Maps
Google Earth, 16–18
and planning, 15
Maximum aperture range, lens definitions, 67–68
Medium-format digital, 95

Meers, Nick
biography, xiii
light direction advice, 89
Menu system
advanced options, 66
basic use, 56–57
color mode, 61–63
color space, 59–61
hue, 64–65
image optimization settings, 59
playback menu, 58
saturation, 64
set-up menu, 57–58
sharpening, 65–66
shooting menu, 58–59
tone, 63
Metering, *see* Light meter
MF, *see* Manual focus (MF)
Migration, wildebeest, 19
Moonlight, as light source, 224
Morgan, Chris, 9, 11
Motion, and light, 111
Movement, as image subject, 19–21
Multisegment metering
basic concept, 42–44
and exposure, 141, 144

N

National Geographic, 5–6, 10, 258–259
Networking, in research and planning, 9–10
Ngorongoro Crater (Tanzania), 244
Nichols, Michael "Nick"
biography, xiv
planning advice, 5–6
visualization advice, 16
Nikon, 31, 32, 42, 44, 56, 58, 66, 67, 68, 70, 75, 94, 95, 170, 238
Noise, camera exercises, 256

Noise pollution, ISO, 150–151
Noise-reduction software, applications, 151,
152, 153

O
Olympus, 94
Optical stabilization (OS)
and camera handling, 75
expert advice, 76
lens definitions, 68–69
Order, and light, 111
OS, *see* Optical stabilization (OS)
Overexposure, issues, 140

P
Packing
equipment and airports, 22–24
photobag choice, 25–27
pre-planning, 21
Padlocks, and photobags, 26–27
Patterns, in image design, 200–201
Patterson, Freeman
biography, xiv
creative thinking exercise, 256
Pentax, 50
Perspective, and camera's eye view, 98–100
Photo bag, choosing, 25–27
Photo merging, and HDR imaging, 134
Photoshop
B&W shooting mode, 219
for cropping, 181
exposure correction, 139–140
hippo example, 220
for photo merging, 134
Planning
animal behavior and shot prediction, 10–14
expert advice, 5–6
initial steps, 6–7

networking, 9–10
overview, 4
packing, 21–27
sample project forms, 256–259
visualization, 16–21
Playback menu, operation, 58
Polygons, in image design, 195–196
Predictive focus, application, 170–172
Program mode, basic concept, 46–47
Provia, and color mode, 62

R
RAW data
advanced menu options, 66
and DSLRs, 38
as file type, 36–38
and JPEGs, 35–36
overview, 34
shooting menu, 58–59
and white balance, 39, 158, 161
Reciprocity law, light management, 109–110
Reflectance, and exposure compensation, 121
Research
expert advice, 10
initial steps, 6–7
Internet tools, 7–8
networking, 9–10
overview, 5
visualization, 16–21
RGB
and color space, 59–61
histogram reading, 52
and hue, 64
menu settings, 59–61
Rosebury Topping, 15
Rules
direction of flow, 208–209
eye level photography, 207–208

fill the frame, 207
ideal conditions, 209–210
learning and breaking, 203–204
Rule of Thirds, 204–205
sloping horizons, 205–206
Rule of Thirds, 204–205

S
Safari Companion, 12
Sartore, Joel
biography, xiv–xv
research advice, 10
Saturation, menu operation, 64–65
Scene dynamic range
via hand-held meter, 133
measurement, 130–131
*The Secret Language and Remarkable
Behaviour of Animals,* 12
Sekonic meter, expert advice, 144
Sensitivity-priority auto mode, definition, 50
Serengeti (Tanzania), 19
Set-up menu, operation, 57–58
Shape element, in image design, 195–197
Sharpening, menu operation, 65–66
Shooting examples
Africa zebra, 244–245
Alaska bear, 246–247
avocets, 230–231
Bass Rock, 242–243
bird reserve, 232–233
cheetah, 238–239
disused quarry, 248–249
hippo, 220–221
Kruger National Park, 234–235
lighthouse, 222–223
moonlight, 224–225
red-billed hornbills, 236–237
Scottish Cairngorms forest, 240–241

Victoria Falls, 228–229
Zimbabwe, 226
Shooting menu, operation, 58–59
Shot prediction, animal behavior, 10–14
Shutter priority
basic concept, 47–50
mode choice, 145
Shutter speed
for artistic emphasis, 112–113
camera exercises, 255
and light intensity, 85
in light management, 107–108
and reciprocity law, 109
Sigma, 66, 68, 70
Silhouette
and exposure, 141
as exposure tool, 186–187
Sloping horizons
expert advice, 207
as photography rule, 205–206
Small format, 95
Soft light, definition, 86
Software
B&W shooting mode, 219
for cropping, 181
exposure correction, 139–140
for noise reduction, 151
photo manipulation, 220
for photo merging, 134
South Africa, 12, 234–235
Spatial relationships, definition, 162
Spheres, in image design, 196
Spirit level, 207
Spot metering
basic concept, 44–46
and exposure, 141, 143–144
and exposure compensation, 122, 125–126
sRGB, 59–61

Stop, see Exposure value (EV)
Stops, and exposure compensation, 122–127
Subject
animal behavior and shot prediction,
10–14
defining, 216–219
movement as, 19–21

T
Tamron, 67, 68, 70
Tanzania, 244
Targeting, with autofocus, 167, 169
Tarn, David
biography, xv
sloping horizon advice, 207
Texture, in image design, 200–201
Through the lens (TTL) meter
and exposure compensation, 119
hand-held meter, 144
lens types, 70
meter mode, 42
TIFF files
format comparisons, 34, 36
shooting menu, 59
Time, and light, 111
Time of day, and light direction, 89
Tone
assessment, 129
and exposure, 137–138
and exposure compensation, 121–122
menu setting, 63
and white balance, 153
Tracking, and autofocus, 164–165
Travel
airports, 25–26
packing, 21
research and planning, 5
Travel photography

direction of light, 89
sharpening level, 66
Triangles, in image design, 195–196
Tripods, expert advice, 77–80
TTL, see Through the lens (TTL) meter

U
Underexposure
issues, 138–139
as omission tool, 186–187

V
Value, definition, 121
Vanuga, Jeff
biography, xv
exposure compensation advice, 128
HDR imaging advice, 134
ideal conditions advice, 210
image design advice, 201
VC, see Vibration compensation (VC)
Velvia, and color mode, 61–62
Vertical lines, and visual energy, 194–195
Vibration compensation (VC), definition, 68
Vibration reduction (VR), definition, 68
Victoria Falls, 228–229
Visual energy, in image design, 194–195
Visualization
definition, 16
with Google Earth, 16–18
VR, see Vibration reduction (VR)

W
WB, see White balance (WB)
Westmoreland, Stuart
biography, xv
stabilization advice, 76
Weston, Chris, biography, xv–xvi

Weston, Edward, rules advice, 203–204
White balance (WB)
 alteration effects, 153–157
 and aperture priority, 47
 basic operation, 151, 153
 camera exercises, 254
 and camera operation, 38–39
 and color temperature, 153, 158
 customized values, 161
 fluorescent setting, 158–161
 photo example, 40
 and program mode, 46
 and shutter priority, 50
 and tones, 153

Wildlife photography
 aperture-priority AE mode, 146
 autofocus, 164–165, 169, 172
 birds in flight, 169
 blurry *vs.* sharp, 184
 color mode, 62
 exercise, 252–254
 exposure mode, 145–146
 eye level rule, 207–208
 HDR imaging, 134
 ideal conditions, 210
 image design, 189
 lens control, 71
 manual focus, 173
 pre-shot questions, 215
 priority selection, 170
 Provia film, 62
 sharpening, 66
 shooting information, 220-249
 subject knowledge, 10
 time and motion, 111
Wolfe, Art
 biography, xvi
 tripod advice, 78

Z
Zimbabwe, 215, 226